**WASHINGTON ART MATTERS:** ART LIFE IN THE CAPITAL  1940 – 1990

BY JEAN LAWLOR COHEN · SIDNEY LAWRENCE · ELIZABETH TEBOW · AFTERWORD BY BENJAMIN FORGEY

**WASHINGTON ARTS MUSEUM**

**Dedicated to Phillip Thomas Abraham**

(July 13, 1936–May 3, 2008)
Washington builder, developer, lover of opera
and art, without whose generosity this book
would not have been possible.

FRONT COVER, clockwise from top (details): Martin Puryear, *Arbor*, p. 98;
Morris Louis, *Untitled 5-76*, p.44; James Hilleary, *Untitled*, p. 63; Alan Feltus,
*Four Women*, p.93; Thomas Downing, *Blue-Tender*, p. 51; Clark V. Fox,
*George Washington*, p. 95; W.C. Richardson, *Red Shift*, p. 183; William Calfee,
study for WPA mural, p. 14

SPINE: Gene Davis, *Gentle Jackhammer* (detail), p. 48

BACK COVER, clockwise from top: Michael Platt; Walter Hopps; Sherman
Fleming/Rod Force; unidentified woman; Paul Reed; Lee Fleming; Joy Silverman
and Al Nodal; Henrietta Ehrsam

© 2013 WASHINGTON ARTS MUSEUM
ISBN 9780615828268

# Contents

# Washington Arts Museum

This book is the final project of the Washington Arts Museum (WAM). From its inception in 1999 at a meeting in an Adams Morgan restaurant attended by many in the local art community, WAM had two goals: to spotlight important and, in some cases, neglected artists, who worked in the Washington area and to support and encourage Washington art. For more than a decade, functioning solely with the support of private donations, small public grants and dedicated volunteers, WAM accomplished a lot.

We mounted eleven exhibitions of Washington art in various venues, including the windows of a defunct department store, the DCAC alternative space, a restaurant and Pepco's Edison Place Gallery. Distinguished curators, artists and dealers served as guest curators and essayists for the shows' color catalogs, among them, Jean Lawlor Cohen, Barbara Fendrick, Sam Gilliam, Walter Hopps, Donald Kuspit, Jamie Smith and Sarah Tanguy.

We also organized and videotaped panel discussions at the Arts Club of Washington and other venues, events that revisited important local art history and gave context to our exhibitions. WAM's history committee of volunteers recorded interviews with Washington artists and amassed a collection of books, posters and memorabilia.

As with other efforts to bring attention to Washington art, WAM reached a point where, lacking sustainable and significant funding and a permanent home, it could no longer continue its ambitious mission. Along with our longtime board member Duncan Tebow, we decided that a book covering the years 1940 to 1990—five decades that were the primary focus of WAM exhibitions—made an appropriate capstone.

Chapters that deal with the 1940s, 50s and 60s expand a 1988 series of articles produced for *Museum & Arts Washington* magazine by Jean Lawlor Cohen, now a magazine editor and independent curator. Art professor and historian Elizabeth Tebow's newly researched chapter on the 1970s grew out of a 2001 panel she organized for WAM. Sidney Lawrence, an artist who first showed his work in Washington in the 1980s while on staff as Press Officer at the Hirshhorn Museum, brings experience as a curator, participant and critic to that decade. Benjamin Forgey, longtime art and architecture critic for *The Washington Star* and *The Washington Post*, provides a reflective epilogue. We thank them for their enthusiastic, unwavering commitment to the project that has entailed nearly four years of effort.

The design of this book was created by Monica Bussolati and Noelle Weber at Bussolati in Washington, D.C.

—Renee Butler and Giorgio Furioso

## Acknowledgments

Many other persons made this book possible. They include Joseph S. Horobetz, who brought a practiced eye and thoughtful suggestions to the task of copy editor and Monica Bussolati and her design team who put it all together in such a handsome way. The authors are also very grateful to the many individuals who shared their memories, suggestions, photographs, memorabilia and moral support for this book.

We would especially like to thank:

Anne Abramson
Darrell Acree
Alison B. Amick
Darrell J. Andruski
Allen Appel
Wendy Hurlock Baker
Dixie Bare
Tom Birch
Brigitta Blair
Betty Boone and the Robinson Family
Nizette Brennan
Wilfred Brunner
Teresia Bush
Carolyn Campbell
Chang Won Chang
Sandra and William Christenberry
Manon Cleary
Leigh Conner
Dabney Cortina
Diane Deiss
Claudia DeMonte

Arnold Edelman
Mary Beth Edelson
Robert Epstein
Paul Feinberg
Sal Fiorito
Sherman Fleming
Jeremy Flick
Barbara Frank
David Furchgott
Elizabeth Furman
Alberto Gaitán
Amy Giarmo
Margery Goldberg
James Goode
Janis Goodman
Anabeth Guthrie
Derek Guthrie
Johanna Halford-MacLeod, Franz and Virginia Bader Fund
Faye Haskins

Joe Holbach
Andrew Hudson
Ida Jervis
Pamela Johnson
Dan and Paul Kainen
Liza Kirwin
Anna Kuehl
Mokha Laget
Katie Langjahr (ARS)
Bobby Lennon
Jane Livingston
Bill Lombardo
Jacquelin Mabey of Marlborough Gallery
J.W. Mahoney
Anne Mannix-Brown
Gretchen Martin
Rachel Martin
Ed McGowin
Michael Rosenfeld Gallery
Jamie Mitchell
Robin Moore

Nan Montgomery
Ignacio Moreno
Jody Mussoff
Ramon Osuna
Andrea Pollan
Max Protetch
Martin Puryear
Samantha Quigley
Candace Randle
Jessica Racine White
Jack Rasmussen
Paul Reed
Lizanne Reger
Paul Richard
Martha Robertson
Susan Abramowitz Rosenbaum
Eric Rudd
Rachel Sanchez
Karen Schneider

Helen S. Schonebelen
Ellen Sinel
Roy Slade
Gary Snyder
Richard Sorensen
Robert Stackhouse
Kristine Stiles
Joe "Ben" Summerford
Isabel Swift
Mary L. Swift
Patrick A. Thomas
Roxy Vaughn
Noelle Weber
Brandon Webster
Joe White
D. Wigmore Fine Art, Inc.
Jeff Wilkes
Clarissa Wittenberg
Capt. Gregory A. Wolf
Anne S. Wood

Three persons deserve special thanks: Giorgio Furioso for first proposing that we undertake this project and never flagging in his support; Duncan Tebow, for his business sense, good humor and guidance through WAM's final days; and WAM co-founder Renee Butler, who shepherded the book from its inception five years ago, organizing and hosting planning sessions, soliciting writers, gathering images and generally nudging, cajoling and encouraging.

# Preface

*You can't avoid a multitude of influences—
art history, what you've seen, read, heard. But the
whole point of being an artist is to try to be yourself,
to be stiff-necked about what you think or feel, and
in the long run it will show. And it might be in the
very long run.* —Jacob Kainen

From an interview by Mary Swift,
*Washington Review*, June-July 1992

The years 1940 to 1990 bracket the evolution of Washington, D.C.'s art identity—from federal arts projects and the influx of newcomers in war and post-war times to heady acclaim for the Washington Color School, from ambitious experimentation in the 1960s to mobilization of artists in the 70s and 80s, spurred by D.C.'s boom as a cultural center as well as by political events. All that time, D.C. artists and gallery owners, collectors, curators and writer peers faced daunting tasks—to compete for visibility despite or via New York, to find studio and exhibition spaces, to foster a sense of community, to educate the public, to stimulate a strong market and, perhaps most difficult, to establish themselves in an international city of national museums.

Our stand-alone chapters make no claim to being a critical assessment of the art made here or to including all who factored in the capital's art life between 1940 and 1990. (A start-up list of solo shows in those years proved overwhelming.) No doubt many artists, institutions and events have been missed, although they deserve mention. Consider this book a well-intentioned effort, an affectionate look at personalities and happenings, a culling of anecdotes and a compilation of facts from archives, publications, principals and witnesses.

We hope that this account of the complex realities of the art life in our city will inform today's artists who make it their home and workplace and that it will encourage future scholars. The art of Washington in the second half of the 20th century mattered then, and it matters still.

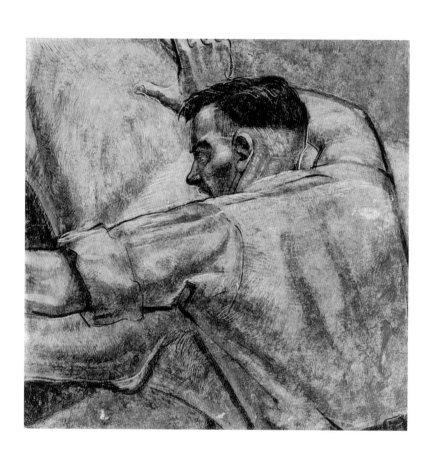

## CHAPTER 1

# The Old Guard

## THE 1940S

BY JEAN LAWLOR COHEN

On November 6, 1938, the *Washington Times Herald* devoted its society page ("These Charming People") to an emergency fundraiser for Washington's branch of the Museum of Modern Art. The Museum had opened the year before, on the first floor of the private Metropolitan Club, with an exhibition of five "moderns" —Cézanne, Gauguin, Renoir, Seurat and Van Gogh, even then too radical for most local tastes. Unfortunately, by 1939, the set of "charming people" found themselves with only 300 members, a deficit of $23,000 and a consensus to disband.

Ten years (and a world war) passed before Washington generated its own art identity and two decades until the rest of the world, i.e., the New York press, took notice. What happened between the demise of the capital's own MOMA and the emergence, in the 1950s, of the so-called Washington Color School? Was the city a cultural Sahara during the 1940s, or was it, especially in the peacetime second half, a viable art community with mentors, art students, a marketplace and regional influence?

What Washingtonians may not know, in the endless gauging of our city against New York, is that, before World War II, New York itself had a minimal gallery scene, some 20 dealers, concentrated along a few blocks of 57th Street. Admittedly that city boasted more collectors, raised more money for its museums and held on to more of the creative émigrés. But of the artists who arrived there and stayed, most benefited from camaraderie, not from financial reward or critical attention.

Washington may have seemed an inhospitable place for artists and art lovers in 1940, but no American city of its size could claim a vibrant contemporary market. In many respects, the capital had advantages. Well-funded WPA and Treasury projects brought artists such as Ben Shahn, Reginald Marsh and Chaim Gross from New York to work on federal buildings from the mid-1930s until 1942. Everyone had access to the Corcoran Gallery of Art, the city's oldest collection, and to the nation's official art repositories—the Smithsonian's National Collection of Fine Arts, until 1968 in the Natural History building, and the National Gallery of Art.

A 1939 competition to design a Smithsonian Art Gallery had drawn more than 400 submissions. Eero Saarinen of Saarinen, Swanson and Saarinen won with an avant-garde, Bauhaus-like plan that delighted architecture critics but dismayed conservative

1. PREVIOUS:. Study (detail) for a WPA mural by William Calfee, c. 1942, oil on plywood, 24 x 24 inches

officials like Edward Bruce of the Public Works of Art Project. With all construction suspended because of imminent world war, no work began on the designated site, now occupied by the National Air and Space Museum. The initiation of another long-planned gallery on the National Mall ultimately doomed the modernist project.

When the National Gallery of Art opened in March 1941, President Franklin D. Roosevelt attended the dedication at which Paul Mellon presented his father Andrew Mellon's gift of the building and art collection. Mellon's choice of neoclassical architect John Russell Pope satisfied bureaucrats and trustees who had opted for what critics called "a streamlined pantheon." For some years, thanks to the largesse of industrialist and banker Andrew W. Mellon, many continued to refer to the new museum as "the Mellon gallery."

The late Jacob Kainen, for years the unofficial dean of Washington artists, remembered the museums of that time as stodgy places. He recalled that the Corcoran Gallery displayed its original collection in 19th-century style, the paintings and plaster casts stacked in rows up dimly lit walls. The National Collection of Fine Arts, precursor of the Smithsonian American Art Museum, hung its paintings by Albert Pinkham Ryder in a corridor lit by naked bulbs.

Still, old newspapers and archives reveal that Washington had a small, somewhat erratic but lively arts scene even during the war years. Contemporary art got made and shown, thanks to a number of rugged individualists—artists and teachers, gallery dealers and rare collectors, all of whom nourished themselves at The Phillips Collection, America's first museum of modern art.

Duncan Phillips (1886-1966) had opened his family residence to the public in 1921, showing works by modernist masters (Klee, Bonnard, Matisse) and their sources (El Greco, Daumier, Van Gogh), eight years *before* New York got its MOMA. Local artists brought their work to Phillips, who sometimes bought, but most had to find less rigorous *community* showcases.

Serious and amateur artists exhibited with the Washington Society of Artists (founded 1892) and at the *Times Herald* Art Fair, which awarded $20,000 in prizes. Many showed at the Water Color Club, the Society of Miniature Painters, the Landscape Painters Society, the Arts Club, the progressive Artists Guild and even the Junior League. Newspaper reviewers covered each opening with small-town fervor, using phrases like "just the right touch of lightness, freighted with sincerity."

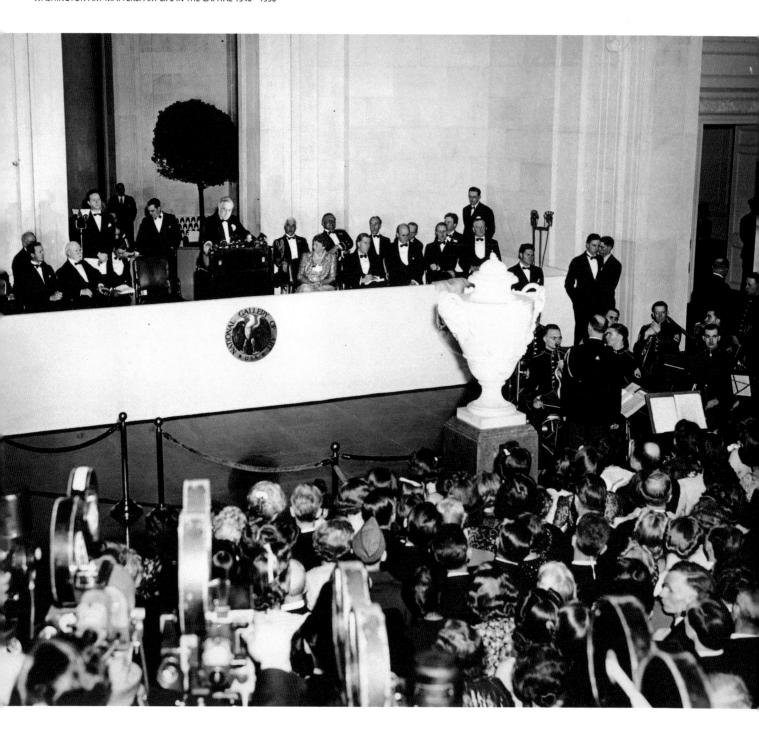

The Corcoran Gallery's biennial exhibition featured out-of-town "name" artists such as Raphael Soyer and Edward Hopper, always ones who satisfied conservative tastes. In 1946, yielding to community pressure, the Corcoran mounted its first regional show. The jurors, all out-of-town museum directors, chose 120 works from 800 submissions. After that event, the gallery began to show, some said grudgingly, the so-called "modern" paintings and sculptures favored by Washington's arrivistes.

An early (1930s) WPA assessment of the capital had whined, "Whatever culture there is started elsewhere and was...pasted on." But after World War II, that weakness turned out to be a strength. As the demographics of America changed from provincial and homogeneous to mobile and heterogeneous, any city's culture came to be measured by the talents of its émigrés. With few exceptions, the art pioneers of Washington were enlightened outsiders who came to town for a variety of non-art reasons: the war effort, a spouse's job, even escape from the Axis powers.

In 1942 Jacob Kainen arrived in Washington, fresh from WPA projects in New York and a circle of painter-friends who included Arshile Gorky, John Graham and Stuart Davis. He had landed a job at the Smithsonian ("scientific aide, graphic arts") and moved his family here, but the adjustment was painful. Kainen missed the art talk and the spirit of the studios around Union Square. He recalled a Cézanne show review by the *Star*'s Leila Mechlin in which she said, "Everyone knows that a painting is an open window through which you see nature. Cézanne doesn't know what art's about." He wondered, "What am I getting into?"

Kainen gave a first show to Sam Bookatz, a newly commissioned Navy man who came from Ohio and had

3. At the Smithsonian, Jacob Kainen's job was to assist citizens by identifying but not appraising their prints. But his most important function was to curate a monthly exhibition, often the first for a major printmaker. These shows were so low-budget that featured artists paid their own shipping to Washington.

OPPOSITE: 2. President Roosevelt at the opening of the National Gallery of Art, 1941

4. *Excavation at the White House*, c. 1941, by Mitchell Jamieson, watercolor on paper, 22 3/4 x 17 inches

5. Lt. Samuel Bookatz, in 1943, wearing an artist's smock over his navy uniform, as he paints a panel for a naval hospital mural

worked on WPA projects. Bookatz received his orders directly from President Roosevelt: Document, in portraits, every surgeon general of the Navy and, in murals, the history of the medical corps. His studio was the White House, where he propped himself against Lincoln's bed to paint likenesses of the prominent, including the Roosevelts themselves.

Bookatz (1910-2009) spent most of his life here, worked into his final years in an Alexandria studio and in 2000 received a Corcoran Gallery of Art retrospective. "I'm an everything painter, really," he told *The Washington Post*. "I can work on 12 canvases in one day ranging from the realist to the abstract...I don't know what's going to happen from minute to minute."

Later, like many of his contemporaries, he bemoaned that Washington had forgotten "us artists who started it all." By that, he said, he meant figurative painter and teacher Andrea Zerega (1916-1990), sculptors Benjamin Abramowitz (1917-2011) and Pietro Lazzari (1898-1979) as well as semi-abstract painter Mitchell Jamieson (1915-1976) and cityscapist Jack

Perlmutter (1920-2006), the last two later commissioned to document the space program for NASA.

In 1932 Zerega and his mother came from Italy to Washington to reunite with family. From 1935 to 1939, he studied at the Corcoran School. Eventually his works, ranging from landscapes and expressionistic portraits (like Redskins QB Sammy Baugh in action) to abstract painting, hung in group shows at the Metropolitan Museum and the Pennsylvania Academy and earned him a Corcoran solo show in 1951.

In 1968, Zerega moved back to Italy ("I was suffocating...America was burning") to live in his ancestral town Zerega, its name adopted years before as his surname. In the mid-1980s, in failing health, he returned to Washington with his wife and spent his last days making small, slab-like, painted wood sculpture in a Connecticut Avenue apartment within the sound of National Cathedral bells.

Lazzari, an Italian Futurist painter, fled fascist Italy for New York, worked as a WPA fresco painter and moved to Washington in 1942 for the war effort. He enjoyed being outrageous and once pulled a wine glass from his pocket to offer the genteel Duncan Phillips "a little vino." Later he taught at the Corcoran School and American University, while producing bronze sculpture (busts of Eleanor Roosevelt and, from life, Pope Paul VI) and paintings he labeled "polychrome concrete."

Benjamin Abramowitz (1917-2011), a WPA artist in New York, also came in 1942 for a wartime job—graphic artist at the U.S. Agriculture department. He settled with his wife and two children in the new town of Greenbelt, Maryland, and soon won prizes for his paintings in regional art shows. By the 1950s he became a teacher-mentor, a Ford Foundation traveling lecturer and an accomplished sculptor. He continued to show (the Jefferson Place Gallery in 1972, Gallery K in 1989) and to work until halted by macular degeneration.

None of these pioneers—in fact, no one in Washington—made a living by art alone. Despite a number of optimistic gallery owners, the city had no bohemian neighborhood, no cafes or coffee houses to pull artists and their patrons, no gathering places for a subculture during the war. Kainen remembered seeing only one watercolorist at work on an easel in Dupont Circle. "We couldn't afford the restaurants, and most of us had families to get home to."

6. *Homecoming* , 1945 - 1946, by Benjamin Abromowitz, pencil drawing at close of World War II

7. *Old House*, 1943, by Jacob Kainen, oil on canvas

Kainen lived on Seventh Street NW and caught a trolley each day to the stop one block east of M and Wisconsin at 31st Street where he rented a walk-up studio. Because the landlord provided no heat, Kainen painted in hat, coat and gloves, and even years later he sometimes felt a numbness in his fingers. Still the city made a positive impact on his work. He said, "The old buildings were new to me. I began to sketch street scenes, to take off on their Victorian arabesques. I was the most abstract painter in Washington then, redoing cityscapes in an expressionistic manner. There was a luminous quality to the light here, something I hadn't seen in New York with its elevated skyline."

At the Whyte Bookstore, just north of Dupont Circle, Kainen met Franz Bader, who eventually became one of his dealers and the undisputed father of D.C.'s commercial gallery scene. Bader had fled Nazi-occupied Vienna in 1938 and come to Washington with the promise of a job from bookseller James Whyte. He clerked to an international clientele and eventually commandeered the mezzanine for displaying works by local artists.

As a peacetime economy revived the housing market and with it an interest in decorating, Franz Bader (1903-1994) became the prime source of small-scale, reasonably priced contemporary fine art. He retired at 85 but welcomed visitors to his Foxhall neighborhood home, a mini-museum where he kept 40 years of scrapbooks about "my group," the artists he represented and befriended. "I never took a salary, and I never refused to show someone because he was too advanced. I only had to be convinced that a work was done not to make money or to get talked about but because it had to be done. I still believe in trusting the instincts."

Worthy footnote: Since 2002, the Franz and Virginia Bader Fund has distributed $535,000 in grants as of December 2012 to 30 visual artists. From a pool of applicants, a committee of nine, all friends of the late couple, selects grantees who must have reached the age of 40, reside within 150 miles of Washington, D.C. and prove that a grant will benefit their work.

One of Bader's early clients, Marc Moyens became a prominent art dealer himself. Moyens arrived in Washington from France in 1945 for a two-month assignment as a multilingual interpreter but was offered a job at the World Bank and never left. A compatriot of the wartime underground and friend of Parisian

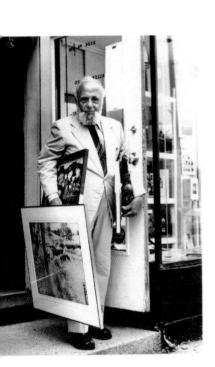

8. Franz Bader, 1980s, outside his
last gallery, Pennsylvania Avenue

artists, he later recalled, "Washington was a village. Cows were grazing on Georgia Avenue."

The only apartment he could find, a block south of Dupont Circle, was "a shambles." After six months of "buff-gray walls staring at me," Moyens bought his first painting from Bader at the Whyte gallery. That purchase made the other walls look bad, and collecting became, he said, "the addiction for which there is no cure."

At first unable to find art talk here, Moyens spent weekends in New York, visiting galleries and hanging out in the Cedar Bar with artists like Larry Rivers. But by the end of the 1940s, he said that Washington had developed its own art scene, with openings at the Whyte and Barnett-Aden galleries, invitations to artists' studios and group excursions to the Howard Theatre and "jazz joints."

At least one other serious collector of contemporary art lived in Washington then. Alfred Auerbach, a wealthy industrial designer, had moved from New York to head a war effort agency, The Office of Price Administration. He began collecting in the 1930s and once bought a painting when Arshile Gorky stopped him on a Greenwich Village street in need of rent money.

Auerbach hung works by de Kooning, Matta, Motherwell and Picasso in his Dorchester Towers apartment on 16th Street. In 1944 he invited a journalist friend Gene Davis to see the collection. Davis reacted at first with philistine anger, but the art tantalized him so much that he asked to come back for another look. Later, when Davis emerged as a major painter, he credited Auerbach with introducing him to the "wild men" of modern art and rekindling his childhood artistic interest.

Although Auerbach probably never patronized them, a number of contemporary galleries operated here, some as early as the 1930s. Probably the first was the Little Gallery (1934), located in not yet fashionable Georgetown and run by Mrs. D.C. Fox until the late 1940s. It offered works for rent as well as purchase. The Gallery of Future Masters opened in 1934, its artists an average age of 23 and its most expensive canvas $75. Next came the Georgetown Galleries (1938), featuring works the press praised for being "restful" but "devoid of social themes."

That same year Donald Whyte, brother of book dealer James, opened Washington's most ambitious gallery. He hired a New York interior designer who covered the walls with dustproof monk's cloth, guaranteed not to show nail holes. Whyte exhibited

9. *First Gallery* (Alonzo J. Aden)
by John N. Robinson, 1947,
oil on canvas board

everyone from Maurice Prendergast and Alexander Calder to Walt Disney (drawings and celluloids from *Pinocchio*), and his name comes up in every knowledgeable remembrance of the times.

However, to admire "modern" art was to hold oneself up to ridicule. Dealers risked the wrath of the ubiquitous critic Leila Mechlin (later elected to the British Royal Society of Arts), who in 1937 wrote about abstract art: "It is difficult to understand how anyone can find the products of a diseased or unbalanced mind amusing...echoes from a madhouse, [not] jolly like Disney [but] perversions of the worst sort. One turns [from them] with horror and depression."

Washington must have seemed forbidding to Caresse Crosby, who arrived in 1941 and quickly became the city's *character bohème*. (At 21, she had invented the first modern brassiere and sold the patent.) Before the war forced her to leave Paris, she and husband Harry Crosby ran the avant-garde Black Sun Press and enjoyed being in the circle of Gertrude Stein. Segregated Washington with its exclusive restaurants and theaters dismayed her. She patronized an African restaurant, the Benghazi, and staged her own production of *Othello*, with black actor Canada Lee in the title role and herself as Desdemona.

With her European connections, Crosby imported the works of moderns like the Surrealists Giorgio de Chirico and Max Ernst. For five years beginning in 1942, she hosted openings, helped "discover" Romare Bearden, gave servant-less dinner parties and focused the local art scene as it hadn't been since the days of Alice Pike Barney and her Sheridan Circle salon. (Encouraged by her lover Pietro Lazzari, Crosby also bought a castle in Abruzzi, Italy, where for some years she welcomed artists and fellow "one world" thinkers.)

David Porter came from Chicago in 1942 to work as a junior economist for the War Production Board and, on the side, showed Midwestern art on the walls of a Georgetown real estate office. Soon, although 15 years her junior, he became romantically involved with Crosby, and they rented a three-story building at 910 G Street NW where they lived and managed their galleries, hers on the first floor, his on the second.

Shedding his regional conservatism, Porter began to mount risky shows of photography and Ethiopian art and gave Kainen a first solo exhibition of work the artist eventually labeled Figurative Expressionism. For the most part, however, Porter (1912-2005) showed Mark Rothko and other New York artists, until he left in 1946 to become a New York artist himself.

Discouraged by the lack of interest among Washington collectors, Crosby closed her gallery in 1947. Working out of her house near Dupont Circle, she published *Portfolio: Intercontinental Review of Art and Literature*. This ambitious but short-lived (1945-1948) magazine ran a silk-screen reproduction of a color holograph by Henry Miller and became the first periodical to publish the work of Sartre in America. Kainen noted that by the time Crosby (1892-1970) wrote her memoirs (*Passionate Years*, 1953), other more dramatic events crowded out any reference to Washington.

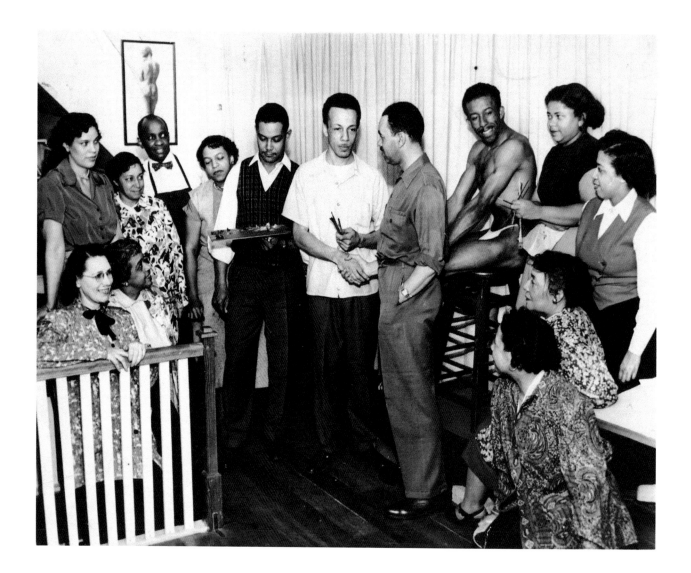

In 1943 James Herring and Alonzo Aden opened the city's and likely the nation's first black-owned private gallery. The two men had met at Howard University, where Herring (1897-1963) chaired the art department and Aden (1906-1961) had studied and by then curated the university's collection. In the first-floor rooms of Aden's 127 Randolph Place residence, they established the Barnett-Aden Gallery. (Barnett was Aden's mother's name.)

The two aimed to win recognition for contemporary artists, white as well as black, and to provide a place in segregated Washington where art could be the common denominator. Eventually their openings attracted visitors from both official (Mrs. Roosevelt) and cultural (Duncan Phillips) Washington. Until it closed in 1962, Barnett-Aden provided serious exposure for most of America's "name" black artists: Jacob Lawrence, Romare Bearden, Aaron Douglas, Henry O. Tanner, James Wells, Richard Dempsey, Alma Thomas, Elizabeth Catlett and Lois Mailou-Jones, a Howard teacher later known as the *grande dame* of Washington's women artists. A 1948 photo shows Jones (1905-1998), Thomas (1891-1978) and other artists who exhibited together often as the "Little Paris Group."

Herring, impressed by the pencil studies of a D.C. youth named John N. Robinson, offered the 17-year old janitorial work (he was not expected to perform) at Howard in exchange for drawing and composition instruction from influential teacher James Porter. With no further study, Robinson (1912-1994) built a career in the 1940s, painting backdrops for Anacostia's Capitol Photo Studios, breaking color barriers at art fairs and winning friendship and support from Kainen and Perlmutter. In 1976, he received an Anacostia Museum-Corcoran Gallery retrospective. His commissioned portrait of Aden now belongs to BET founder Robert L. Johnson's

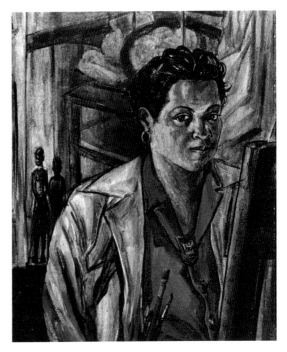

11. *Self Portrait* by Lois Mailou Jones, 1940, casein on board, 18 1/4 x 15 inches

10. OPPOSITE: Little Paris Group, 1948, in studio of Lois Mailou Jones (seated lower right); (far left) Celine Tabary; (with brushes at center) guest artist Richard Dempsey; (model) Russell Nesbit, (beside him) Tritobia Benjamin; (beside Jones) Alma Thomas.

Others in Little Paris Group: Barbara Buckner, Delilah Pierce, Bruce Brown, Barbara Linger, Frank West, Don Roberts, Desdemona Wade, Elizabeth Williamson.

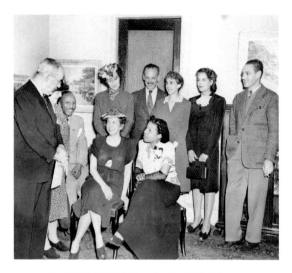

12. At Barnett-Aden, the opening of "Paintings by Lois Mailou Jones," April 1946, the artist seated at right beside A.U.'s Sarah Baker

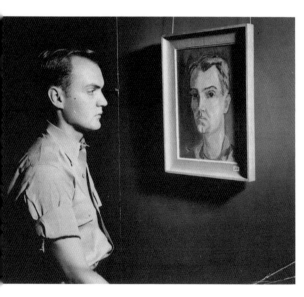

13. Ben Summerford with self portrait, circa 1948

Barnett-Aden Collection, 250 works of African-American art in Tampa.

Until the late 1940s, the city seemed no place for artistic autodidacts. If one wanted to paint or sculpt, he or she submitted to a regimen of classes, either with private instructors such as muralist Bernice Cross and painter Prentiss Taylor or within an academy. Students had three choices in the early 1940s: the Corcoran School, where traditional academic training required drawing from plaster casts (and through the 1930s the word "impressionism" was banned); Howard University, which had strong but conservative artist-teachers; and the Phillips Gallery Art School, which used works from the collection to pose aesthetic problems.

Undoubtedly the Phillips's students had an edge. They benefited from artists-in-residence like Augustus Vincent Tack (1870-1949), a favorite of Duncan Phillips, who, with Phillips's encouragement, had abandoned society portraiture for abstraction. Tack's largest work still hangs in George Washington University's Lisner Auditorium: "The Spirit of Creation," an ethereal, glass-fiber fire curtain that, some say, Tack stenciled with a dressmaker's wheel, then spray-painted with a vacuum cleaner hose.

From 1942 until it closed in 1945, the Phillips School provided studio instruction for students at American University (A.U.). William Calfee, who helped Law Watkins teach classes at the Phillips, recalled, "We had so many students, including servicemen in the evenings, that some people had to go outside to set up easels." During the war, Calfee also founded the Artists Guild, a group that aimed to support the war effort by producing posters and offering graphics services.

When A.U.'s president decided to pursue Watkins's idea for an arts degree program, he asked "the Phillips group" (Watkins, painters Calfee, Sarah Baker and, soon after, Robert Gates) plus Pietro Lazzari, to form the faculty. (The Navy gave Gates a Distinguished Civilian Service Award for his model making and designs for camouflage.) As the war ended, the newly expanded department set up in a building vacated by the Department of Defense. Thus Amerian University became one of the first institutions of higher learning in the United States to offer undergraduate and graduate degrees in fine arts.

Heading the department was Calfee (1909-1995), a native son with impressive credentials. The painter-sculptor had studied at the Beaux Arts in Paris and at Cranbrook Academy in Michigan and had worked on several federal arts projects. He later bemoaned the fact that his first one-man show opened at the Whyte Gallery the day Japan attacked Pearl Harbor.

14. Fire screen
by Augustus Tack
at G.W.U. Lisner,
oil on fiberglass,
24 X 55 feet

15. Morris Louis, circa 1942

Under Calfee, the fine arts department at American University had considerable influence. A.U. published an art journal *The Right Angle* and prepared many in the first generation of artists, art teachers and museum directors who considered themselves free of the European tradition. The school also brought to Washington, as visiting professors, a number of major art figures, particularly the early semi-abstractionists.

Ben Summerford, now retired after decades as full professor of painting at AU, entered during the school's first year on the GI Bill. He remembers the succeeding years as exciting for artists. "We had hibernated during the war, and now we sensed that American art could come into its own. New York didn't seem that far away, and AU artists visited and showed there. I went to see de Kooning in his studio, and he was curious about what I thought of Pollock's drips just shown for the first time. Many of us began looking to Abstract Expressionism as a way to break with tradition."

AU's Watkins Gallery, located at first in a Quonset hut, mounted some of the earliest shows of important artists like Pollock, de Kooning, and David Smith and did so on a small budget. Both Summerford and Calfee recalled hauling works from various New York studios and galleries in a truck or a station wagon. A fortunate few paid what now seem bargain prices for paintings shown there, for example, $500 for a major de Kooning.

Those in the AU orbit shared certain aesthetic principles: love of the sculptural or tactile, concern for pattern and fundamentals, respect for traditional materials and loyalty to the controlling (rather than the automatic) hand. Calfee felt that there was no identifiable "look" to the work, but what Summerford identifies as his own formal interests—"space, light, and aspects of direct observation"—continued to concern them all. In a latter-day review, *Washington Post* critic Paul Richard said, "When you peer into a Summerford, you see Washington's art history, or at least a major chunk of it, unashamedly staring back."

The presence of Karl Knaths, first at the Phillips and later at AU, seems to have been formative. "Knaths was primarily interested in color," said Calfee. "He devised his own color theories ... and assigned exercises, like, 'Create a work with no curves and only two colors beside black and white.'" From such formal issues, AU evolved an academic philosophy that allowed not only for semi-abstraction but also for a return to conservative figurative work in the years ahead.

In 1947 a quite different universe of artists was being set in motion in an unlikely place: the top floor of the old Walsh-MacLean Mansion, now the Indonesian Embassy on Massachusetts Avenue. Helmuth Kern with Leon Berkowitz, a teacher at Western High School, and Berkowitz's wife Ida Fox, a poet, opened the Washington Workshop Center of the Arts as a co-op, meaning that artists put up seed money for "shares." Kainen remembered earning $48 a night as a studio teacher and donating works for benefit auctions to help pay the rent, but no one ever saw a profit.

The payoff came in fellowship, with teaching artists like Jack Perlmutter, later Morris Louis and repeat visitors like Gene Davis and Howard Mehring climbing three flights of stairs for art talk and inspiration. In a newspaper story of the time, Davis, who never actually signed up for a course, joked that what really inspired the artists were "the smell of turpentine and the altitude."

Many of the Workshop crowd nourished themselves at two other alternative institutions also founded in 1947: the Dupont Theater Lounge, just south of Dupont Circle, with its juried art shows (no movie ticket required), and the Institute of Contemporary Arts (ICA). The ICA, on the third floor of a building in the 1300 block of New York Avenue, was a project of Robert Richman, poet and onetime literary editor of the *New Republic*. He described it as "more of an idea than a physical reality," but for a dozen years, in various settings, the ICA sponsored literary readings (T.S. Eliot, Robert Penn Warren), art shows (photography, Moholy-Nagy, Josef Albers), concerts, symposia, avant-garde films and workshops in design, painting, sculpture, pottery and graphics. Kainen called it "sort of a Washington Bauhaus."

Anne Truitt took instruction there from Alexander Giampietro (1912-2010), a sculptor who had studied with Moholy-Nagy and later taught at Catholic University from 1950 to 1992. The ICA also offered a student teacher job to the young painter Kenneth Noland. He arrived from Black Mountain College in North Carolina, where he had studied with Albers and befriended Clement Greenberg, the man who became a critical power in the careers of Noland and others in the next decade.

Noland and his wife Cornelia set up housekeeping and his studio in a small walk-up apartment in Georgetown. Kainen recalled visiting him there and watching the work evolve from Klee-like compositions to canvases that were, as the younger artist put

it, intentionally "bad." Soon Noland showed these early paintings (at A.U.) but later destroyed them in his pursuit of a fresh history.

That same year (1947), Morris Louis, a painter-teacher with a following in Baltimore, moved to Washington to join his new wife. Eventually he taught a few classes at the Workshop, by then located on New Hampshire Avenue, and sometimes encouraged beginning students, without much success, to put their canvases on the floor and throw paint like the Expressionists.

Louis kept his own work out of sight, recalled Kainen. "He was not a talker, and we never went to his studio. His methods were somewhat mysterious, but they involved using water in different emulsions with oil paint, egg, or glue." Kainen saw some drip works à la Pollock—black on white with grayish tones, but Louis (1912-1962) too destroyed his early paintings.

Tensions building in the so-called "McCarthy days" made little impact on Washington artists. Only a few people held art-related government jobs, and the dominant semi-abstraction seemed to be message-free. Almost everyone ignored the senator who denounced expressionism as a Communist plot to soften American brains. The former Works Projects Administration (WPA) and Treasury artists, whose early art had clearly "socialist" echoes, were either invisible by now, devoted to innocuous portraiture or involved in the new abstraction.

Jacob Kainen, however, did become a target of investigators. As a young man in New York, he had signed petitions and written articles for leftist causes. Now he watched as Congress pressured government agencies to fire anyone who was "not in the best interests of the department," and soon enough he was interrogated. But Kainen kept his job for two reasons—one, the attitude of superiors at the Smithsonian, people, he said, "accustomed to dealing with ideas," and two, an earlier commendation by J. Edgar Hoover himself. It seems that Kainen had earned the FBI's gratitude by teaching printing methods to agency trainees, and Hoover had sent a letter saying, "You've done our country a great service." When the FBI rediscovered this bit of history, the visits stopped.

As the 1940s closed, artists here resisted labels, even as they identified with worldly, postwar influences. In retrospect, what appeared to unite them was some affinity with the French artistic tradition, nurtured perhaps by hours spent looking

at the Phillips's old and new masterworks. Each artist jumped in through a different window—Symbolism, naturalist landscapes, Cubism, Matisse. Yet all adopted, consciously or not, the concerns of Post-impressionism: exploring the tensions between negative and positive space, mulling the interrelationships of form and color.

By now all the elements for a Washington art community were in place. The city had commercial galleries and a growing, albeit low-profile, base of collectors. It had an academic center—American University—providing a regional presence and a link to the national scene. But most importantly, Washington had a critical mass of brashly confident free spirits.

As the decade ended, Kainen for the first time abandoned recognizable subjects for non-objective forms, and Noland, Louis and Davis went off to work furiously in solitude. The last three had yet to free themselves from Abstract Expressionism's seductive grip, to exorcise its disconcerting devils and to give themselves over to geometric shapes and pure color. Surely the moment signaled that something important could happen here.

16. *Dock With Red Sky*
by Jacob Kainen, 1947,
oil on linen,
28 x 36 inches

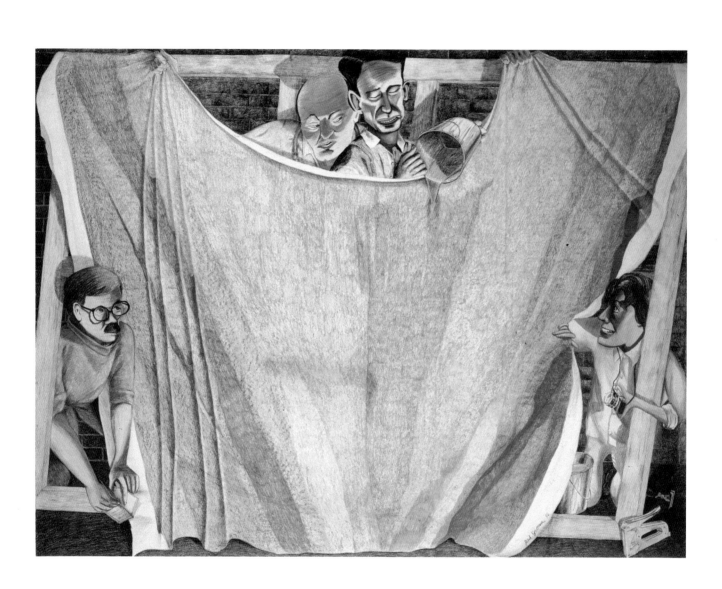

CHAPTER 2

# Making of the Color School

## THE 1950S

BY JEAN LAWLOR COHEN

One evening in 1950 an arts reporter climbed four flights of stairs in the old Walsh-MacLean mansion to check out what some called the soul of a local art scene—the Washington Workshop Center for the Arts. Run by Leon and Ida Berkowitz, the Workshop, at the corner of 21st and Massachusetts, had become an off-hours hangout for creative folks, a place where dancers might agree to pose as models, and painters might pick up a dance step.

Leon Berkowitz (1911-1987) described for the reporter that night the Workshop's clientele: bureaucrats, housewives, a Shoreham Hotel doorman, military officers, a retired fireman, the building's janitor and one guy, a public relations man named Gene Davis, whose work had been singled out as exceptional. Davis, newly infatuated with painting, happened to be "hanging out" that evening when the reporter arrived. Himself a journalist, Davis offered to articulate a new way of seeing. "What used to be just a tree against the sky is now a pattern; the trolley wires overhead seem to have a design, and even the mud on the ground shows up as a collection of colors." Pattern. Design. Color.

Davis (1920-1985) later became one of the few painters who found success basing his entire career in Washington. By the time he died of a heart attack, he had critical acclaim, financial reward, the respect of students, major commissions and New York attention (gallery shows almost very year). And he never considered leaving home. For whatever reason—luck, psychoanalysis, high energy or ornery resistance—Davis stayed and prospered while others faltered or left.

In retrospect, it's not surprising that he was at the Workshop that evening, eager to explain the scene. He worked as an editor (the AAA magazine) and had covered the White House in the Roosevelt-Truman years. As his art reputation grew over the decades, he continued to teach and to seek out the company of other, often younger artists for art talk even as he kept to a monastic discipline in his studio. Early on he seemed to know that his art came out of balancing dialogue and solitude.

Artists could find both in the manageable universe of 1950s Washington. They tended to live settled lives in the loosely defined neighborhoods of a relatively small city. They saw each other at lectures sponsored by the Institute of Contemporary Arts (ICA), at gallery openings, Phillips concerts and the Corcoran's juried shows. Even Washington's low skyline and old trees contributed to the illusion of "small-town."

1. PREVIOUS: *The Pouring* (1986), colored pencil, by Red Grooms depicts the secretive Morris Louis, his process being spied upon by Gene Davis (top) and two unidentified artists, most likely Downing and Noland.

Jacob Kainen taught at the Workshop and met Davis there. About twice a month Kainen made a lunch-hour visit to Davis's apartment-studio at 1 Scott Circle and, for a small fee, critiqued the beginning artist's work. Often he brought along reproductions of old and new masters to convince Davis of the importance of composition, and for the next seven years the two friends trekked and talked their way through Washington's museums and galleries. (Kainen recalled that, when he left for a European sabbatical, Noland took a turn "critiquing" Davis, an arrangement Davis later denied. )

In effect, Kainen (1909-2001) gave his fellows a model of what the serious artist could be: passionate about art history, disciplined by studio regimen, open to contemporary ideas, yet confident enough to buck trends. At a time when many artists with a mature style withdrew from confrontation with the new, Kainen nourished himself and ambitious younger painters with his studio visits and commentary.

One afternoon in 1953 Kainen took Davis along on a visit to Kenneth Noland's studio. Noland had been in Washington since 1949, having come to teach principles of design at the ICA, and was by now on the art faculty at Catholic University. (Noland spent 10 years at Catholic, curating contemporary shows in spaces previously devoted to traditional and often "religious" art.) To reach Noland's studio, Kainen and Davis climbed up a ladder, through a trapdoor and into a space kept warm by a potbelly stove. Noland was always glad to show others his work, and on this day he lined up a series of experimental canvases, most of which he later destroyed.

That same year Kainen watched as Noland and Morris Louis, his Workshop colleagues, rolled out a bare swath of cotton duck canvas on the center's floor. The two were ready to improvise a color work together, side by side like jazz

2. Indonesian Embassy, its top floor once the site of the Washington Workshop Center

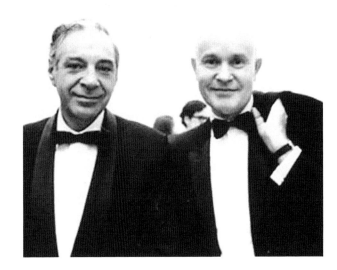

3. Jacob Kainen and Gene Davis, longtime friends, at a Corcoran Gallery opening 1969

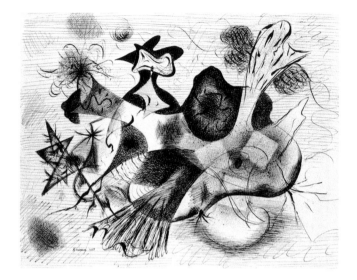

4. *Metamorphosis*, 1950, by
Jacob Kainen, pen and ink on
paper sheet: 18 x 23 inches

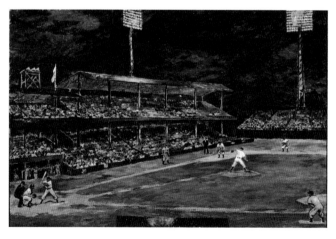

5. *Night Baseball*, 1951, by baseball
fan Marjorie Phillips, Joe DiMaggio
at bat against the Senators at
Griffith Stadium
oil on canvas, 24 1/4 x 36 inches.

musicians, intuitively applying paint in "a jamming session."
"Come on, and join in," they insisted, but Kainen declined.

Over a period of weeks, Noland and Louis poured, dribbled
and rubbed thin washes of paint across unprimed canvas.
They adopted the floor-as-easel à la Jackson Pollock and likely
for the same reasons: so there would be no architecturally
dictated top and bottom, no stepping back to assess until the
action had run its course.

Kainen later explained his resistance. "I couldn't approach
the canvas that way. To me, it wasn't worth sacrificing mass for
flatness. I realized that Noland and Louis didn't want to be on
the surface but to be the surface. And to me staining wasn't flat,
anyway, because it let you see the texture of the canvas. If an
artist wants flatness, he'd be better off working on glass!" With
no need for radicalizing exercises, Kainen returned to his studio
and his work of "sculptured" abstraction.

This story explains the two profiles that serious Washington
artists would assume in the years ahead. The first generation
of postwar painters saw themselves continuing the American
art tradition, their work evolving out of 1940s formal concerns
and their own hard-won circumspection. The not much younger
"sons," like Davis and Noland, entered love affairs with color
and geometry, scale and materials, working alone or in fitful
collaboration, intent on finding a breakthrough vision.

From the start Davis looked for that breakthrough in
the abstract masters, particularly Paul Klee at The Phillips
Collection. He often haunted the gallery on lunch hours
and recalled some weekends sitting with a book amidst the
Matisses and Bonnards, himself the only visitor. The paintings
convinced him, he said, that great art came not out of technical
know-how but from taking chances.

Davis saw the Phillips as oasis, school and meeting ground. He told of once strolling through the rooms with Kenneth Noland and "cowboy artist" Harry Jackson, picking friendly arguments. Jackson (1924-2011), then a rising Abstract Expressionist painter, later became a successful figurative sculptor. The three stopped before Renoir's "The Luncheon of the Boating Party," which Noland dismissed as badly painted except for several gastronomical objects dashed off with great bravura.

On another occasion Davis encountered Morris Louis there, and they enjoyed "a long and fruitful discussion" in front of a large ethereal canvas by Augustus Tack, whom some consider a precursor of color-field painting. Davis later insisted there was "good evidence Louis learned a few lessons" from the eccentric Tack.

Duncan Phillips continued in the 1950s, through his writings and the artists he showed, to represent an enlightened modernist point of view. Excited by the New York abstractionists, Phillips borrowed works by many of the touted "comers" for a 1952 show. Vincent Melzac, a successful TV pitchman, part-time art critic and serious collector who'd recently arrived from the midwest, encountered Phillips as he uncrated his finds.

Melzac recalled that Phillips asked him, "Will you give me your honest opinion?" The younger man looked over what he thought were rather lackluster paintings and said, "The show is incomplete without a Jackson Pollock." Phillips supposedly blushed and admitted, "I cannot hang someone who paints with such violence. I suppose there comes a time when one can no longer see the new." (Melzac owned deKooning's "Asheville," which he loaned to the show and sold to Phillips soon after for $1,400, reportedly the amount Melzac had paid deKooning on a studio visit.)

Yet Abstract Expressionism had already begun to intrigue Washington's younger artists. Hungry for word of New York "firsts" and gallery shows, they read *Art News* and *Art Digest* plus *Life* which gave highest visibility to the "action painters," artists who were honoring impulse and gesture over subject matter. New York artists like David Smith and Jack Tworkov came to jury shows and to lecture, but they were, as Kainen recalled, only "on the verge of expressionism." Eventually Willem de Kooning showed up for an exhibition of his work at the Workshop in 1953 and, in off-the-cuff remarks, made a plea for art that would touch the emotions: "hallelujah paintings!"

With that, it seemed, every Washington artist in search of a style jumped headlong into gestural painting. "Throwing paint" promised liberation, and so, for the next

five years, expressionism consumed their energy, seduced them into dead ends and frustrated attempts at originality. Ultimately the "look" of Abstract Expressionism mattered less than its "sociology"—the obsessive methods of execution, a fascination with material properties, the focus on uniqueness of personality and a willingness (if not eagerness) to risk ridicule.

For all their passion, Washington artists still had to squeeze studio time into evenings, weekends and lunch hours and support themselves with non-art jobs. Painters and sculptors worked as teachers, their gallery dealers as framers, booksellers or even deliverymen. For a while Kenneth Noland, married to a U.S. senator's daughter (journalist Cornelia Langer), drove a D.C. cab. Certainly art was being made as the decade got under way but for love, not money. As Kainen put it, "Those were heroic times."

Although Washington artists cultivated a loose sense of professional identity, they divided into groups that are still roughly in place today: teachers and followetrs, independents and the gallery-represented, purists and jacks-of-all-trades, loners and showmen. Inevitably most of the creative spirits wanted community and "painting buddies," not just because dialogue itself was important but because rising media attention encouraged a certain amount of self-consciousness, a circling of the wagons.

For some artists, the times called for mobilization. Painter Marcella Comès Winslow (1905-2000), best known for her portraits of famous writers, kept a clipping file on the early efforts of local artists to organize. She came to believe that artists by their nature resist group action. Jack Perlmutter, she recalled, refused his place on a roster, calling it "as much honor as being in the phone directory."

What most artists wanted even then was gallery representation, an agent who not only provided space for shows but also promoted sales and kept the books. Fortunately the still-active commercial pioneers—Franz Bader (on his own by 1953), Whyte's Book Store (which closed in 1956), and the Barnett-Aden (which lasted until 1962)—were joined by a number of new galleries, Mickelson's and Obelisk, among them.

One of the most ambitious was north of Dupont Circle, the Gres Gallery founded by a South American woman named Madame Tanya Gres, who soon sold the operation to 10 shareholders putting up $1,000 apiece. Their manager Mrs. Hart Perry traveled to Europe and South America, selecting works for first-in-America exhibits, such as oils by "a skinny young artist" named Fernando Botero.

6. Marcella Comès Winslow in 1979, painted by her son John Winslow

Although the Gres had little interest in showing local art, it created excitement among collectors who until then bought only in New York and Chicago. And it created a social scene—with Larry Rivers, for example, playing jazz piano into the night. Alice Denney remembers that gallery goers would arrive at her less-endowed operation the Jefferson Place Gallery trailing balloon bouquets from the Gres's more elaborate openings

The Jefferson was a co-op venture, the idea of several American University-connected artists who bemoaned the lack of a showcase for local "art of serious purpose." In 1957 Bill Calfee, Helene Herzbrun, Ben "Joe" Summerford, Mary Orwen and Robert Gates (plus Baltimore artist Shelby Shackleford) enlisted Denney as director. She found two display rooms on the second floor of a building south of Dupont Circle at the corner of Jefferson Place and 18th Street NW.

Denney remembers hanging shows for Noland (his earliest concentric circles and wall-sized works priced up to $500) as well as for out-of-towners like Rauschenberg and Johns. Occasionally she sold to only one customer, herself. It was during this period that Noland sometimes tied canvases to his car roof and headed to New York, where Tibor de Nagy gave him two shows. Once, when a rope broke, he stopped highway traffic to retrieve his paintings.

Another co-op venture was the Origo Gallery, founded in 1959 by Tom Downing, Howard Mehring, Betty Pajac and others. Breton Morse showed there and recalled the friendly competitiveness with the Jefferson Place. "They were the established avant-garde, but we had two floors of a townhouse and painted bigger, more experimental paintings." Before closing in 1960, the gallery exhibited drip paintings and stained glass by Lowell Nesbitt (1933-1993), who credited his art career to hours spent at The Phillips Collection as a night watchman. Nesbitt, best known for painting realistic nudes and large, lush close-ups of flowers, also showed at Pyramid and Henri.

He later moved to New York but, grateful to the Corcoran Gallery for a 1964 exhibition, wrote into his will a $1.5 million bequest to the museum. In 1989 when the Corcoran canceled the controversial Mapplethorpe photography show, Nesbitt changed his beneficiary to The Phillips Collection which, by the time he died, received money but no paintings.

As many as 1,800 regional artists submitted work to the annual Corcoran "Area" shows, considered a testing ground, a chance to be seen by prominent judges like David Smith in 1951 and Andrew Wyeth in 1955. On occasion, disgruntled artists formed committees to press for changes in the jury and awards system.

Kainen recalled that when the Corcoran's prestigious biennial included a large percentage of abstract works, he congratulated Hermann Warner Williams, the gallery director. Williams, a former curator of armor and a scholar of pre-20th-centuryAmerican painting, sighed, "Yes, we had to get modern." In 1953 *The Washington Post* commended artists for their volubility and a "somewhat harassed Corcoran" for its adaptability.

Certainly American University continued to have influence, with exhibitions of on-the-rise artists from New York and Washington and with residencies for established ones. But by now A.U.'s central figures had settled into their mature styles, ranging from lyrical semi-abstraction to energetic expressionism. Gradually those painters

relinquished the notion, if they ever held it, that they comprised the city's avant-garde.

For the newcomers, however, energy seemed to emanate from the Workshop, which by the fall of 1952 had moved into new quarters and hired Morris Louis (until 1939 Bernstein) as a faculty member. Louis, whom Berkowitz described as "a quiet person, with penetrating eyes the color of violets," had taught in Baltimore and at Howard University. He had moved here in 1947, after marrying Marcella Siegel (later Brenner).

When Louis was introduced to Ken Noland, he reportedly said: "Suddenly, I wasn't alone." Although Louis was 12 years older and temperamentally the opposite of the gregarious Noland, he seemed to relish the friendship. Soon he visited New York with Noland, who introduced him to David Smith and critic Clement Greenberg.

In April 1953 the two (along with the Berkowitzes and others) made their now-legendary trip with Greenberg to the studio of Helen Frankenthaler. (The artist herself wasn't there.) But that day they saw her monumental, just-finished painting now in the National Gallery collection—"Mountains and Sea."

Frankenthaler's technique was to apply directly soft washes of oil pigment, thinned with turpentine, to unsized, raw cotton duck canvas. Louis described her work as "a bridge between Pollock and what was possible." Greenberg believed that for Louis it was a revelation, claiming the Washington artist abruptly changed direction and abandoned Cubism for layered pouring. Louis "began to feel, think, and conceive almost exclusively in terms of open color," said Greenberg. "Cubism meant shapes...armatures of light and dark. Color meant areas and zones."

Louis pursued staining for two more years, then in 1954 broke off contact with Noland when differences arose and

7. Robert Gates explains a work in his Watkins Gallery solo show.

8. *Untitled 5-76*, 1956, by Morris Louis
acrylic and/or oil on canvas, 82 x 96 inches

9. *Split*, 1959, by Kenneth Noland,
signaling his centered imagery of
the 1960s, acrylic on canvas,
94 x 94 1/4 inches

returned to expressionist work, most of which he eventually destroyed. In 1958, when he came back to staining, it was to make the "Veils," "Florals," and "Unfurleds," which established his reputation as a supreme colorist. Louis painted in the 12-by-14-foot dining room of a small house on Legation Street NW and stored in his basement as many as 600 canvases, which, at $300 apiece, almost no one wanted to buy.

Noland moved more slowly out from under painterly influences and, until the mid-1950s, produced heavily impastoed canvases, even as his subject matter became more geometric and simplified. By 1959 Greenberg had conferred major status on him and Louis by selecting the two for a show of "Emerging Talent" at New York's Kootz Gallery, arranging solo shows at the prestigious French and Company and touting them in *Art International*. These events may have proved shattering to others here. No doubt the unprecedented power of a "king-making" critic stung the excluded colorists, affecting the acceleration and, in some cases, the direction of their careers in years to come.

Greenberg, from his vantage point of New York, seemed to romanticize Washington ("250 miles...from the new Babylon of art") as a haven for primitive genius. He wrote, "From Washington you can keep in steady contact with the New York art scene without being subjected as constantly to its pressures to conform."

Those who directly or indirectly accepted the Greenberg aesthetic became known in the 1960s as the Washington Color School painters. In addition to Louis and Noland, the label eventually applied to such disparate painters as Thomas Downing, Howard Mehring, Paul Reed and Gene Davis.

Virginia native Thomas Downing (1928-1985) came to Washington in 1953 after study at Pratt, sojourns in Paris and

Florence and a military stint. By 1956 Downing was part of the Washington Workshop and by 1958 the Sculptors Studio, where he taught and received his first one-man show—dripped, poured and brushed Pollock-like enamels.

By the end of the decade, Downing was "trying everything." Then, under Noland's influence, he said he recognized "the expressive potential of pure color—the necessity for a form which was simple and direct to convey it." As the 1960s got under way, Downing set to work painting the dotted grids and hovering disks that earned him national attention.

Howard Mehring (1931-1978) is often reflexively paired with Downing, and their biographies explain why. Close in age, the two shared a studio for a time, and both studied with Noland at Catholic University, where Mehring earned an M.F.A. in 1955. Both blossomed in the Color School hothouse, producing work that established their importance as innovators. And both died in middle age, Mehring at 47, Downing at 57, their later work variously successful.

With few exceptions, Mehring's paintings avoided the decisive hard edge of his contemporaries. Many considered his late-1950s, all-over sponged stipples of Renaissance color embarrassingly beautiful. Yet his progress, even in the years of national recognition (showing at A.M. Sachs in New York), seemed tinged by self-doubt, and he followed, some said slavishly, the advice of Greenberg.

Paul Reed worked as a graphic designer in New York until 1950, when he came back to his hometown, resumed a boyhood friendship with Gene Davis and began in 1953 to paint seriously. Like the other colorists, he exhausted an early fascination with gesture, accident and poured paint. Unlike those who favored direct execution, Reed plotted his color combinations in collage studies.

Gene Davis's work of the 1950s epitomized every artist's necessary passage from experimentation to mature style. He tried Dadaist collages, mirror-imbedded canvases, even Pop Art cartoons. Once he instructed Galliher's Lumber Company to cut masonite panels into any shapes but rectangles. These he painted and framed or covered with gravel and rocks, which he bonded to the surface with cement and poured paint. After carting some of the 50-pound works to New York (they took six months to dry) and interesting dealer Betty Parsons, Davis abandoned texture for gesture.

10. *Untitled*, 1952, by Kenneth Noland before he devoted himself to flatness, oil on fiberboard mounted on plywood, 21 3/8 x 13 1/8 inches

11. *Banner*, 1957, by Howard
Mehring, among many works by the
artist given to the Smithsonian by
Vincent Melzac, acrylic on canvas 52
1/2 x 65 1/2 inches

As he spent much of the 1950s trying to paint himself free of expressionism, strong vertical elements began to appear along the sides of his paintings and in his lyrical drawings. In 1958 he made the first edge-to-edge striped canvas (later titled "Peach Glow"), a small freehand work of alternating pink and white, and set it aside. Collector-dealer Marc Moyens, on a visit to Davis's Scott Circle apartment-studio, saw the canvas and said, "You've got something there." For a year Davis experimented with the stripe format, even as he prepared for a Jefferson Place show in 1959 that would be his farewell to abstract expressionism.

In a 1981 interview with Buck Pennington, Davis explained, "All the college art departments were grinding out little de Koonings and Pollocks and Klines and so on. So, in that climate, it seemed like Abstract Expressionism was academic, and there was no place to go. It had already been used up. And you had to go somewhere."

Yet even as Davis and others moved to abandon action painting, many local reporters still seemed affronted by the style. Helen Stern, who later befriended Davis and admired his stripe works, mused early on that, while one did not expect much from a monkey with paintbrushes, one did expect more from a man. Similarly Tom Donnelly of the *Washington Daily News* observed that "at the Jefferson they've got compositions that make Jackson Pollock look like Rembrandt."

Two Washington art journalists tended to be more descriptive than critical. Leslie Judd Ahlander of the *Washington Post and Times Herald* and Florence Berryman of *The Washington Star* looked at local art with enthusiasts' eyes, often letting the artists speak for themselves. In 1956, Berryman interviewed Davis, who credited breakthroughs to weekly psychotherapy and described his wildly expressionist works as "A variety of cryptic forms from the chaos of the unconscious."

The aspiring players still sought out the bulletins from New York, the heady risk taking and the stimulation of peers. Yet as Gene Davis mused, "The Washington art community has never been particularly fraternal." Despite a somewhat tenuous group identity, they knew that each had to discover a personal, idiosyncratic vision. Like the preceding, must-break-from-Europe generation of American painters, they faced a dilemma: how to swallow the masters—past and present—yet see the canvas with innocent eyes.

12. *Untitled,* 1957, by Gene Davis, from his expressionist years, oil paint and pencil on paper, 13 7/8 x 16 5/8 inches

# Stars and Stripes

## THE 1960S

BY JEAN LAWLOR COHEN

April 26, 1966 (D.C.'s Kalorama roller rink)—On the first night of the "Now Festival," hundreds of people sit politely on folding chairs as artist Robert Rauschenberg spins past on roller skates, trailing a parachute. A man munches fried chicken as he reclines in a wire coop with six live hens. But the audience can barely see the evening's main attraction, a slight blond person who wears sunglasses in the shadows. It's Andy Warhol, the "soup can artist," who brings, direct from New York, his girl-of-the-year Nico, two dancers in leather and chrome, a light show and a very loud rock band called The Velvet Underground.

Most of the local arts reporters reached their verdicts even before the end of that five-day festival (three performances, a film night, a symposium and a "dress madly" ball). "Amiable chaos," one sniffed. Others lamented, "A pretentious bore." "The Emperor's new clothes." A few jaded natives complained, "By the time it got to Washington, it was the Then Festival."

Yet for many like Ted Fields, a sculptor/dentist with artist-friends and the chairman of that opening night, the event marked "the awakening of a small Southern town." Certainly the festival established its producer Alice Denney as the capital's link to art new, serious and hipper-than-here. But most importantly, it brought together the people—incipient collectors, artists, known patrons, museum folks, newcomers and students—who eventually put their faces to an art scene.

Old newspaper clips show the major performers, and editorial reports provide clues that this was standard avant-garde stuff—movement for its own sake, John Cage making "music" out of radio static, an underground film with the power to induce seizures and, of course, aesthetic tedium. What shocks, almost a half-century later in the few dim, black-and-white photos (the originals sold by *The Washington Post* long ago), is the audience: crew-cut men in dark suits and ties, women in tailored dresses and pearls and not a pair of jeans in sight!

Why, more than mid-way through the 1960s, did D.C. folks look like Eisenhower-era concertgoers? Had it taken that long for the costume era to arrive? With hindsight, the Now Festival seems a farewell, both to "the way we were" and to prevailing tastes. Even the elegant "Color School" paintings, those vibrant,

1. PREVIOUS: *Gentle Jackhammer*, 1969, by Gene Davis, acrylic on canvas, 70 x 96 inches

large-scale canvases that had recently put our city on the national art map, would soon become "establishment" with the influx of younger artists.

People born since that era may not understand the absolute rightness of the early stained and geometric paintings, the pure but obsessive impact they made on the (popular phrase) "responsive eye." But those canvases had the look of the time—movie-screen scale, patterns both "op" and meditative, hot colors straight from the tube. They promised escape from the angst of 1950's expressionism, and eventually they popped up in the non-art venues— commercial graphics, film festivals and all manner of psychedelic gear.

"We felt enormous momentum and excitement," recalls painter Paul Reed, or, as sculptor Anne Truitt put it, "The brew began to boil up." Artists, like everyone else, took hope from the promises of a Great Society and the democratization of culture via TV, assuming that the serious arts would benefit too. "We believed that newness would go on forever," said *Washington Post* critic Paul Richard, "and I saw myself as a promoter of the new."

Artists in Washington and New York kept tabs on each other, but now they shared a passion for ordered imagery as well as for "breakthrough." Critic Richard has always speculated that Washington painters worked from a particular sensibility, nourished by the grids and circles of the original L'Enfant plan. Others insist that the recurrence of central images (like targets and disks) came from a lot of off-hours talk about "centering."

Fact: in the late 1950s and early 1960s, artists Kenneth Noland, Tom Downing and Howard Mehring plus others in their circle took the train to Philadelphia for individual

2. *Blue-Tender*, 1964,
by Thomas Downing,
magna on canvas,
88 x 87.75 inches

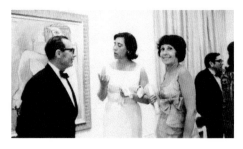

3. At *Picasso Since 1945* in 1966, Sue Green (center) with David and Carmen Kreeger, arts patrons and founders of the Kreeger Museum; (far right) Warren Robbins, founder Museum of African Art

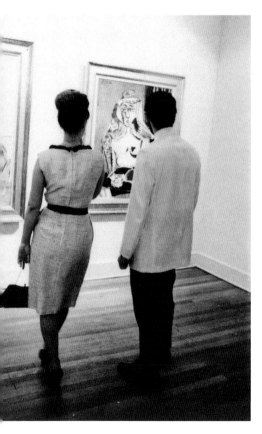

4. Picasso show at the Washington Gallery of Art

sessions of "orgone therapy." Downing's first wife Polly Brewer remembers those trips to see a Reichian doctor Charles I. Oller, who taught that one released blocks to creativity by physical means like screaming or growling into a pillow. Brewer recalls that Downing made an "orgone accumulator" out of a galvanized bucket and would lie with it on his chest to focus primal energies.

Yet for all the lively talk in studios and art classes, no museum showed the latest national "stars" or European trendsetters. That status changed in October 1962, when an enthusiastic coterie (old Washington money and new ideas) celebrated the opening of a museum devoted to things contemporary—the Washington Gallery of Modern Art (WGMA). In a spacious townhouse at 1503 21st Street, west of Dupont Circle, former Baltimore Museum director Adelyn Breeskin accepted that same position and the founders' ambitious plans: to exhibit works of current significance, encourage interest in the arts (even film, architecture, new music) and build a collection.

Assistant director Alice Denney, who with Dr. Julian Eisenstein helped initiate the museum, pushed for showing the most advanced art. To kick off the 1963 "Pop Festival," Claes Oldenburg hung up a gigantic pair of pants and staged a happening in which a young girl ironed a plastic model of the Washington Monument while a large canvas moved back and forth across the floor to simulate Potomac River tides. At the same time, a glamorous woman (a New Yorker, of course) slowly stripped as she descended the main staircase.

In 1965, the WGMA mounted an exhibition of unprecedented local impact—"The Washington Color Painters." Director Gerald Nordland chose six

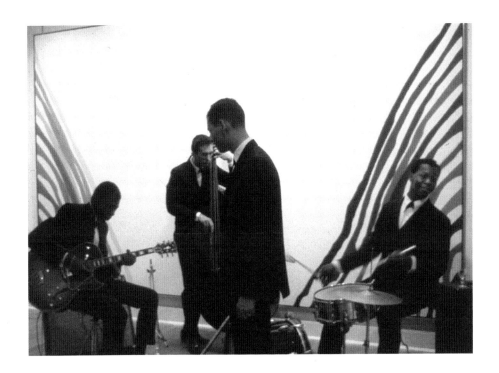

artists—Morris Louis, Kenneth Noland, Gene Davis, Tom Downing, Howard Mehring and Paul Reed, and it remains unclear who, if anyone, was wrongly included or excluded. Some lobbied at the time for rising painter Mary Pinchot Meyer, and others, years later, mentioned Sam Gilliam. But neither Gilliam, who discounts the notion he was in the running, nor Leon Berkowitz, who taught full-time at Western High School, had yet established professional track records.

Eleanor "Sue" Green, a curator at WGMA from 1964 to 1966, remembered that critic Clement Greenberg, as protector of his favorites' careers, allowed the inclusion of only one work each by Louis and Noland. Green (1928-1995) also recalled that the critic insisted on "checking" the catalog essay to ensure it reflected the proper formalist line. Thereafter Greenberg's relation to the other painters consisted of studio visits, advisory postcards and placing Louis, Noland, Mehring, Downing and Davis in his 1964 "Post Painterly Abstraction" traveling show.

Contrary to myth, neither Greenberg nor director Nordland coined the label "Washington Color School." The earliest use of the word "school" (this writer

5.–7. At the 1965 Washington Color Painters show: the band before a Morris Louis painting, couple with a Tom Downing painting, Howard Mehring with a T-square painting

8. Kenneth Noland, in typical
studio posture, circa 1968

could find) appears in an August 26, 1962 *Washington Post* interview in which Gene Davis linked the locals (plus Helen Frankenthaler), because they all used unsized, unprimed canvas. By then the label "school" (in small caps) must have been current, inoffensive lingo, although later Davis insisted that it should always carry the adjective "so-called."

More acceptable terms like "Washington colorists" and "color painters" also appear in several early 1960s accounts, but the artists no doubt tolerated the "school" handle, because the press needed one. They accepted the irony that, although they pursued distinct obsessions, in critic Richard's words, "Each artist shares something with another. Their works, when seen together, clearly comprise a school." Of course, it soon became obvious that no one, WGMA show or not, could ride the coattails of Noland and Louis who had been "anointed" early on as Washington's most important painters.

For better or worse, the 1965 WGMA exhibition crystallized the "Color School." After that, the chosen six took on what Green called an "artificially imposed identity." The label, she said, only served to satisfy the requirements of "curators who didn't know D.C. art politics." Ironically, the term's overuse fed the notion that Washington artists might never be as influential again.

In 1966 Charlie Millard, a Dumbarton Oaks administrator, replaced Nordland, but by then, as Green said, only "a last gasp effort" could save the WGMA. Its seed money (grants from the Meyer and Ford foundations) and membership fees (at peak, 1,000 people paying $10 single, $15 couple) could no longer cover expenses. NEA funding, corporate

sponsorship, and high-power development techniques were yet to make their influence felt.

By 1967, unsuccessful fundraising forced the sale of the WGMA collection to The Oklahoma Arts Center in Oklahoma City. This move astounds now, not only because the city lost so many works of importance that should have remained in Washington but because the lot went for only $125,000, $15,000 of that for shipping!

What caused the failure? Some insiders say "bad timing." Certain "strange" shows offended conservative tastes, and many balked at paying the 50-cent admission. For experimental film showings, embarrassingly small audiences (often including J. Carter Brown, in 1969 named director of the National Gallery of Art) turned out, and one day only three visitors passed through a major Josef Albers exhibition.

But non-cultural pressures factored too. "WGMA was pre-empted by bigger phenomena," admits one observer. "People who used to talk art would gather after the protest marches to talk politics." Suddenly financing an art museum seemed "elitist, if not downright venal." Many supporters chose to put their money toward other causes like the needs of minority artists who seemed to gain overnight visibility.

Merging with the Corcoran in 1968, WGMA became the "Dupont Center," a teaching-studio annex for the larger institution. In 1969, its Calvert Street Workshop provided studio space for sculptor Anne Truitt, painter Andrew Hudson, silkscreen printer Lou Stovall and photographers Joe Cameron and John Gossage. For a while, WGMA's final director Walter Hopps managed to invigorate the operation with exhibitions like a Kienholz installation, works by Chicago's Hairy Who and Lloyd McNeill's 152-hour-long dance/light/sound show.

Hopps, more than anyone else, may have forced the issue of moving local art beyond the Color School. He came here from the Pasadena Museum of Art in 1967 with, as Paul Richard puts it, "a California aesthetic." He brought wide-ranging interests (from films and jazz to children's art) and a desire to demystify the role of the museum. Dubbed by *The New York Times* "the most gifted museum man on the West Coast and, in the field of contemporary art, possibly in the Nation," Hopps

9.–11. FROM TOP: At festive show openings, Paul Richard and Sam Gilliam, Carroll Sockwell and Gene Davis in 1969, and Walter Hopps and Ramon Osuna in 1980

(1932-2005) saw Washington as one of five American cities capable of broadening the base of art.

*Newsweek* in 1968 pronounced Washington "a museum enclave to rival even New York." That year Lyndon and Lady Bird Johnson presided at the gala re-installation of the National Collection of Fine Arts (now the Smithsonian American Art Museum). Welcoming them was director David Scott who oversaw the Collection's move from its dark quarters at the Museum of Natural History to the historic, repurposed Patent Office Building. For the Smithsonian and its Secretary S. Dillon Ripley, this period marked other beginnings—the Renwick for fine crafts, the National Portrait Gallery, the Anacostia Museum and first steps toward the Hirshhorn Museum and Sculpture Garden.

Across town at The Phillips Collection, curator James McLaughlin (1909-1982) often looked at the portfolios of young artists and advised them where to show. And Marjorie (Mrs. Duncan) Phillips, who had assumed the directorship in 1966 upon her husband's death, revived "The Washington Room," a coveted showcase for those who wanted to hang among modern masters. Often she paid visits to commercial galleries and astonished Sam Gilliam by offering him the 1967 exhibition that helped establish the market for his work.

The Corcoran Gallery, under Hermann Warner Williams (director from 1946 to 1968), mounted biennial Area Exhibitions in which unknowns competed to hang beside local "names." The 18th incarnation (1967) expanded eligibility to artists within a 200-mile radius of D.C., added film and photography categories and permitted entries by slide. Out of more than 1,000 paintings, juror Bates Lowry selected 92 by, among others, Willem deLooper, Thomas Downing, Sam Gilliam, Hilary Hynes and Jacob Kainen. Paul Richard, in his lengthy *Washington Post* review "A Disaster at the Corcoran," bemoaned inclusion of so many amateurs, calling the show "the worst" in a local museum and "visual Muzak."

Director Williams (1908-1974), anticipating the likelihood of less quality, had asked trustees to discontinue the "open-to-all" series. His tenure, however, was marked by dignity under pressure, a balanced budget, wise purchases and insistence that the gallery reserve space for Washington artists. When Williams retired, the Corcoran entered a period of upheaval and moments of high-visibility

12. Party girl at a 1960s Corcoran opening, identity unknown

success. The next director, James Harithas envisioned the gallery as a cultural scene and reversed its stodgy image with parties and rock bands. Although he convinced the trustees with his visions, ultimately he failed to expand the endowment and membership.

To everyone's surprise, the Corcoran made the cover of *Time* with its 1967 "Scale as Content" exhibition curated by Eleanor Green. The news? That modern art had outgrown the museums (on the New York Avenue corner rose Barnett Newman's "Broken Obelisk") and that a U.S. museum could commission works to fit its spaces (Ron Bladen's colossal "X" and Tony Smith's "Smoke.") Green bemoaned the fact no one raised the money to buy Newman's then bargain "Obelisk," but the work struck some as too blatantly political, its broken, upended form mocking the Washington Monument, if not the nearby White House. Houston's Menil Collection acquired it soon after and placed it outside the Rothko Chapel where it remains.

The Corcoran's art school generated its own scene with artist/teachers like Bill Woodward, Frank Wright and Bill Christenberry. Yet the museum got mixed reviews in a late 1960's artists survey taken by Cornelia (Kenneth's ex) Noland for *Washingtonian* magazine: "a mausoleum...a cemetery of degenerate art," she wrote, "Grandma Moses in miniskirts, so afraid that if it didn't swing it would be left behind" yet the gallery "most supportive" of Washington artists.

Certainly some newcomers could thank the Corcoran for exposure in shows like "New Painting: Structure" (1969) which featured Ken Wade, Carroll Sockwell, Robert Newmann and Michael Clark. By the end of the decade, however, the Corcoran suffered from a depleted

13. *Sarah's Reach*, 1964,
by Kenneth Noland,
acrylic on canvas,
93 3/4 x 91 5/8 inches

endowment (as well as no air conditioning) and risked losing its national museum association standing. Rumors circulated that it might even be absorbed by the Smithsonian. At press time for this book, issues of Corcoran survival surface once again.

Throughout the 1960s, many persisted in thinking that all local painters must be first or second generation "color painters" just because they lived in Washington. Willem deLooper (1932-2009) resisted the label and traced his work not to that generation but to common sources—works at The Phillips Collection where he spent many years on the staff, from night watchman to chief curator.

Berkowitz, a chronological peer of the "school," continually disassociated himself by theory and metaphysical bent. He had spent much of the decade abroad and later explained why he shouldn't be considered an official Washington colorist: "My growing concern with light led me away from the hard edge of the Color School." According to Renee Butler, curator of "Looking Into Color," the Washington Arts Museum's 2007 tribute exhibition for the artist, Berkowitz often acknowledged "the greater influences of poetry, music and physics" over color for color's sake.

14. LEFT: Willem DeLooper documenting a new abstraction
15. RIGHT: Leon Berkowitz in his studio

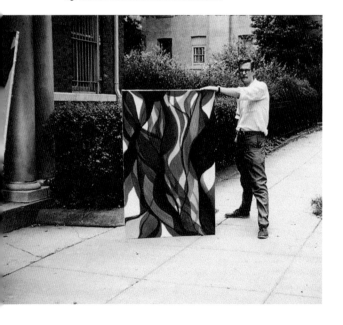

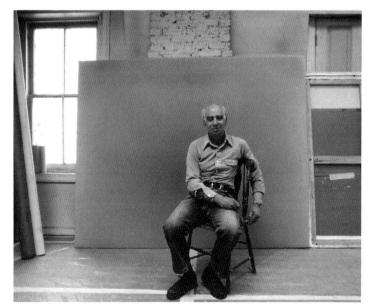

Alma Thomas made her own path through the "color field." Her shimmering dabs of pigment (which Kainen called "Cyclopean masonry—put a slab here, a slab there") earned Thomas a Whitney Museum retrospective (1972), the first for a Washington artist and the first for an African–American woman. Kainen remembered her sophistication and strength of character. He said, "At the end, Alma was so weak she asked to be wedged in so she could stand up to paint."

Not surprisingly, the decade brought new visibility to women artists. Anne Truitt (1921-2004), in contact with New York and Noland, signed with Andre Emmerich. In 1961, Emmerich showed her rectangular sculptures set on recessed bases, work that Greenberg later insisted, "started or anticipated Minimal Art." The Jefferson Place Gallery claimed the largest female contingent—Sheila Isham, Sandy Waters, Helene Herzbrun, V.V. Rankine, Valerie Hollister, Hilda Thorpe and Mary Orwen.

Rankine (1920-2004), both a painter and minimalist sculptor, used the top floor of the Jefferson Place as her studio and received a 1966 solo show from Betty Parsons in New York. A dramatic figure, she had several brushes with celebrity: study with Josef Albers and Willem de Kooning (1947-48) at Black Mountain College, where her classmates were Noland and Rauschenberg, and a late 1930s encounter with Katharine Hepburn at a New York skating rink. V.V.'s proper family refused Hepburn's request that V.V. (then Elvine) play the star's younger sister on Broadway in "The Philadelphia Story."

Although "flat" abstract painting dominated the time, art moved on multiple fronts. Mitchell Jamieson depicted the realities of the Vietnam War, Ed Kelley turned to

16. *Light Blue Nursery* 1968
by Alma Thomas,
acrylic on canvas,
49 x 47 7/8 inches

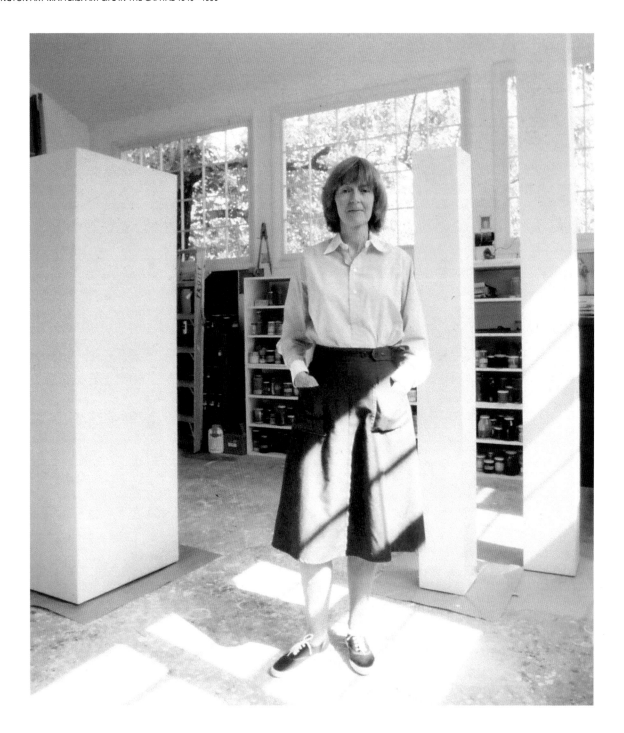

filmmaking, and Breton Morse created armatures that projected his canvases into the viewer's space. Sculptor Lolo Sarnoff, later founder of Arts for the Aging, employed fiber-optics, perhaps the first to adapt this technology for art. Others managed a personal pluralism—Blaine Larson with painted furniture and biomorphic paintings, Jennie Lea Knight with meticulous animal carvings and minimalist floor pieces. When debilitated by illness, Knight (1933-2007), a co-founder of the Studio Gallery co-op in 1956, moved from large-scale to intimate pieces.

While the scattered commercial galleries of the early 1960's struggled to attract paying customers, late 1960's dealers, mostly concentrated along P Street west of Dupont Circle, created a short-lived scene with opening night parties, happenings and at least one wedding—Frauke and Willem de Looper's at the Jefferson Place.

Sam Gilliam remembers that he first exhibited at a co-op, the Adams-Morgan Gallery, which also showed Reed, Mehring and poet/sculptor Sy Gresser, who, after study at the ICA, began a lifetime of direct carving in wood and stone. *The Washington Post* covered their openings, but sales never covered the rent. (Mehring's "broken color constructed" paintings went begging at $50 apiece.) The landlord forced them out by opening all the water faucets on the floor above, and Gresser recalled, "We came back at two in the morning to steal our artwork."

Painter/teacher Jack Perlmutter presided over the opening of the Dickey Gallery in 1962. With non-profit status and contributions from a group of art lovers, Perlmutter reclaimed three rooms at D.C. Teachers College on Pennsylvania Avenue. The premiere show "Then and Now" displayed old and new canvases by eleven artists

17. OPPOSITE: Anne Truitt in her studio
18. BELOW: Truitt's *Sun Flower*, 1971, acrylic on wood, 72 x 12 x 12 inches

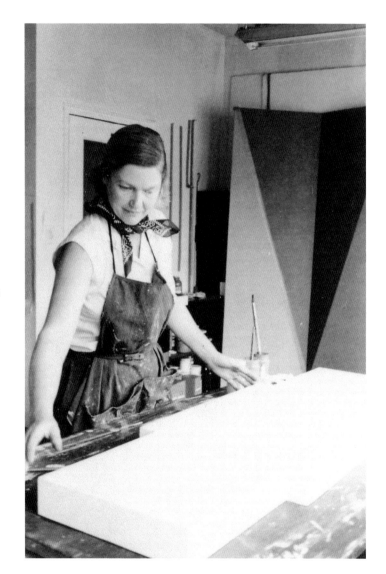

19. *V.V. Rankine in her studio*

20. OPPOSITE: *Peribleptos*, 1966
by V.V. Rankine, acrylic on
fiberboard, 81 7/8 x 28 7/8 inches

including Samuel Bookatz, Pietro Lazzari, Prentiss Taylor and Andrea de Zerega, all of whom continued to work in painterly, mostly semi-abstract styles.

In the fall of 1963, the Mickelson Gallery opened within its owners' long-established frame shop at 707 G Street. *Washington Evening Star* critic Frank Getlein (1921-2000) rightly predicted the venture would survive (and it did for decades) because of "style, luck, good New York connections, and, not least important, plenty of money." Mickelson showed sculpture even during the dominance of painting and introduced to the capital M.C. Escher, Carol Summers, Jack Levine and Richard Anuskiewicz.

Nesta Dorrance came to town in the early 1950's by way of Swansea, Wales, and the London School of Economics and, for a time, studied painting at American University. When the Jefferson Place Gallery opened in 1957, Dorrance made the first purchase—a Robert Gates canvas, but when the co-op folded in 1961, she got the gallery's name, a short list of patrons and less than fifty dollars in petty cash

For more than a decade out of a converted P Street townhouse, Dorrance (1925-1999) ran the Jefferson Place as a risky showcase and erratically profitable business. By 1969, she had thirty-one artists in the stable, including Mehring, Gilliam, Reed, Rockne Krebs, David Moy and Eric Rudd. That same year, she showed the welded plastic cube sculptures of an eighteen-year-old Cuban émigré/Corcoran student Roberto Polo. Years later, Polo resurfaced in *Wall Street Journal* headlines as big-time art buyer and alleged embezzler of $110 million. *Vanity Fair*'s Dominick Dunne chronicled the rise and fall of Polo, who spent time in Swiss prisons and reportedly has become a Paris gallerist.

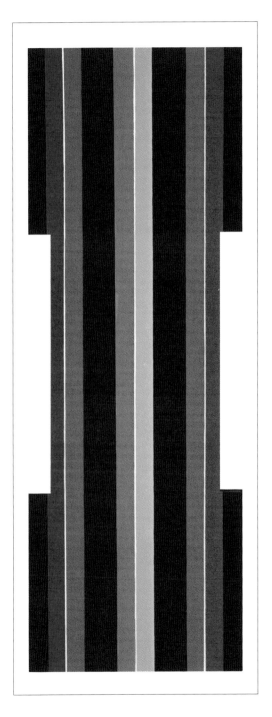

21. *GI in Profile-Vietnam* (circa
1967-68) by Mitchell Jamieson,
pen and ink and ink wash on
paper, 9 1/4 x 6 1/8 inches

Barbara Fendrick may be the city's first private dealer. Throughout the 1960s, she sold contemporary prints from her Chevy Chase house and by mail order. She recalls, "We took art to people with exhibits at the Arena Stage and the State Department and by organizing traveling shows." Later with galleries in Georgetown and So Ho, she marveled at the changes. She and her late husband Daniel "looked at the art business as public service rather than marketing a commodity." The gallery closed in 1991, having represented national figures plus Washington sculptors Ray Kaskey and John Dreyfuss, painters Sam Gilliam and Patricia Tobacco Forrester (1940-2011).

Local journalists noted the growing importance of art made in Washington, but New York opinion still seemed to matter more. Suddenly artists who felt their work was out of fashion began to gauge their positions and reassess directions. Some "went underground for the duration," said Kainen, who, always on his own tack, abandoned abstraction and returned to the human figure. Many painters not concerned with color and flatness found themselves all but invisible. Until the Color School influence ran its course and even after, some were left, as Kainen put it, "skulking in their tents." Several painters resented that a chosen few were, in Kainen's words, "smothering in kisses."

Mehring, in particular, felt Greenberg had treated him unfairly, passing over his own chevron paintings to select Noland's for an international exhibition. A 1966 solo show at New York's A.M. Sachs Gallery earned good press and sales to several museums, yet in 1968, Mehring stopped painting altogether. Some took it as a loss of nerve, but Corcoran curator Jane Livingston said, "He had the

insight—or the guts—to stop at the right time." When he died of a heart attack 10 years later, an exhibition of his paintings had just opened at the Phillips, and his address was a Maryland motel.

Paul Reed, now the only survivor of the 1965 exhibition six, began to show in Washington in the early 1960s. His works then and later featured centralized images and jigsaw shapes that seemed to spin with a centrifugal force. Reed, for some years a beloved Corcoran School teacher, continues to work in his Arlington studio and show his work. A recent series consists of tissue-like panels of color that he suspends in windows to catch the light.

After national spotlights beamed elsewhere, Reed, Davis, Mehring and Downing, for the most part, kept to the workmanlike regimens of their early careers. They gave time, however, to "newer guys" who hung out around the Corcoran or visited their studios—Davis in a seedy walk-up at 1736 Pennsylvania Avenue and Mehring above a store at the corner of Columbia Road and 18th. Often, at Downing's kitchen table, Sam Gilliam and others played poker and talked into the night.

In 1969, Hopps selected Ed McGowin, Gilliam, and Rockne Krebs—all early 1960's newcomers—for a major show that filled the Corcoran's second floor and suspended Gilliam's vast "drape" paintings in the atrium. Hopps scheduled it to coincide with a David Smith exhibition which, he knew, would bring New York attention. At the same time, he worked to secure grants, studio space and national exposure for a number of local artists.

He chose Gilliam, McGowin and Krebs, because, to him, they represented Washington's newest techniques and extremes of sensibility as well as three detours around the Color School. Only Gilliam had paid his dues as a geometric painter, Krebs had moved from sculpting wood in the U.S. Navy Station hobby shop to laser technology, and McGowin had jumped from expressionism into "Uvex" plastic constructions.

McGowin has a photo of himself in mod suit and narrow tie, circa 1962, standing next to a Mississippi congressman on the steps of the Capitol. Fresh out of Tuscaloosa and Hattiesburg and newly married with a baby, McGowin had moved to Washington to work as staffer and sometime doorman on the House floor. With him came a cache of paintings he showed to a Corcoran curator. By December

22. *Primal*, 1961-62, by Howard Mehring, acrylic on canvas, 71 1/4 x 71 inches

23. Nesta Dorrance, last owner of the Jefferson Place Gallery

of that year, he had a solo exhibition at the museum, complete with catalog.

Also early on, McGowin met Henrietta Ehrsam (1909-1996), a dealer who sold the work of national artists along with used clothes out of a circa 1790 Alexandria townhouse, until 1967 when she moved to the corner of P and 21st streets in Washington. Frank Getlein recalled fantasizing with Henri a dramatic, press-worthy arrival, crossing the Potomac by rowboat à la George Washington crossing the Delaware. Henri commissioned painter James Hilleary to act as architect and oversee the renovation of the turreted Victorian townhouse. In 1968, Hilleary had his first solo show there, and then Gene Davis installed his experimental "stripe column" in the showcase bay window.

When McGowin installed his first of many Henri Gallery shows, he told her, "I don't even want a label, unless the label is 'change.' " This anticipated McGowin's "name change" concept piece begun in 1970, his successful petition each month for a year of a different, legal name. Even now he continues producing art by those personas.

By the end of 1967, McGowin had a New York gallery, a teaching job at the Corcoran, a National Endowment award and a vast studio space provided by landlord/attorney Donald Brown in exchange for artwork. Although in 1977 he left for New York, his progress from "new boy in town" to established (and still-connected) figure illustrates the Washington artist survival story. He had arrived to find a relatively unintimidating museum scene, access to other artists and galleries, and Washington and national press alerted that fame just might begin here. The "color guys" had made it fashionable to honor local heroes.

24. OPPOSITE: Paul Reed in his studio

25. ABOVE: *Untitled*, 1962, by Reed, acrylic on canvas, 36 X 36 inches

FROM TOP: 26. *Untitled*, 1968, by James
Hilleary, acrylic on canvas, 64 x 64 inches
27. Gene Davis's illuminated "barber
pole" in the Henri Gallery bay

Gilliam and his wife Dorothy, a journalist, moved from Louisville in 1962, choosing Washington over New York because it was the right place to raise a family, and he felt "things were happening here." Eventually a no-strings grant of $5,000 from the National Endowment allowed him to go from full to part-time teaching (McKinley High to the Madeira School). Then a grant and rent-free studio space via the Stern Foundation gave him the freedom and impetus to work large-scale. Another break: Downing told him how to buy canvas from Baltimore on the installment plan.

What resulted were works twenty feet wide and up to 225 feet long (200 yards by 1974). Sometimes the artist donned boots and wielded a rag mop as he applied washes of color to massive canvases laid across his studio floor. When he realized that suspending and draping might free his work from traditional stretchers, Gilliam adapted a Morris Louis technique—manipulating the canvas itself to achieve "runs" of color.

Rockne Krebs (1938-2011), stationed here as a junior Naval officer in 1964, might not have returned to art (although he had a sculpture degree) if he'd missed Antony Caro's first one-man show at the Washington Gallery of Modern Art. That, in his words, "critical event" inspired him to visit Caro and then Noland, who warned against the hazards of being an artist in New York without "a visual vocabulary."

Although never a painter, Krebs acknowledged he was influenced by the Color School. His early chevron sculptures of freestanding aluminum were essentially bands of color. He retained their simple geometry when he switched to transparent plexiglass, a material "colored" by

its own reflections. Even Krebs's laser works—his mesmerizing "Ran" in the 1969 Corcoran show and a piece for Osaka's Expo '70—denied traditional 3-D sculpture by "painting" the air, dematerializing form in order to salvage pure color.

The Corcoran show blessed the three with a heady, local fame. In a *Washington Post* feature labeling them "The Third Wave," critic Ben Forgey praised their departure from fixed and isolated objects to works that interact with the room. McGowin remembers, "The press made it appear that we were having an impact. We figured the Arts Endowment would draw people, and artists would have more leverage and control. We fully expected the star system to continue and the context of art to develop in a linear fashion. But we were naive; the structure evolved into something bigger than New York versus D.C."

Krebs recalled that "the three of us never talked about what we were going to do, but we were heading into new territory." Their fascination with processes and materials called for unprecedented budgets—with Gilliam's monumental drapes and luxuriant pigments, McGowin's air-brush and vacuum-forming techniques and Krebs's logistical and technical expenditures. More importantly, their divergence implied the pluralism to come.

28. Juan Downey with his participatory light work at the Corcoran Gallery, 1969

29. The mistress of Henri Gallery, self-professed enemy of "boring" art

Only three years after "The Now Festival," Washington art folks had assumed the nation's ubiquitous look—hirsute, costumed and beaded. Moreover, by decade's end, everyone from Corcoran students to gallery-goers took "happenings" as a matter of artistic course. On one occasion, conceptualist Juan Downey (1940-1993) invited people to the Smithsonian Castle and asked them to travel as far as they could, call in locations (that meant phone booths) and return by midnight. His intent: that bodies and cars trace his invisible work on the landscape. Soon Downey left for New York where he pioneered as a video artist.

But of all such events, the "Give-Away" best capsuled the times. Doug Davis, art critic for the *National Observer*, had suggested burning canvases in the street, but McGowin pushed for homage to the once-and-for-all-finished Color School. With Gene Davis's support, a crew of Corcoran students led by Michael Clark made fifty exact copies of Davis's six by six-foot painting "Popsicle."

On May 22, 1969, several hundred gathered in the Mayflower Hotel ballroom. Most wore black tie or cocktail dress and did so with a touch of self-mockery that fit the occasion: dispensing serious art by random drawing. "It was a catharsis," says McGowin. "From then on, anyone who came here to be a color painter was downright silly."

By 1969, it was clear that the art-historic impact of the Color School had been an aberration. None of Washington's comers could expect to trade on old connections or on the myth of "artist-as-uncorrupted-visionary." Instead, as the economy expanded, and audiences became collectors, each person's success and notoriety would depend on clear-headed professionalism, market savvy and the scuttling of a regionalist point of view.

31. *Los-i*, 1966, by Ed McGowin, acrylic/vacuum-formed plastic, 23 3/4 x 22 5/8 x 10 inches

30. OPPOSITE: McGowin with sculpture in his 1967 show at Henri Gallery

71

James Twitty (1916-1994), a professor at the Corcoran School and George Washington University, recalled that, when he arrived in Washington in the early 1960s, a headline caught his eye: "Culture Is At A Low Ebb Here." He made a plaque out of the newsprint and hung it permanently in his painting studio. By 1969, the same newspaper declared that the city's hottest new artists "had significantly extended the history of art." Somewhere between the pessimism and the hyperbole, a viable art community staked out territory.

33. Sam Gilliam's precedent-breaking draped canvases in the Corcoran Gallery atrium, 1969

32. OPPOSITE: Sam Gilliam in his studio, 1969

## CHAPTER 4

# The Way We Were

## THE 1970S

BY ELIZABETH TEBOW

On the evening of October 1, 1974, a crowd gathered for the grand opening of the Hirshhorn Museum and Sculpture Garden on the National Mall. Alongside a line of black limos, a Volkswagen bus pulled onto Independence Avenue, and out came young people resplendent in bell bottoms and peasant skirts, feathers and velvet. Presenting forged tickets at the door, they joined the throng of politicians, diplomats, lawyers and corporate types dressed in tuxes and party dresses being greeted by Joseph and Olga Hirshhorn, the museum's donors.

New York writer David Bourdon had described social events in Washington as "usually filled with political types and a moneyed crowd that actually spend little on any kind of art, and that living artists, if present, are a distinct minority."[1] But the party crashers that night at the Hirshhorn, young artists from Beverly Court, a run-down apartment building on Columbia Road , demonstrated that Washington artists were ready to take center stage, or at least claim their fair share of attention in the city where they lived, worked and made their art.

Unlike the Washington Color School painters, who often harbored feelings of suspicion and jealousy toward each other, artists in the 70s seemed to enjoy one another's company. They were more community-minded than their predecessors, more eager to collaborate on everything from showing their art to espousing political causes and socializing. Their sense of mutual support was to some degree galvanized by major events and causes of the decade: the nation's Bicentennial celebration, the civil rights movement, women's liberation and opposition to the Vietnam War. Artists were also buoyed by dedicated arts promoters who came from a variety of ranks: museum curators, art newspaper publishers, developers of alternative art spaces and well-heeled individuals who espoused art causes.

There were also new opportunities for commissions through "percent for art" construction programs as well as private urban renewal projects for which art space was considered an essential ingredient. The GSA and National Park Service also supported art and new venues. In addition, the cultural fabric of the city was expanding with the establishment of the Hirshhorn as well as The John F. Kennedy Center for the Performing Arts (1971), The National Air and Space Museum (1976), and the East Building of the

1. PREVIOUS: Mary Beth Edelson,
*Work Box* for *22 Others*

2. J. Carter Brown (left) with Marjorie Phillips and son Laughlin Phillips at her retirement party

3. Joseph and Olga Hirshhorn, Hirshhorn Museum and Sculpture Garden Opening, 1974

National Gallery of Art (1978). The Seventies, in the jargon of the day, was a "happening time" for Washington and for Washington art.

Despite the giddy audacity of the Hirshhorn party crashers, Washington artists had good reason to doubt that the National Gallery and the Hirshhorn Museum would be interested in their work. Older institutions, such as the National Collection of Fine Arts (now the Smithsonian American Art Museum) which mounted a big Robert Rauschenberg show in 1973, had largely ignored local artists. At best, with their avowed national focus on modern art, the new venues for modern art in Washington were positioned to compete with New York's MOMA, Whitney and Guggenheim. In effect, they offered the city an indirect benefit by bringing an increased awareness of and prestige to contemporary art in the city. Although some grumbled that the older museums in town, The Phillips Collection and the Corcoran, were not much better than the new venues with regard to the local art community, that was actually not the case.

When Richard Friedman became chief curator of The Phillips in 1971, he continued Marjorie Phillips's support of local artists with an annual exhibition and some solo shows until his abrupt departure in 1975 after being accused of stealing prints from the collection. Laughlin Phillips, founder of *Washingtonian Magazine* and former CIA man, stepped in to run his father's museum and continued to feature local artists, most notably sculptors Yuri Schwebler (1943 – 1990) and Jennie Lea Knight (1933–2007) and painters Enid Sanford, Hilda Thorpe [1920 – 2000], Willem de Looper (1932–2009) and Judy Bass. In the 70s, The Phillips also featured works by Washington printmakers, Dan Kuhne's watercolors and a show of drawings by Kevin MacDonald (1945–2006).

The Corcoran, which had a long-standing relationship with local artists, reinstituted its Washington Room in 1971 under director Gene Baro (1945–1982) with an exhibition of work by Donald Corrigan, Sam Gilliam and Ed McGowin. But in 1972, the Corcoran faced huge deficits for the museum and school, its facility badly needed an overhaul, and conflict arose between its administration and board. These problems led to the closing of two of its most beneficial programs for Washington artists: the printmaking workshop and the fellowship program. (Lou Stovall continued to run the printmaking workshop without Corcoran support for several years in two floors of Philip and Leni Stern's house on S Street.)

That fall, Vincent Melzac (1914–1989), the museum's second CEO in five years, and Baro, the third director in as many years, had an altercation at a black-tie opening reception over a seemingly trivial issue exacerbated by long-simmering animosity. Melzac threw a wild punch and cut Baro's brow with his ring.[2] Embarrassing pictures of the injured Baro appeared in the papers and national newsmagazines "bleeding like a stuck pig," as he described himself. The board soon fired them both and moved Roy Slade from dean of the school to director of the gallery.[3] Despite his lack of museum experience, Slade proved a good choice, for within a few years he succeeded in restoring the Corcoran to firmer footing. In addition to overseeing repairs and upgrades of the physical plant, he also brought the magnificent collection of 19th -century American art out of storage for permanent display and refocused and expanded the museum's thematic exhibitions of national and international art while continuing to show local artists in the Washington Room.[4]

5. Gene Baro at the Corcoran

6. Roy Slade in his Corcoran office

4. OPPOSITE: Lou Stovall in the Corcoran printmaking workshop.

7. Yuri Schwebler holding model for *Pyramid Project, Washington Star*, January 8, 1974. A newspaper caption reads in part, "Schwebler stands with a model in his hands as he wonders how to get the pyramids up in time for the announced opening on Friday."

While the successful 1967 *Scale as Content* show featured large site-specific interior works by New York artists, in the 70s, the Corcoran turned to Washington artists for big installations. In 1973, Robert Stackhouse spanned the atrium balcony with 40 x 20 foot wooden beams for his *Sleeping King Ascending*. Tom Green (1942–2012) filled a nearby room with an autobiographical piece comprised of a black tar-coated coffin on a bed of white sand, black tree branches, plants, a 19th-century thrift store drawing, a plaster cast of his own teeth, charcoal drawings, and blue lights. In 1974, Yuri Schwebler created *Pyramid Project*, a group of three large and eight small plywood and faux-stone pyramidal structures aligned with the atrium's skylights and surrounded by plum bobs hanging from the ceiling. Ed McGowin's 1975 installation included a crashed airplane which Jane Livingston, the Corcoran's newly appointed curator of contemporary art, obtained from the National Air and Space Museum.

In the 70s, protest was definitely in the air, and Washington artists took an active role. On May 22, 1970, in solidarity with a national day of protest initiated in New York by sculptor Robert Morris, a group of Washington artists proclaimed its opposition to "racism, repression, the killing of students, and the war in Southeast Asia." The protestors who met at Leon Berkowitz's home included American University professors Robert Gates and Helen Herzbrun as well as Gene Davis, Howard Mehring, Paul Reed and younger artists Rockne Krebs and Michael Clark. Thirty of the 42 artists in the Baltimore Museum of Art show *Washington: Twenty Years* joined the protesters' demand that museums and commercial galleries in the District of Columbia and in Baltimore either remove their works or drape them in black.

8. Robert Stackhouse,
*Sleeping King Ascending*,
Corcoran atrium installation,
1973, wood, 40 x 20 feet

Although their art work was not overtly political, five African-American artists took part in the protest—Sam Gilliam, Lou Stovall and Martin Puryear, as well as Lois Maïlou Jones (1905–1998) and longtime Howard art professor David C. Driskell, a graduate of Catholic University's MFA program. Except for Jones, whose paintings reflected African and Caribbean influences, and Driskell, who created lush tropical landscapes, many of Washington's contemporary black artists worked non-objectively and eschewed racial commentary in their art.

Years later, Puryear said that he could not imagine requiring his art "to serve an exclusively social or political role."[5] Gilliam admits that at the time he was criticized by other black artists for working in abstraction and with no ethnic agenda.[6] Significantly, however, Gilliam titled a 1971 work *Dark as I Am* (a tribute to poet Langston Hughes) and called a 1975 triptych for the Corcoran Biennial *3 Panels for Mr. Robeson*, in tribute to expatriate African-American actor/singer Paul Robeson.[7]

9. Lois Mailou Jones,
*Moon Masque,* 1971,
oil and collage on canvas,
41 x 30 1/8 inches

Ironically, one of the most overt commentaries on racial tensions in the U.S. was by a white artist. William Christenberry came to Washington from Alabama in the late 60s to teach at the Corcoran. In addition to color photographs inspired by the Depression-era Alabama work of Walker Evans, Christenberry became known in Washington through exhibitions at the Henri Gallery and other venues for his assemblages of store signs, license plates and other found objects evocative of both the rural south and of contemporary Pop Art.

Haunted by a boyhood confrontation with the Ku Klux Klan, Christenberry began to assemble and construct KKK objects– G.I. Joe dolls in Klan regalia, an illuminated cross, ritual items– for an installation in a room adjacent to his Connecticut Avenue studio. Only a few friends, dealers and Corcoran students had seen it when in early January of 1979, someone broke into the *Klan Room* during the night and stole several key pieces. Christenberry, frightened by possibly sinister motives for the theft, announced to the media that "most of my photographs, most of my sculptures, celebrate the positive side of where I come from. The *Klan room* stressed the negative."[8] The crime has never been solved, but the remaining pieces have been exhibited in recent years in several venues and various forms, including at the Smithsonian American Art Museum, the Corcoran and American University's Katzen Art Center which sent it on for exhibition at the University of Mississippi thanks to the sponsorship of Old Miss alumnus John Grisham.

When Walter Hopps's 1971 Corcoran Biennial Exhibition had no women artists in a group of 22, Mary Beth Edelson staged a protest at the opening reception and offered visitors red ribbon arm bands as a show of support."[9] Edelson also used feminist themes for her art. In her *Some Living Women Artists/Last Supper* she substituted portraits of famous women

artists for the apostles in Leonardo da Vinci's *Last Supper*. Her environmental pieces, live performances, videos and installations addressed such formerly taboo issues as menstruation and female sexuality. For *Twenty-Two Others*, a 1973 show held jointly at Henri and the Corcoran, Edelson solicited subjects and themes for pieces from 22 friends. The list of the participants reads like a "Who's Who" of Washington art at the time, among them, Alice Denney, Gene Davis, Roy Slade, Gene Baro, Henrietta Ehrsam and Walter Hopps. Their suggestions included "a pre-natal work" (Davis), "a white elephant" (Henri), and "polyptych altarpieces with spiritual conviction" (Hopps).[10]

In 1972, Edelson, along with art historian Josephine Withers, curator Susan Sollins and artists Barbara Frank, Cynthia Bickley, Yvonne Wolf and Enid Sanford, organized a National Conference for Women in the Visual Arts. It took place at the same museum that excluded women from the Biennial the year before. Artists and activists converged from all over the country for the event, and galleries and museums across town mounted works by women artists. That same year, D.C. artists founded a chapter of the National Women's Caucus for Art.

Inspired by the era's counter-culture idea of artist collectives, a group of mostly women started Madam's Organ, a feminist play on Adams Morgan, the name of their D.C. neighborhood centered around 18th Street and Columbia Road, N.W. The founders, many with Corcoran connections, pooled resources to pay rent for a space on 18th Street described by one observer as "part clubhouse, part headquarters and part home." The co-op supported video shows and dance performances, published a mimeographed magazine called *Eye Wash* and hosted spontaneous exhibitions and "psychic experiments."[11] In the fall of 1974, they staged *Alternative To*, a show of 300 objects that had been rejected by the Corcoran's juried Area Show.

Sensitivity to women's issues also resulted in one of the more amusing art controversies in the city. In 1975, Corcoran instructor Bill Newman obtained permission to paint a mural on a temporary wall around a GSA construction site at 17th and G Streets, N.W., near the school. To the delight of construction workers, but dismay of many female passersby, the 24-foot wide mural depicted a bikini-clad 18 year-old student of Newman identified only as "Sarah." Already flooded with complaints, the GSA ordered the mural removed when Newman admitted that the water-based paint he had used for the bikini would wash away in the first hard rain and reveal the nude figure underneath.

10. William Christenberry, *From the Klan Room*, 1982, mixed media, 5 x 5 inches

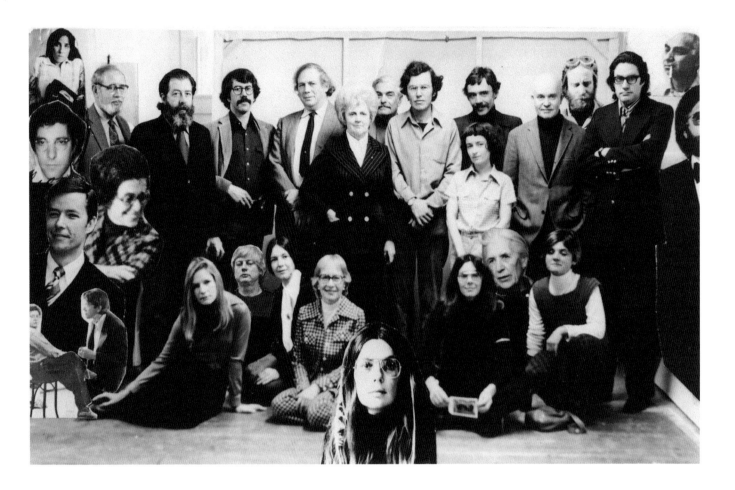

The national, especially New York bias of curators and dealers was a recurring theme and complaint. In 1974, fourteen artists, among them, Edelson, Krebs, and Stovall, signed a petition protesting the exclusion of Washington representatives in *Art Now 74*, a nineteen-day event at the Kennedy Center advertised as "a national multimedia festival of the arts." They complained that the majority of the artists selected were from two New York galleries, Leo Castelli and Ileana Sonnabend. *Art Now's* organizer, Nina Sundell, who happened to be Castelli and Sonnabend's daughter, responded that she had "always intended to invite Washington artists to participate" but added that the emphasis was on "performance and post-object art." [12] In the end, three D.C. artists (all signers of the petition) ended up in the festival—laser artist Krebs and non-objective painters Gilliam

and Davis. The event was still controversial, as much for the largely avant-garde nature of the art as for what locals saw as its snobbishness and exclusivity. Yet Krebs' *Irish Light,* a laser installation visible from the Center's terraces as well as from other parts of the city, turned out to be one of the biggest hits of the show.[13]

Despite limited opportunities for local artists at the big venues, prospects were good at the smaller, independent galleries in town and out in the suburbs. The Emerson Gallery in McLean (now the McLean Project for the Arts), which started in the basement of a suburban Virginia house in 1962, continued an ambitious schedule of exhibitions of contemporary art. Under the direction of faculty chair Lois McArdle, the Annandale Campus of Northern Virginia College had shows for Willem De Looper, Enid Sanford Cafritz, Hilda Thorpe, Brockie Stevenson and Alan Feltus.[14] Georgetown continued to attract dealers. Louis Andre moved his Wolfe Street Gallery there from Alexandria, Virginia, in the early 70s and showed work by Gayil Nalls, Hank Harmon and other young painters in his second floor space. Chris Murray's Govinda Gallery, which opened in Georgetown in 1975 (and stayed in business for 40 years), was famous for showing photographs of blues and rock legends. Staffed by a succession of "Govinda Girls," exhibitions often opened with entertainment by popular musicians, among them, Murray's pal Donovan.

However, it was the Dupont Circle area centered on P Street that became the closest to what could be called a gallery district in the early 70s. Dealers launched new galleries or moved there from other locations, attracted by cheap rent, the proximity of The Phillips Collection and the residual impact of the short-lived Washington Gallery of Modern Art. It was also the site of an arts festival in the summer of 1971 organized by Luis Lastra who, with fellow Cuban émigré Ramon Osuna, had opened the Pyramid Gallery on the street the previous year. The Jefferson Place Gallery, Henri Gallery, Gallery Marc, and The Sign of Jonah participated with exhibitions that spilled out onto the sidewalk and into the road which had been closed by order of the D.C. City Council. They served free beer, sold cookies for a penny, secured the services of a tattoo artist, and provided pens and paper for making art on the spot. The festival attracted a large crowd of artists, collectors, neighbors, friends and the curious. Rockne Krebs created a searchlight piece, Geny Dignac lined the street with highway flares, Jennie Lea Knight piled up a mound of straw which children gleefully demolished, Ed Zerne made a solidified foam sculpture

11. OPPOSITE: Mary Beth Edelson, photo montage, *22 Others,* 1973, Henri Gallery. Pictured are collaborative participants Nina Felshin, Henry Berne, Ira Lowe. Renato Danese, Gene Baro, Henri, Henry Lederer, Don Corrigan, Ed McGowin, Lawra Gregory, Gene Davis, Robert Stackhouse, Walter Hopps, Leon Berkowitz, Roy Slade, Paul Richard, John Bullard, Alice Denney, Italo Scanga, Benjamin Forgey, Enid Sanford, Paul Reed, Pat Berne, Bobby Lederer, Mary Beth Edelson, Adelyn Breeskin, Cynthia Bickley.

12. Kevin MacDonald and Michael
Breed lighting dry ice,
P Street art festival, 1971

13. Henrietta Ehrsam and her
daughter peer out of Henri Gallery,
21st and P streets N.W.

and Michael Breed created a work out of a 140-foot strip of
dry ice.

Citing the concentration of new galleries and the success
of this festival, *Washington Star* art critic Benjamin Forgey
optimistically suggested that the "P Street Strip" could become
D.C.'s equivalent of Manhattan's 57th Street.[15] In the short
term, Forgey proved right. Even though Osuna and Lastra also
represented European artists and dealt in Old Master works,
their gallery became a popular venue with shows of blue-chip
Americans such as Andy Warhol and Joseph Cornell as well as
young locals.[16] Other galleries soon opened up in the area. "They
all seem to think P Street is paved with gold, and they want a
piece of it," observed Osuna in 1976.[17]

Prints and drawings dealer Jane Haslem moved to the P
Street area from Georgetown. After a stint on 7th Street, in
the 80s, Haslem returned to the neighborhood where she still
operates today and represents many Washington painters
and printmakers, among them, Joe White, along with American
masters like Edward Hopper and Josef Albers. Max Protetch, in
his Georgetown gallery with first partner Harold Rivkin, was
the first dealer to show conceptual art in the city, but when he
branched out on his own, he moved to P Street and took over an
old pet shop. Kathleen Ewing moved her photography gallery
from her original location on K Street under the Whitehurst
Freeway. Diane Brown, one of the few sculpture dealers in
town, opened a gallery on the ground floor of an apartment
building. Also on the street: Gallery 10, a co-op started by painter
Noche Crist, Gallery K opened by Marc Moyens and his partner
Komei Wachi and Middendorf/Lane Gallery, a joint project of
newlyweds Chris Middendorf and Helen Palmer Lane. Although
a second art block party never happened, a tradition of monthly

evening openings on P Street continued well beyond the 70s, and the area still is a home to many galleries.

Washington art received a significant amount of press coverage in the 70s. Writers at the *Washington Post* (notably Paul Richard and Jo Ann Lewis) and the *Washington Star* (Frank Getlein and Benjamin Forgey) regularly reviewed exhibitions at the national museums and commercial galleries as well as at colleges in the Virginia and Maryland suburbs. Local television stations and magazines also covered art events.

An important addition to arts coverage, *Washington Review* was introduced in 1975 by Clarissa Wittenberg and Jean Lewton as a tabloid-style paper to cover artists, galleries, the literary scene and theater. Supported by grants and donations, the *Review* featured poetry, fiction, interviews, show reviews, photographs of art and artists. It continued as a vital voice for 30 years under the direction of Mary Swift, its managing editor, chief photographer and indefatigable supporter of local art and artists, and through the work of chief writer and critic Lee Fleming.

Art also had an important spokesperson in Joan Mondale, wife of Vice President Walter Mondale during the Carter administration. A potter herself, "Joan of Art, "as she was popularly known, made art her official focus. Among other projects, including hosting artists at the Vice President's Residence and lending her support to exhibitions, she also invited curators from American museums to install art in the official residence at Observatory Circle and commissioned craft artists to make furniture for the house and place settings for official entertaining. In addition to nationally-known artists from around the country, including Wendell Castle, John Glick and Sam Maloof, she acquired pieces by Vally Possony (1905-1989), Mondale's local pottery teacher. Craft art also benefited from shows at the Smithsonian's new Renwick Gallery and through the opening of pottery workshops and centers, including one in the Torpedo Factory Art Center, established in Old Town Alexandria in 1974. American Hand in Georgetown sold pottery, and Jackie Chalkley sold ceramics and wearable art at her boutique.

For a new generation of painters in the 1970s, the Washington Color School was both an inescapable influence and point of rebellion. Although Morris Louis died in 1962 and Kenneth Noland had left Washington for New York in 1961, several of the leaders of the movement remained in the nation's capital, painting and showing their work. By the 70s, a few took on the status of Washington "old masters," especially after The National

14 Lee Fleming asleep under a copy of the *Washington Review*

15. Joan Mondale at the Vice President's residence standing behind David Smith's *Star Cage*, 1950, on loan from the University of Minnesota Art Museum, 1977.

16. Gene Davis working on his
*Magic Circle* Corcoran rotunda
installation, 1976

Gallery purchased Louis's painting *Beta Kappa* in 1972. In 1976, Slade invited Gene Davis to paint the Corcoran rotunda so that visitors would be surrounded by a "magic circle" of colored stripes.

The next year the Corcoran gave a retrospective to Howard Mehring and held a Kenneth Noland retrospective in conjunction with one at the Guggenheim Museum. (The Corcoran showed early work; the Guggenheim the more recent pieces). By now, the Hirshhorn had brought to its galleries a significant group of Color School canvases from the astute collector's founding gift.

Some artists continued the Color School tradition, at least for a while. In 1970, Robert Newmann, a 26 year-old painter who studied with Tom Downing, sold out his first commercial show in 1970 at Pyramid. *Washington Post* critic Paul Richard wrote that Newmann's success proved there is still "life in hard-edge, geometric structured Washington color painting" and that the local market for this art was "knowledgeable and growing."[18] American University alum Hilda Thorpe, who showed at The Phillips Collection and the Corcoran, created color abstractions in a variety of media, including handmade paper, ceramic and draped canvas. James Hilleary, an architect by training, painted canvases charged with optical illusions of vibrating color, while Willem de Looper (who also worked as a Phillips curator for many years) continued his lifelong devotion to abstraction in paintings with muted, tonalist color.

Others used the Color School as a point of departure. Gilliam, who had already made a dramatic break in the late 60s with his draped, un-stretched, stained canvases, went even further in the 70s. Using eccentric techniques such as raking paint and sewing together pieces of canvas, Gilliam enlivened his paintings' surfaces and evoked sources such as the piecework in African-American quilts.

Berkowitz, who had been in Washington off and on for years, in contrast to the purely formalist interests of Louis, Noland and other Color School painters, proclaimed his interest in evoking music and poetry through color abstraction in his 1973 Corcoran show which he titled *The Sound of Light*. Enid Sanford (Cafritz) introduced a new element of spatial illusion in her paintings in a 1976 show at Henri Gallery featuring *trompe l'oeil* images of crumpled and taped paper. Carroll Sockwell's paintings became more gestural and expressionistic. Jean Meisel introduced forms derived from nature to her geometric abstractions. Nan Montgomery, who had studied color theory with Josef Albers at Yale,

20. Ed McGowin standing under installation for *True Stories*, Corcoran Gallery of Art, 1975

17. Rockne Krebs, *The Source*, 1980, laser installation for the International Sculpture Conference, Washington, D.C.

abandoned abstract expressionism for geometric abstraction after taking painting classes at the Corcoran and progressed to creating lyrical color effects with images drawn from nature.[19]

Krebs transformed the painted motifs of Noland's colored chevrons and Davis's stripes into beams of light slicing through real space. To create his innovative "sculpture without objects," as he once called his art, Krebs used mirrors, lenses, prisms, the *camera obscura*, fog, sunlight and rainbows, but he is best remembered for his innovative use of laser technology. Krebs installed his first permanent outdoor laser piece, *Sternline*, for Leni and Philip Stern in the garden of their Embassy Row house in the early 70s and soon went on to do installations across the U.S. and abroad. His 1980 piece for The International Sculpture Conference, *The Source*, featured beams of light connecting the Washington Monument and other major landmarks in a pattern that echoed Pierre L'Enfant's city plan. Although plagued with technical problems, it was still an ambitious and beautiful piece.

After experimenting with vacuum-formed plastic wall relief "color fields" in the late 60s, Ed McGowin turned to conceptual art in the early 70s. His first foray was *Name Change*, the 1971 piece for which he had his name legally changed monthly for an entire year. It was a complex project comprised of work in ever-changing media, formats and styles under the succession of new identities, which included, among other somewhat amusing-sounding names, Alva Isaiah Frost, Nathan E. McDuff, and Lawrence S. Orlean. In neo-dada fashion (Marcel Duchamp's alter ego Rrose Selavy comes to mind), McGowin questioned the meaning of artistic identity as he liberated himself from his previous focus. The art works ranged from photographs of exploding frozen custard to a blank-faced clock, from colored stripes reminiscent of Gene Davis to a refrigerator which opened to reveal an erotic image morphing into glowing

light.[20] The series culminated in a show at the Baltimore Museum of Art in 1972 and was documented in a series of silkscreens by David Bronson produced in Lou Stovall's workshop. *Name Change* was followed by the 1975 Corcoran Show, *True Stories*, one of new curator Jane Livingston's first shows at the gallery. His injection of humor, his consciousness of self as entertainment and the conceptual complexities of his work were new to Washington.

Joe White, a California native whose first introduction to Washington audiences was a 1972 solo Corcoran show, abandoned pure abstraction in 1974, for, as he explained, the more challenging imagery of photographs, printed advertisements and Renaissance Old Masters. He retained, however, an abstract, somewhat detached pictorial point of view. In a remarkable reversal of the usual exodus of artists from D.C. to New York, White moved to Washington in 1976 after nearly a decade in New York (and inclusion in the 1964 and 1968 Whitney Biennials as well as the 1969 Acquisitions Show). He came at the urging of Clark and gallery owner/collector Marc Moyens, and he set up a studio in a garage off an alley behind Columbia Road and showed at the Middendorf/Lane gallery.

18. Joe White, *Richmond Buildings*, 1977, oil on linen, 74 x 56 inches

19. Manon Cleary, *Idol*, 1968, acrylic on canvas, 50 x 45 inches

21. Kevin MacDonald, *White Fence*, 1978,
color pencil on paper, 30 x 22 inches

22. Rebecca Davenport, *Linda I*, 1976,
oil on canvas, 72 x 66 inches

Representational art, which had never really gone away in Washington, was clearly taking on renewed prominence. Claire List's 1980 Corcoran show, *Images of the 70's*, had one abstract artist, Jennie Lea Knight. Genna Watson and Joan Danziger showed figurative pieces. The remaining artists, all painters, worked in a variety of representational modes.

Corcoran instructor Brockie Stevenson (1919–2009) painted large scale, precisionist images of buildings, locomotives and industrial subjects. Michael Clark (aka Clark V. Fox), whose early work critics categorized as Color School, had begun making drawings and paintings of building facades in subtle color harmonies and then switched to witty Pop Art portraits.

Manon Cleary (1942–2011), who moved to Washington in 1970 and joined the art faculty of D.C. Teachers College (now the University of the District of Columbia), also went through a Pop Art phase, like Clark, reflecting the era's psychedelic, flower-child culture. By mid-decade, Cleary, a masterful draftsman, was creating exquisitely-rendered portraits of friends and elegant, yet erotic nudes. Her paintings, that included a series based on the ancient Villa of the Mysteries frescoes at Pompeii, lush flower studies and large canvases depicting giant laboratory rats as well as careful renderings of vintage photographs, verged on magic realism.

Kevin MacDonald (1947-–2006), a native Washingtonian, mostly showed small works on paper in color pencil in the 70s, but then went on to use oil, pastel, acrylic and gouache on large-scale as well as tiny formats. In his late works, he mixed coffee, tea, motor oil and other unusual materials with his paint. Depicting ostensibly prosaic imagery–tract houses, back yards, furniture in simple interiors (but rarely figures), MacDonald created poetically-charged images with, at times, sinister overtones enhanced by a masterful evocation of light.[21]

Rebecca Davenport, who was included in the 1972 Corcoran show *New American Realists* and represented by Pyramid, painted from photographs and life. Her self-portraits and figures in interiors seem, at first glance, more straightforward than MacDonald's evocative scenes and Cleary's fantasies, but on further observation prove to be quirky in their details of texture, poses and context. She punningly titled a memorable series of friends sitting on sofas *Davenports*.

In contrast to the subtleties of MacDonald's and Davenport's work, Joe Shannon's paintings, shown at Henri Gallery, were "in-your face" aggressive. Shannon usually included self-portraits in his tableaux of nude women, men in business suits, dogs, gorillas and various objects, the compositions echoing masters like Degas and Ingres. Hopps gave Shannon a one-person show at the Corcoran in 1969 and declared "no matter how many painters turned to abstraction, there's always boys in the back room who refuse to go along." [22] Another "back room" boy whose work got noticed toward the end of the decade, Fred Folsom, painted the "strip" joints and bars along a seedy, but lively, stretch of Georgia Avenue.

23. Joe Shannon, *Pete's Beer*, 1970, acrylic on canvas, 84 x 68 inches

After a decade of teaching and working in obscurity in the Virginia suburbs, Allen "Big Al" Carter (1947-2008) had his first major D.C. show at the Rowe House Gallery on Wisconsin Avenue in 1979. Although Carter later described Gene Davis's work as an important influence, his approach, in woodcut, canvases and large murals, was considerably different, with figurative imagery derived from comics, scriptures, pop culture and African-American life rendered in a boldly expressionistic style.

Three of the universities in town had important representational artists on their faculties: Alan Feltus at American University; Bill Woodward at George Washington and the Corcoran School; and John Winslow at Catholic University. Feltus, who was born in Washington but moved away as a child, joined the A.U. painting faculty after Yale graduate school and concentrated on the human figure, blending a variety of modes, including early Arshile Gorky, surrealism, and masters of the Italian Renaissance such as Piero della Francesca.

24. Alan Feltus, *Four Women*, 1977, oil on canvas, 59 by 69 inches

Woodward used photographs as a basis for paintings of Arcadian idylls in which lively nudes (his friends and students) frolicked with hippie-like abandon. Winslow, who was the son of D.C. portrait artist Marcella Comès Winslow, painted scenic locales in the suburbs as well as D.C. cityscapes with a bright palette, loose brushwork and *plein-air* feel, often

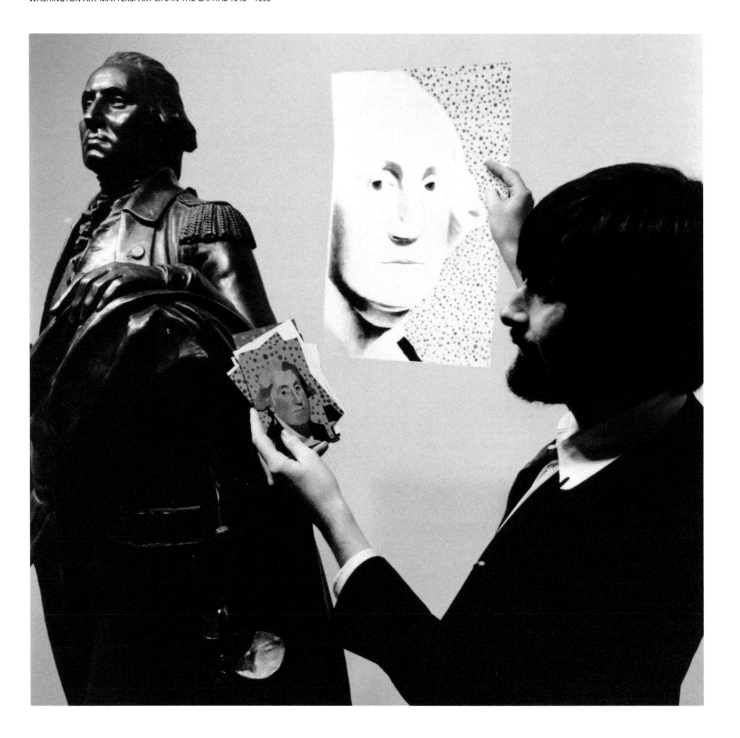

subtly inserting self-portraits. (See page 41 for Winslow's portrait of his mother).

George Washington, as well as the city named for him, was a popular (and at times ironic) subject for artists in the 70s, the decade of both war protests and the nation's 200th birthday. Lenore Miller curated a Bicentennial show for George Washington University's Dimock Gallery called *G.W.B.M.O.C. (George Washington Big Man on Campus)*. For the show, she solicited artists to contribute witty riffs on the University's Gilbert Stuart portrait and a Houdon bust. Michael Clark painted a Pop Art-style portrait of the first president, and William Dunlap painted a screaming Washington. Rockne Krebs proposed projecting an image of George Washington into the sky.

Three years earlier, Bob Stark and Lucy Clark had staged a *Happy Birthday George Group Show* at their studio above the Admiral Benbow Bar on Connecticut Avenue where artists did similar variations on the iconic Stuart portraits. Isabella LeClair cut a reproduction of Stuart's portrait into vertical strips and arranged them in Gene Davis-like stripes. Mary Beth Edelson transformed him into a woman in her version of Stuart's full-length Lansdowne portrait, calling it *President Georgia Washington, the Mother of our Country*. Kevin MacDonald drew a view of the Washington Monument seen through a dormer window that he titled *George Washington Slept Here*. Sam Gilliam sent a birthday wishes telegram.

In 1978, Maurice Tuchman of the L.A. County Museum noted in the exhibition catalog for the Corcoran *21st Area Exhibition*, "Clearly there are first-rate sculptors in this town of painters."[23] The show, for which he served as juror, was devoted entirely to sculpture. The "town of painters" also supplied half of the artists in *New Sculpture: Baltimore, Washington, Richmond*

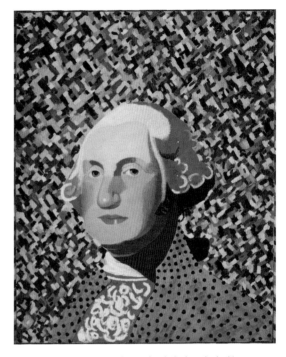

26. Clark V. Fox (a.ka. Michael Clark and Clark), *George Washington*, 1976-81, acrylic, 20 x 16 inches

25. OPPOSITE :Michael Clark (aka Clark V. Fox, aka Clark) holding his portrait of George Washington in front of Jean Antoine Houdon's statue of Washington in the George Washington University Collection.

27. Joan Danziger with a
sculpture, ca. 1971

28. Claudia De Monte, *Self Portrait
(Fashion Head Shot) with Glitter,*
1973, 5 x 6 inches

curated by Renato Danese at the Corcoran in 1970. Along with more traditional, abstract works by artists such as Jennie Lea Knight and Ronald Grown, there were more radical pieces. H. I. Gates made assemblages of found objects (dentures, seashells, taxidermy eyes, and such) in shadow boxes with punning titles and Ed Zerne placed blobs of candy-colored foam on the main staircase. Painter Cynthia Bickley Green showed lyrical panels of colored silk and wood. Robert Stackhouse's piece was a 42 foot long oak "Great Rain Snake" with a tiny smiling head. Donald Corrigan installed a floor of machined aluminum sheets flanked by nine-foot walls of sea oats harvested at the Delaware beach town of Rehoboth.

Pursuing what he called "a valid challenge to our concept of thought rather than perception," Corrigan went on the next year to show conceptual art at the Max Protetch Gallery in the form of lists of Washington artists whom he ranked in various categories, such as the best drinkers, the sexiest, and so forth. Understandably, Corrigan's pieces were met with a mixture of amusement and outrage. His most controversial was the 1972 *Ranking of the Artists of Washington* for which he listed 65 artists in order within three categories, "first rate," "second rate" and "third rate." Gene Davis was at the top of the list and Bert Schumtzhart, sculptor and Corcoran teacher at the bottom. Another work, *Rating of Men in Claudia DeMonte's Life*, delved into the personal life of a fellow artist. A

29. William Lombardo, *Self Portrait as Molly Pritcher*, 1976, terra cotta, 48 x 16 x 16 inches

native New Yorker who worked as a fashion model briefly before moving to Washington for graduate school at Catholic University and a teaching position at the University of Maryland, DeMonte made "trade art" pieces in the 70s. Most dealt with autobiography and issues of identity, as in her altered fashion head shots and her appropriation of the Del Monte brand vegetable logo in pieces using her similar last name. Renee Butler obtained DeMonte's *Self Portrait with Glitter* in exchange for a grocery list she had in her purse. In 1980, De Monte married the most important man her life, Ed McGowin. Perhaps because of the hostility his list pieces attracted, Corrigan decamped to New York and, according to rumor, dropped out of the art scene and took a job as a customs inspector.

The work of the 27 sculptors selected for the 1978 Corcoran exhibition also ran the gamut: minimalism (Jim Sanborn, Nade Haley and V.V. Rankine); figurative (Genna Watson, Mark Oxman and Elizabeth Falk); Pop (Nil Felts); fantasy (Dickson Carroll and Chris Gardner); assemblage (John McCarty) and kinetic (Sara Yerkes).

Critics talked about a "sculpture boom" in the city which they attributed to not only shows at the museums but also to dedicated dealers like Diane Brown, greater exposure through the Hirshhorn's permanent collection, more public and private commissions and the emergence of young talent. Joan Danziger, who moved from New York to Washington in 1970 and remains one of the city's most visible artists,

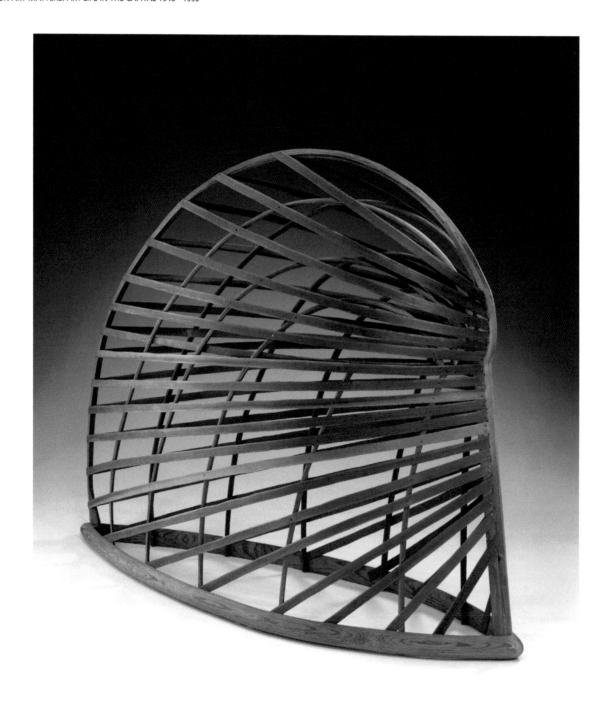

made a splash with whimsical anthropomorphic animals and other fantastical creatures in shows at the Corcoran, Henri Gallery, and National Collection of Fine Arts .

The 70s sculptor who achieved the most national and international fame was Martin Puryear, Washington native and alumnus of Howard University and Catholic University's graduate program. In an early show at Henri Gallery, he exhibited rough-hewn pieces of oak and fir with chains, ropes and found objects, but his 1977 solo show at the Corcoran featured more refined forms and elegantly wrought materials.

His work continued to mature, reflecting sensitivity to materials and craft derived from an apprenticeship in Scandinavia, an interest in tribal shelters and artifacts developed during a Peace Corps stint in Africa and an affinity for the pure forms of minimalist art. Puryear eventually left Washington for points west and north and had major shows at MOMA and the National Gallery.

The Corcoran's ceramics program that began in the 60s under Teruo Hara emphasized traditional techniques and forms, but young faculty artists—Bill Lombardo (whose work was in the 1970 Corcoran sculpture show), Robert Epstein and Bill Suworoff—expanded the curriculum into sculptural ceramics. Lombardo often depicted his own "cherubic, mustachioed face," as one reviewer described it, on the bodies of famous figures like Abraham Lincoln and King Kong.[24] Epstein, who once demonstrated throwing pots on a wheel by using his feet instead of his hands, also made slip-cast fish, among other sculptural work, and took black and white and color panoramic photographs. A piece he did for a 1973 group show at the Washington Gallery of Art was a sculpture in the form of crutches with suction cups and roller skates on their tips. Suworoff famously exhibited six-foot tall brightly

31. John Gossage at his Glen Echo studio, ca. 1973.

32. Photography dealers Kathleen Ewing, Gerd Sander and Harry Lunn, ca. 1979, in Sander's gallery on Connecticut Avenue north of the Calvert Street Bridge

OPPOSITE: 30. Martin Puryear, *Arbor*, 1980, sitka spruce and pine, approximately 5 x 7 x 10 feet

**BRIDGE GULMON TRIPP HODICK SCHWEBLER
APPEL MOELLER GLADING CLEARY ASCIAN**

Pyramid Gallery Ltd. 2121 "P" Street N.W.
Washington, D.C. 20009

OPENING JANUARY 9, 6-9 P.M. through JANUARY 31, 1973
Yuri Schwebler courtesy of Max Protech · Gay Glading courtesy of Henri · Angelo Hodick courtesy of Jefferson Place

33. Poster for 1973 Beverly Court
artists show at Pyramid Gallery

colored ceramic birds, including a duck with guitar and a duck candelabrum which his dealer, Barbara Fendrick, displayed in the windows of her P Street gallery. (Fendrick handled a lot of ceramic artists, including Californian Robert Arneson). The George Washington University ceramics program flourished (as it does today) under the direction of Corcoran alum Turker Ozdogan who eschewed Pop and ironic forms for more abstract sculptural imagery in his ceramics.

Photography was big in the 70s thanks in part to Harry Lunn's decision to sell photographs (albeit by blue-chip masters such as Ansel Adams) along with etchings and lithographs at his Georgetown gallery in 1970. Also concentrating on the top of the market was the Sander Gallery, founded in the mid-70s by Gerd Sander, grandson of the acclaimed German photographer August Sander, whose works he also showed. Local photographers were featured at Sam Tanashiro's Rosslyn, Virginia Gallery, Intuitive Eye.

The Corcoran School had a flourishing photography program under Mark Power, and the museum mounted regular shows by national stars like William Wegman as well as their own faculty and other local photographers, including Joyce Tenneson, Paul Kennedy and Joe Cameron. Staten Island native, John Gossage, a recipient of a Washington Gallery of Modern Art workshop fellowship in the '60s where he and Anne Truitt forged a life-long friendship, taught at the University of Maryland and produced images of the urban landscape.

Kathleen Ewing introduced the work of many local artists, among them Stephen Shore, Steve Szabo, Claudia Smigrod, Mark Power, Frank Di Perna, Allen Appel, David Allison and Allan Janus. Ewing's gallery, with jazz music playing on the stereo and her dogs dashing about, became a popular hangout for dealers, curators, artists, collectors, students, old timers and

newcomers. In an interview when she closed her gallery after a successful 30-year run, Ewing recalled, "It was a very exciting time in the 70's. The National Endowment for the Arts was giving small grants to regional museums to establish photography collections. Many [collectors] were buying contemporary photography because it was cheaper." [25]

Since Washington lacked an identifiable art district and commercial loft spaces, artists set up studios in basements of row houses, as well as garages, converted bedrooms and attics. Beverly Court, the artist enclave of the Hirshhorn crashers, was once a grand apartment building that had been all but abandoned after the riots in the 1960s. Nevertheless, the "creative types" moved in—painters, sculptors, film producers, dressmakers and framers, undeterred by bad plumbing, a broken elevator and peeling paint, tolerant of the few eccentric original residents who stayed on and attracted by cheap rents.

Pyramid Galleries staged a *Beverly Court Show* in 1973 featuring residents Karen Gulmon, Allan Bridge, Yuri Schwebler, Gay Glading, Jonathan Meader (the Hirshhorn ticket forger), Allen Appel, Kristen Moeller, Angelo Hodick and Manon Cleary. They were a mixed group. Gulmon and Bridge were color painters while Schwebler used map coordinates, levels, plumb bobs, cables and other measuring devices to define and interpret spaces around the city. Glading, who worked in calligraphic abstraction, later received several important commissions, such as a planet Venus mural (1977) at the Air and Space Museum and banners for the newly-built White Flint Mall in Bethesda. Meader, heavily into astrology and calling himself "Ascian," made silk screens and etchings of unicorns and shooting stars; and Appel took photographs, printed them on canvas and then hand colored them.

In a *Washington Post* review of the Pyramid show, Paul Richard, who lived at Beverly Court for a time, explained, "Because these artists have learned to see their own art through one another's eyes, this show has an even accessibility that the viewer too can share." [26] According to Cleary, people did not lock doors, and critics and collectors often dropped by to see new works in progress. The residents eventually purchased the building in 1979. Others who lived at Beverly Court over the years included conceptualist landscape painter Virginia Daley, sculptor and painter Janos Enyedi (1947–2011) and sculptor Jennie Lea Knight, who divided her time between Beverly Court and her Upperville, Virginia, farm.

**1206 G Street NW•Thursday, November 2•7-10 P.M**

Museum Of Temporary Art

**MEN AND WOMEN**

Anne Wood

**SERENADE TO A MARRIAGE**

a film by Alison Abelson

34. Invitation for Anne Wood's Museum of Temporary Art exhibition, *Men and Women*, ca. 1977; Abelson's film was about Sidney Lawrence's marital breakup.

35. Walter Hopps selecting work at the Museum of Temporary Art's *36 Hours Show*.

In 1974, a group of artists persuaded the D.C. Redevelopment Land Agency to let them take over two storefront buildings at 12th and G Street for exhibitions. The founders, who included Janet Schmuckal, Michael Breed, Ed Diggs, Anne S. Wood and Richard Squiers, called it The Museum of Temporary Art (MOTA), explaining, "since the world would be too barren for inhabitants in less than 100 years, all art must be temporary."

Shows were chosen at informal monthly meetings and included hand-colored *Little Lulu* comics, a display of 100 mattresses from the defunct Cairo Hotel and an installation comprised of an empty doctor's waiting room.[27] MOTA also ran a small press, hosted a showing of a Cuban film about the Bay of Pigs invasion and held theme parties, including an April Fools Ball and an Evening from the Future hosted by Hodding Carter III, President Jimmy Carter's Assistant Secretary of State for Cultural Affairs.

One of the most memorable MOTA exhibitions was the Thirty-six Hour Show with Walter Hopps as guest curator. Starting at 9 p.m. on December 7, 1978, hundreds lined up hoping that Hopps would select and install their artwork. By 10 a.m. he had chosen more than 300 works, and, after a short nap, he returned to select more. (Renee Butler recalls that she persuaded Hopps to accept her piece, even though it exceeded the size restrictions, when she told him that she went to Coolidge High School with his wife Helen.) After 36 hours, the show came down. Ramon Osuna and a few other gallery owners hung around "scouting." It had, as *Washington Post* critic Richard reported, artists who were "old and young and good and bad and famous and unknowns, more the latter than the former."[28] MOTA eventually folded, but its costume galas, eccentric installations and events embodied the *ad hoc* spirit, inclusiveness and boisterousness of the 70s art scene.

*Hardart Gallery*, another artist-run venue described in *The Washington Post* as an "alternative art gallery-cum-group house" at 407 15th Street, NW, opened in 1975. In addition to art exhibitions (Carroll Sockwell, Robin Rose and Wilfred Brunner showed there), it was the site of poetry readings, performances by punk bands and kinetic multimedia events for a decade.[29]

Alice Denney, whom Benjamin Forgey describes as "Washington's indefatigable one-person art-world stimulant," founded the Washington Project for the Arts, or WPA, as a non-profit center to show, as she explained, "artists who don't have galleries and art we know won't sell." Its first quarters were an old commercial building at 1227 G Street with exhibitions on the second floor and performances on the third. [30]

The opening of the WPA in April 1975 took place over three nights and created a buzz and mixed reviews. *The Washington Post* dance critic, Alan M. Kriegsman, called it "ramshackle and informal" but also described the WPA as "a non-establishment cultural center, a Kennedy Center for the Washington underground."[31] National Gallery of Art director J. Carter Brown came for a dance performance, called the space "grand" and observed that it had "that marvelous excitement of the unrealized."[32]

Denney had scraped together funding for the center from a mix of sources—private contributors, grants, the National Endowment for the Arts, D.C. Commission on the Arts and Humanities and the Cafritz Foundation. Artists pitched in to spruce up the building and prepare it for the opening during which 16-mm films and videotapes ran continuously. Claudia DeMonte installed one of her trade art pieces and Robert Newmann created a "subtractive mural" that exposed layers of wall strata down to plaster and brick.

Denney arranged with local groups, such as the Dance Construction Company, to share expenses in exchange for the use of the facility, and she offered it to visiting dance troupes in need of rehearsal space. (Twyla Tharp and Company rented the third floor to rehearse while performing at the Kennedy Center.)

Although the exhibition space was poorly lit and had narrow rooms and pegboard walls, the WPA mounted shows that proved ambitious, entertaining and sometimes wacky. The fall 1975 season opened with Leslie Kuter's hooked rug "soft paintings," Laurie LeClair's installation of paper airplanes and Mike Shaffer's mixed-media grid compositions. Jack Rasmussen, Denney's assistant director at the time, exhibited

36. Alice Denney holding a copy of the WPA Punk Show publication.

paintings from his American University thesis show and the three live turtles that were his models.

Later that fall, the WPA staged *Drawings from the Studios of Washington Artists*, with work by 100 local artists described as "conceptualists, cartoonists, illustrators, colorists, portraitists and pranksters, many famous, some unknown."[33] The WPA also showed furniture (the work of Peter Danko and Margery Goldberg, among others) and photography. Husband and wife photographers Bernis and Peter von zur Muehlen showed together the following February. Bernis's soft-focused, hand-painted images of nudes contrasted with Peter's "destruction series" of charred junk, wrecked cars (one a life-sized print), and bold montages.[34]

*Another Washington,* which Rasmussen curated, featured Paul Feinberg's photographs of the denizens of the area around New York Avenue and 13th Street: massage parlor workers, burlesque queens, short-order cooks, panhandlers and the like, displayed with an installation by Val Lewton simulating the run-down neighborhood (not far from where a new artists' district was forming). The catalog had an unedited, X-rated text of an essay

37. Paul Feinberg,
*Musas Café*, 1975

about Washington by Joel Siegel, a Grammy-winning jazz critic and popular Georgetown University professor, a cleaned up version of which appeared in *Washingtonian Magazine* illustrated by the Feinberg photographs.

The WPA's month-long Punk Festival in 1978 was one of the more controversial (and unsuccessful) efforts. Denney decided to bring the nihilistic, neo-dada, New York art and music movement to Washington even though, as she said, "It's such a conservative town." Some WPA board members opposed its "bad taste," protestors showed up, there were bomb threats and reviews of the show were largely negative. As one writer lamented, "Washington is perhaps the only city where the concept of punk could arrive one year late and still be five years ahead of its time."[35]

Later that year Denney turned the directorship over to Al Nodal who recalled that he only set out to "polish what she made."[36] Although the annual budget was a modest $70,000, Nodal painted the space, (Rasmussen had already gotten rid of the pegboard walls) and mounted two or three shows a month with printed catalogs. He organized a survey of Washington photography of the 70s and a painting show titled *Metarealities* devoted to D.C.'s strong representational strain.

Despite the vital art scene in the 70s, many artists still felt frustrated by what they saw as the city's provincial outlook. Buyers bypassed the local market for New York, and press coverage seemed inadequate. Not surprisingly, some artists relocated to New York in the 70s, among them, McGowin, DeMonte, Newmann, Clark and Edelson. Dealers Protetch, Brown and Jack Shainman moved there, as well.

In 1978, *Washington Star* critic Benjamin Forgey interviewed eight artists who had decamped. David Tannous followed up with two articles in *Art in America*. One optimistically proposed that Washington was on the "brink of maturity as an art center," while the other had interviews with artists who decided to stay in D.C. In the *Star* piece, DeMonte said that "New York understood her work better."[37]

Although Newmann had made a splash with his sold-out show at Pyramid in 1971 and had produced several site-specific projects, he moved to a Manhattan loft in 1977 to "widen" his "horizons." He felt his later work, like *For Pierre, L'Enfant*, a sand-blasted map of Washington on the side of a building near Dupont Circle, had "baffled Washingtonians." Edelson traded a house with a yard near Rock Creek Park for "the grittier realities of SoHo" and a Mercer Street loft.

Many *émigrés* kept some ties to the city. McGowin commuted to his teaching job at the Corcoran for a year before taking a position at SUNY Stony Brook, but DeMonte returned each week for 33 years to teach at the University of Maryland. Clark divided his time between New York and Washington; in the late 80s he returned to start a gallery called The Museum of Contemporary Art in Georgetown, and reinvented his identity through various new names.[38]

Martin Puryear, who moved back to Washington from Brooklyn in 1977, admitted that New York had a "sharpness" and "intensity" he needed, but that Washington provided him "space." But, he did not stay long. He eventually left for Chicago and then to upstate New York. Kevin MacDonald, of Silver Spring, Maryland, said that he received a lot of "creative energy from the city itself," while Alabama native William Christenberry felt that Washington was a better place to raise a family.[39]

As the 70s came to a close, the center of the city's galleries started to shift. While some remained in the P Street/Dupont Circle area (de Andino Fine Arts and Addison/Ripley opened there in the early 80s), new ones were starting up farther downtown. In early 1975, Ed Cutler and Barbara Price (with help from Duncan Tebow) tried to make a go of a gallery near the National Gallery at 641 Indiana Avenue. Gallery 641, as it was called, had well-received shows like *The Alabama Bag*, which featured Washington and Baltimore artists with Alabama ties, including McGowin and Christenberry. But the gallery barely lasted a year, hurt, as one reviewer noted, by being located in the midst of construction for the new Metro subway system.

Other galleries converged on the neighborhood a few blocks north, in an area now known as Penn Quarter (which the art world would further anoint, see Chapter 5) although then still suffering from the abandonment of businesses and customers that marked downtown after the '68 race riots. Mickelson's, a frame shop that expanded into a gallery, had been on 8th Street since the 1920s. The Smithsonian's National Portrait Gallery and National Collection of Fine Arts shared the Old Patent Office Building between F and G streets. In 1978, Studio Gallery, Washington's oldest coop, and the offices of the *Washington Review* moved to the historic LeDroit building across the plaza from the Portrait Gallery. The LeDroit, along with the Atlas Building around the corner on 9th Street and a building on 10th Street near Ford's Theatre, had provided high-ceilinged, low rent

38. Joe White (left) at his alley garage studio off 18th Street with unidentified visitors

39. Mary Swift in a garden in Spain, date unknown

studio space for artists for a number of years, among them, Judy Jashinsky, Sheila Isham, Jacob Kainen and John Clemente Sirios.[40]

In 1978, Margery Goldberg, a 27-year-old wood carver and furniture maker, moved into a carriage house near the 1400 block of Rhode Island Avenue with plans to rent the top floors to fellow artists. Within a year, she expanded next door and with business partner Michael Kline opened Zenith Gallery. The art complex, which became known as Zenith Square, spread to adjacent buildings, including the site of a former Bible college and a law center.

Liz Lerman's dance troupe in its pre-Dance Exchange Days and Joy Zinoman's Actor's Studio (predecessor of her Studio Theater) performed in Goldberg's studio space. At 50,000-square feet, it housed as many as 50 artists and fostered, as painter Ellen Sinel recalls, a pretty wild lifestyle as well as a supportive arts community.[41]

Zenith Gallery mounted a mix of shows ranging from wearable art to wood sculpture, landscape paintings to mixed-media work. Zenith Square shut down over a zoning dispute in the 80s, but the gallery continued to operate on 7th Street until 2008 when Goldberg began curating shows and representing artists at various commercial locations around Washington and in the Maryland suburbs.

Artist and entrepreneur Eric Rudd bought a warehouse at North Capitol and O streets with ambitious plans for artists' studios, living spaces and galleries.[42] Real estate investor Bobby Lennon and Pyramid's Ramon Osuna acquired an adjacent property and joined him in planning the development of what they called the Hanover Arts Project. *Washington Post* critic Paul Richard touted it as having the potential to become "the District's SoHo." Yuri Schwebler, Ed May, David Moy, Nan Montgomery, Carol Goldberg and Renee Butler were among the first artists to move in along with sculpture dealer Brown, delighted by space three times larger than her P Street Gallery.[43] But, the transitional neighborhood was a bit worrisome. Butler recalls seeing a rooftop chase with blazing guns from her studio. The project never really took off, and by the 80s, most artists had moved, galleries relocated or closed and the site descended back into a desolate, drug-plagued neighborhood.[44]

One Saturday night in October 1979, friends of Mary Swift surprised her with a birthday party in Eric Rudd's building on O Street organized by Mary Ann Melchert, wife of the National Endowment for the Arts visual arts head Jim Melchert. As Diane Brown said in the

*Washington Post*, "Name a Washington artist and they were here." [sic.] Everyone knew and appreciated the good-natured, if sometimes feisty, Swift for her keen photographic eye, rapport with creative people of all disciplines (as an interviewer and in person), great parties in her modern Georgetown house and quiet passion for the *Washington Review*, a life force for the city's creative underground. Many did not know that despite her laid back apparel (even at formal events), she was heir to several fortunes (National Cash Register, the *Times-Herald* paper) and was an accomplished equestrienne with a Middleburg estate. At her party, Swift received gifts, was entertained by a belly dancer and a dance band and partied with her friends into the wee hours. One guest praised Swift, saying, "If Mary hasn't done something special for you, it's only because you haven't asked." [45]

The celebration also marked the close of an exciting decade for Washington art. It had been a time when artists joined together to take a stand on national issues. Artist communities flourished. New galleries and museums had opened and prospered. Media attention had increased. The market for local art was strong. Hopes for Washington's cultural future were high.

**NOTES**

1 *Art In America*, July/August 1978, p. 96.

2 Supposedly they argued over who should be in a photograph, although Gene Davis said Baro insulted Melzac's wife.

3 Meryle Secrest and Jeannette Smyth, "Corcoran Fisticuffs," *The Washington Post,* November 4, 1972, C3. Roy Slade has written an informative account of the clash and his subsequent appointment at director on his website: *http://www.royslade.com.*

4 For the centennial, The Corcoran published *The Corcoran & Washington Art* (Washington, D.C.: Corcoran Gallery of Art, 1976). In the introduction, Slade explains that the book is "a summary of the gallery's involvement with Washington art, particularly during the seventies," but also suggests that the Corcoran wanted to "stop emphasizing the separateness of Washington art and integrate it in the mainstream of American art, where it belongs."

5 In answer to a question posed by Richard J. Powell in *Martin Puryear* (New York: Museum of Modern Art, 2007), 105.

6 Smithsonian American Art Museum Archives of American Art Oral History Interview with Sam Gilliam conducted by Benjamin Forgey, November 4 - 11, 1989, p. 13.

7 Another successful black artist, Carroll Sockwell [1943 – 1992], who received support and encouragement from Hopps, worked abstractly, but his expressionistic drawings and complex collages from the period hint at emotional turmoil resulting from personal demons and addictions, as well as, likely, issues of racial identity.

8 Paul Richard, "The Missing Klan Room," *The Washington Post*, Style, March 17, 1979, B1, col. 2, B7 col. 5.

9 Richard, "Biennial," *The Washington Post,*" March 1, 1971, B2.

10 *Mary Beth Edelson*, May 5 – May 31, (Washington, D.C.: Henri 2 Gallery exhibition catalog). Also listed in the catalog are concurrent shows at the Corcoran (*Environment/Psychodrama Live Performance*, April 19 and June 1 and an outdoor piece at Fletcher's Boathouse.

11 Richard, "Artist-Run Collectives Gathering Momentum," *The Washington Post*, June 16, 1975, B2.

12 Richard, "An Artsy Protest," *The Washington Post*, February 20, 1974, B5.

13 Richard, "After All the Fuss, The Shows Goes On," *The Washington Post*, May 29, 1947, D1.

14 In 1976, I curated *A Sampler of American Painting,* a show at the Annandale Campus of Northern Virginia Community College of works lent by The Phillips Collection, The National Collection of Fine Arts (now SAAM) and The Virginia Museum of Fine Arts to celebrate the Bicentennial. It was installed in the unsecured campus library. Times were different!

15 Ben Forgey, "Art Tremors in Washington: Epicenter on P Street," *Washington Magazine, The Sunday Star and Washington Daily News*, September 24, 1974.

16 After Pyramid closed , Ramon Osuna continued to show Washington art at various locations (now as Osuna Art & Antiques, Kensington, Maryland).

17 Jo Ann Lewis, "P Street 'Strip': Artist's Mecca, *The Washington Post*, September 18, 1976, B1.

18 Richard, "A Young Color Painter Makes History," *The Washington Post* , May 3, 1970, 134.

19 Montgomery has stated that she does not consider the Color School to have been an influence on her work.

20 *Name Change*. Some of the works were included in *Catalyst: 35 Years of the Washington Project for the Arts* curated by J.W. Mahoney at American University's Katzen Arts Center in the fall of 2010.

21 Kevin MacDonald was a long-term contributor to WAM's activities, including serving with the author on the history committee organizing panel discussions and artist interviews. He is greatly missed.

22 Richard, "The Back Room Boys," *The Washington Post,* December 7, 1969, H1, H2.

23 Maurice Tuchman, *Corcoran Gallery of Art 21st Area Exhibition Catalog:* Sculpture, 1978, 5.

24 Lewis, "Galleries", *The Washington Post*, September 15, 1979, B5.

25 Jessica Dawson, "Time to Shutter," *The Washington Post*, May 1, 2009, C1.Ewing Post article

26 Richard, "A Sense of Peace and Sharing," *The Washington Post*, January 17, 1973, E9. Find an excellent article on Manon Cleary and the Beverly Court experience in John Metcalfe, "Queen of Beverly Court," *Washington City Paper*, July 2, 2004, 18 – 25.

27 Emily Isberg, "D.C. Dirt: Now It's A Work of Art," *The Washington Post*, February 9, 1973, D.C. 2.

28 Richard, "Time Out for Temporary Art, 36 Hours to Fill the Walls with Anybody's Art," *The Washington Post*, December 9, 1973, D4.

29 Blair Gately, "But Was It Art?", *The Washington Post Magazine*, May 19, 1985, 14.

30 Richard, "Artist-Run Collectives Gaining Momentum, " *The Washington Post*, June 16, 1975, B2.

31 Alan M. Kriegsman, "WPA: A (Counter) Cultural Center," *The Washington Post*, April 16, 1975, B1.

32 Kriegsman, B2.

33 Richard, *The Washington Post*, October 23, 1975, B9.

34 The von zur Muehlens, dedicated collectors of Washington art, fill their Reston, Virginia, townhouse with works by Rebecca Davenport, Tom Dineen, Manon Cleary, Mary Frank and many others. See Stephanie Mansfield, "Collecting Couple: Art and Avocation," *The Washington Post*, November 28, 1976, 33.

35 Tom Zito and Stephanie Mansfield, "Look Out, Punk City!" *The Washington Post*, May 16, 1978, C1.

36 Richard, "The Wizard of G Street, Director Al Nodal Has Transformed the Washington Project for the Arts," *The Washington Post*, March 23, 1978, K1.

37 Bob Arnebeck, "The Art Game in Washington," *The Washington Post*, September 17, 1978, 11.

38 Michael Clark changed his name to Clark and now calls himself Clark V. Fox.

39 Tannous "Those Who Stay," *Art in America*, July/ August, 1978, 78 – 87, 135.

40 Lewis, "The Arts Downtown, The Scene's Getting Busier on F Street," *The Washington Post*, January 7, 1978, E1.

41 Carol Newmyer, "Remembering Zenith – Toasts to Margery Goldberg," *http://zenithgallery.blogspot.com/2009/03/rememberingzenith-toasts-to-margery.html.*

42 Rudd, who had solo shows at the Corcoran and Washington Gallery of Art in 1973, became known for monumental polycarbonate sculptures. He left Washington for North Adams, Massachusetts in 1990 where he transformed abandoned mills and a church into art spaces.

43 Richard, "Lofty Ambitions," *Style, The Washington Post*, August 25, 1979, B1.

44 Not long after, Ramon Osuna moved back to the area near Dupont Circle into a small space on Q Street between 17th and 19th. Manon Cleary remembers that it was so small they called it the "Amazing Shrimp Gallery." Others followed suit in the reverse migration, among them Jane Haslem. Brown eventually relocated to New York City.

45 Lewis, "Limelight," *The Washington Post*, October 21, 1979, K3. .

# Album

CHOSEN AND CAPTIONED BY SIDNEY LAWRENCE

National Gallery of Art moment, 1970s—Big Al Carter, Officer Lee Douglas and Michael Clark (in copyist mode)

Hirshhorn moment, late '70s—director Abram Lerner gets serious with staffer Jody Mussoff at an opening; a drawing by Mussoff was later acquired by the museum.

Versailles-ites at the Corcoran Ball, 1980s

Gene Davis, Andrew Hudson, Bill Christenberry, Ed McGowin and unidentified woman on the steps of the Corcoran School

The bar at d.c. space, 1983, with a Mary Swift self-portrait and co-owner Al Jinkowic

Party time, early '70s—critic-about-town Frank Getlein and Claudia DeMonte

To the Capitol steps, 1989—J.W. Mahoney (center), Washington art apostle, and critic-historian Martha McWilliams (right) march against censorship.

Pulling onto P Street—galleries just ahead—late '70s

Outside the Corcoran, 1989—collector-restaurateur Bill Wooby and artist Ruth Bolduan provide tech support at the Mapplethorpe demonstration. The speaker is unidentified.

Another marcher

Texas downtown, 1979—Robert Wade's *The Biggest Cowboy Boots in the World* at WPA Art Site

Custom awning on F Street, 1983

Eighth Street, 1987—Gene Davis's widow Flo and Jean Lawlor Cohen help stripe the street, a project inspired by Davis's *Franklin's Footpath*, 1972, in Philadelphia, overseen here by Mokha Laget. A Davis memorial show at the National Museum of American Art occasioned the Washington event.

# HANOVER
## February 6 — March 5, 1982

bessant braumbart clopton codi cushner dubois falk
ferraioli firestone furioso goldberg gouverneux gratz
haley hallman hannan isralow jackovich-case jenkins
kehoe kraft kravitz lee lees mccurdy merican miller
mitchell morrison montgomery newell richardson
rosenberg rudd savage schoebel sleichter spaulding
sporny stoddard stone thorpe vanalstine vogel

Reception February 6th 3 to 7 p.m.

## Osuna Gallery
406 7th St., N.W.     Washington, D.C. 20004     (202) 296-1963

Accidents in
North American
Mountaineering
1985

Art Attack hits the
big time (details in
Chapter 5)

IN PRINT

Jo Ann Crisp-Ellert (painter-salonista), early 1950s,
a self-portrait

Jeff Donaldson (Afri-Cobra guru), 1976, a self-portrait with family

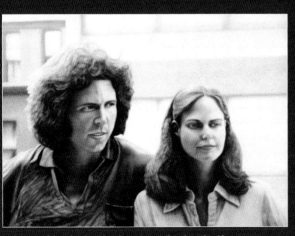

Chris Middendorf and Palmer Lane (husband-wife
gallery owners) 1977, by Joe White

Jacob Kainen, ca. 1942, a self-portrait

Gene Davis, 1961, by Jacob Kainen

*Walter Hopps* (curator-director), 1978, oil on canvas, by Michal Hunter

urateur-collector-salonista) and Howard Fox
wn), 1983, by Sidney Lawrence

Georgia O'Keeffe surveys the Mall from the Hirshhorn balcony
with Olga Hirshhorn, Ira Lowe and Sidney Lawrence, 1977

At the Corcoran School of Art, 1980 (left to right):
Bob Colacello, editor of *Interview*; Andy Warhol;
Chris Murray, D.C. link to the Factory

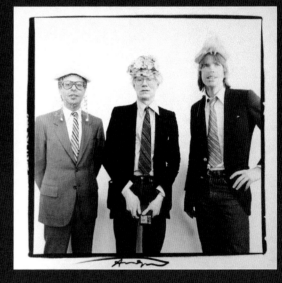

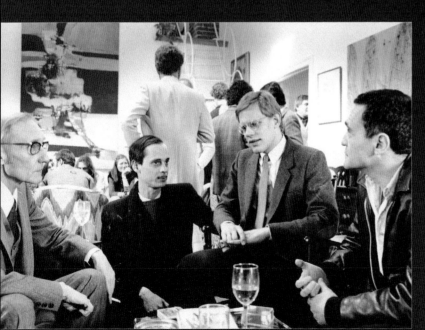

Bad-boy conceptualist Vito Acconci of New York (second from left) watches as the International Sculpture Center's David Furchgott unfurls Acconci's banner piece during the Hirshhorn's "Metaphor" show opening in 1982.

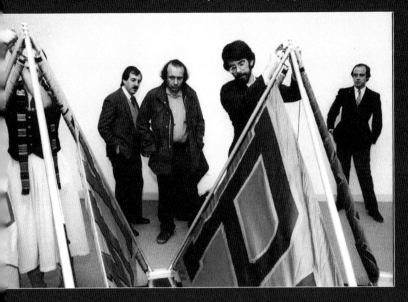

Exhibition-bound Nancy Reagan is greeted by D.C. schoolgirls and staffer Carolyn Campbell outside the Corcoran's Black Folk Art show, 1982. The First Lady had yet to meet Mr. T.

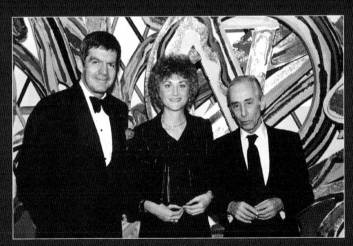

Dealer-legends Irving Blum of L.A. and Leo Castelli of New York pose with the Corcoran's Jane Livingston, a stellar trio, at the opening of "Stella Since '60" in 1982.

Director Roy Slade and President and Mrs. Jimmy Carter pause for a Hiram Powers moment on their Corcoran tour.

Beaux-Arts baking, 1979—the Corcoran's hundred-and-tenth anniversary cake, with trustee-collectors Carmen and David Lloyd Kreeger doing the honors.

Joe's 80th Birthday cake August 11, 1979

**Modernist baking, 1979—a can't-miss-it cake from the newly-turned-octogenarian's birthday bash, as depicted on Joe and Olga Hirshhorn's holiday card.**

Ed McGowin in a Michael Clark t-shirt (sipping), d.c. space, ca. 1980

The ever-Hoppsian Walter Hopps, National Collection of Fine Arts, mid-1970s

AT THE TABLE

William Christenberry's studio, mid-1970s

Martin Puryear's studio, mid-1970s

Ed McGowin's show at Henri, with P Street beyond, 1967

## CHAPTER 5

# A Decade Of Reckoning

## 1980S PART 1

BY SIDNEY LAWRENCE

T he 1980s was a decade of conflicts and resolutions, victories and losses, and the best way to tell this complex tale is not strictly chronologically, but in a more casual, meandering way, mixing anecdotes, historical facts, profiles of key players and reflections on the aesthetic issues of those times, most still unresolved. An art culture in a political city is basically an underground one, reliably graphed as a sine-wave of up-curves and down-curves. In the 1980s, it rose gradually, teetered occasionally, started to coalesce and finally, almost involuntarily, exploded.

J. W. Mahoney, Washington-based artist, critic and curator 1

2. A Corcoran pas-de-deux by "Empire" dancers Arne Zane and Bill T. Jones, a now-legendary duo brought to D.C. for the 1980 event

1. PREVIOUS: The Robert Mapplethorpe projection on the Corcoran Gallery facade in 1989

Put another way, the D.C. art community became more pro-active and self-aware during the 1980s, and power politics—the heartbeat of this city—became less and less avoidable. The Culture Wars gained momentum, and it was time to take a stand. Against this backdrop, valiant attempts were made to define a "Washington art" as salient and nationally significant as the Washington Color School. Washington may not have evolved into a world art center along the lines of London, Tokyo or New York, or today's Berlin, for instance, but commitment to art as a principle and a practice reached new levels during the decade. The Mapplethorpe debacle of 1989, discussed at the end of this essay, fired up the troops.

The 1980s dawned with a bit of schizophrenia. Reagan's inauguration was a huge relief for some (a decisive president) and a horrible threat to others (arts funding cuts). The sexual revolution further liberated men and women, but with the arrival of AIDS in 1981, that freedom held a darker reality. Money seemed to flow as never before with conspicuous spending, while shrinking government funds for social-welfare and mental-health programs forced increasing numbers of the needy into the streets.

All the while, artists produced, dealers sold, critics analyzed, teachers instructed and collectors collected. To even the most financially flush collector-investors (including law firms, developers and corporations with curator-consultants), the value of the creative eye and mind prevailed. The passion was for art.

Washington continued to watch New York. Already in 1980, Howard Halley had introduced his Corcoran students to some of that city's edgiest work via slides of Julian Schnabel's plate paintings and Sherrie Levine's retreads of past art by males. Then Robert Longo (painter of the boldly graphic, retro-Kennedy-era figures in agitated poses) came to town to present the world premiere of his two-night performance, "Empire," in the Corcoran atrium.[2] While 300 people watched, students held candles, dancers weaved through the crowd, Brian Eno's amorphous music played (plus live saxophones), smoke billowed, and semi-naked figures posed on a revolving turntable in what amounted to "a sensory tour-de-force," recalls Mahoney. "It was very stylish, but without much meaning. Postmodern New York had arrived, with a bang."

## POSTMODERN—YES OR NO?

What was this "Postmodernism"? Certain New York artists of the 1980s struggled with how to be "new" in an era when newness, in the sense of stylistic innovation — the seedbed of modernist painting and sculpture — had run its course with earthworks (sculpture as landscape intervention) and minimalism (the ultimate abstraction a la Ad Reinhardt and Carl André).

Eschewing visible handicraft and veering toward a cool, mechanical look and conceptual strategizing, Postmodernists co-opted other people's art (often classic modernism), cinema history and TV clichés (as in Longo's imagery), and the Pop Art ethos of commercialism. Their works ranged from staged photographs and near-perfect art reproductions to whizzing electronic signboards and stenciled posters, tote bags, stickers and pencils with quasi-philosophical slogans. Themes of feminism, consumer culture and pop mythology permeated these creations. Postmodernism's essence was less about art's time-honored role as a locus for quiet contemplation and personal reverie, and more about big-city buzz and the impulse to critique social, cultural and aesthetic issues of the moment. That left a whole lot of art, including Washington's celebrated painting trend of the 1960s—its Color School — in the dustbin.

In Washington, Postmodernism was met with skeptical curiosity. In his new space on 7th Street in 1982, dealer Chris Middendorf showed a compendium of photo-based examples—Richard Prince's Marlboro Man riffs, Richard Goldstein's painted copies of Margaret Bourke-White's London Blitz photos and Cindy Sherman's ever-stagier self-posings. That same year Hirshhorn curator Phyllis Rosenzweig presented Sherrie Levine's precise renderings of early 20th century abstractions by Russian avant-gardist Kasimir Malevich as part of "United Artists," a renegade series of exhibitions initiated by

3. At a Hirshhorn opening in 1991, curator Frank Gettings (right) keeps things lively with an unidentified guest (left) while exhibiting sculptor Saint-Clair Cemin, a Brazilian, chats with D.C.'s Robin Rose.

Corcoran professor Doug Lang.[3] Such ironies told Washington artists little they didn't already know. Post-Pop-Art detachment in the Warholian mold was hip and interesting, to be sure, but where was the substance, and why should D.C. pay attention?

## THE HIRSHHORN AND LOCAL ART

The Hirshhorn hired a new director in 1984 to replace genial founding director Abram "Al" Lerner (1913-1997), who had shepherded the museum through its sometimes difficult early years. James Demetrion from the Des Moines Art Center, a one-time protégé (at the Pasadena Art Museum) of curatorial maestro Walter Hopps, immediately made it clear that his primary goal as director was to prune and upgrade the 12,000-work holdings donated and bequeathed by founder Joseph H. Hirshhorn, who had died in 1981.

Demetrion also kept an eye on Washington art, aware of, but not blinded by, New York. Curators looked too, and the Hirshhorn soon bought selective pieces by installation-savvy painter-sculptor Kendall Buster, abstract imagist W.C. "Chip" Richardson and encaustic color poet (and rock musician) Robin Rose. Washington art also showed up in major Hirshhorn exhibitions. Buster and Peter Fleps, a painter of landscapes mounted as viewing pedestals, were in Rosenzweig's "Directions" shows of 1983 and 1986, respectively; sculptor John Van Alstine was one of Howard Fox's choices for the inaugural "Directions" show in 1979; and significant pieces by sculptors Alan Stone and Jim Sanborn were part of the mammoth "Content' show of 1984, which Fox co-curated with Rosenzweig and Miranda McClintic (who went independent later that year).

These three curators, plus colleagues Cynthia Jaffee McCabe (1943-86) and Ned Rifkin (relocating from the Corcoran in 1985), made it a point to know local artists, jury D.C. shows and sometimes buy (for themselves) D.C. art. However, to quote Mahoney's vivid recollection, "only Frank Gettings [1931-2011], the museum's Pickwickian, eccentric Curator of Prints and Drawings, spent much quality time talking, and drinking, with Washington artists."

Despite these Washington-friendly gestures, the fact remained that the Hirshhorn, the Smithsonian's internationally-oriented showcase for contemporary art, was minimally interested in sticking its neck out on behalf of local artists. The Phillips Collection, as always, inspired reverence among Washington painters, even as

4. Dynamic duo at WPA:
Joy Silverman and Al Nodal

5. The Ritz Project on opening
night, 1983

renovations, annex construction and masterpieces on tour during the 1980s (director Laughlin Phillips's initiatives to ensure a healthy future) provided disruptions, but nods to local talent did happen, among them a small 1989 show outdoors of recent sculpture by John McCarty. The Corcoran, which had a longer history, an art school and a city-proud board, continued to serve the local art world but, as we shall see, with mixed results.

## BETTER AT IT: WPA

More important contributions came from the Washington Project for the Arts. Under director Al Nodal in 1981, WPA launched the "Options" biennials to showcase "emerging, unrepresented, or under-recognized" D.C. area artists.[4] The first two installments, curated by Gene Davis and Mary Swift (1981) and Ed Love and Joe Shannon (1983), revealed a panoramic art practice in and around Washington—Yuriko Yamaguchi's wall-mounted organisms, Chris Gardner's arrow-dynamic sculptures, Steve Moore's color-intense palm trees and cows, Felrath Hines's airy abstractions, Andrew Krieger's quirky shadowboxes in pencil and Stephen C. Foster's darkly psychological collages, to name a few. Like all people who cluster in cities, artists bring divergent sensibilities and ways of self-expression. Pluralism, long apparent in Washington art, continued through the decade.

In spring 1983, under WPA's watch, scores of D.C. artists (Tom Ashcroft, Ed Bisese, Gene Davis, Georgia Deal, Michael Welzenbach, Michael Platt, Gayil Nalls, Zinnia, et. al.) joined up with at least as many New Yorkers (John Ahearn, Mimi Gross, Kostabi, Tom Otterness, Walter Robinson, Kiki Smith, et al.) to commandeer, East-Village-style, the rooms and hallways of the derelict Ritz Hotel at 920 F Street. The huge, 300-artist, month-long exhibition known as the "Ritz Project," organized jointly with Collaborative Projects Inc. (COLAB) of New York, featured just about everything—visual art, sound, music, film and video, fashion and performance—plus plenty of political activism in the form of jabs at Reagan, sympathetic depictions of social and political outcasts and indictments of the era's materialism.

The New Yorkers did most of the activist work, as it happens—mostly in-your-face, messy concoctions not all that unlike, stylistically, the hot-selling Neo-Expressionist canvases in SoHo galleries—and what better launching pad for them than our own

Washington, D.C., the seat city of the most conservative presidential administration in decades? The Ritz Project became, in the words of one D.C. participant, "a political dump for New York artists," [5] whereas locals, perhaps naively, saw it as an opportunity to make considered artistic statements in this curious wreck of a building. One such work, a collaboration of Ashcroft, Bisese and Deal, was a black-painted environment, a doghouse at its center, with white outlines invoking a woodsy canine dream[6] —an apt contribution from three artists among a multitude who worked in the physically peaceful, tree-lined region. But for the District's fire-hazard officials, the Ritz Project was anything but serene. Citing extreme danger, they shut down the art-dense, rickety building on April 20, five days before the exhibition's announced closing date.

The guerilla group Art Attack was a good fit for the Ritz project. Founded in 1979 in Los Angeles and new to the Washington scene, it specialized in swiftly made, temporary, collaborative site installations by a band of rotating artists. In 1984, thanks again to WPA, the group honed in on the façade on yet another dilapidated downtown building, an Italian Renaissance gem (today fully restored) above the abandoned Julius Lansburgh furniture store. For the summer-long installation, "Zones 1...5." artists Lynn McCary, Billy Burns, Mark Clark and Jared Louche (nee Hendrickson) applied gilding to ornamental relief heads and painted a mural of faces at street level. But the biggest bang for pedestrians came from the artists' *trompe l'oeil* creation of 25 funky, lifesize figures (plywood cut-outs in thrift-shop clothing) precariously climbing the three-story building as if scaling a sheer cliff, a tableau more unsettling and theatrical even than John Ahearn's on-site tenement-dweller portraits in New York. Much to the bemusement of its creators, the Art Attack piece, in

6. John McCarty (b. 1940), "Berlin III," 1989. Steel, lead and limestone, 48 ½ x 49 x 23 inches. Collection Dani and Mirella Levinas, Washington, D.C. Based in the Virginia Piedmont, where he also was born, McCarty made this work, the centerpiece of a Phillips' Solo show that year, after an extended period in West Berlin, when the Wall was still intact and armored buildings were common. McCarty's statement about the work invites these associations and, with a fanciful flourish, "dwarfs, a figure in a sack, the bride bursting from the dark tower."

1985, illustrated the cover of a trade publication about the perils of mountain climbing.[7]
(see Album)

## MORE GALLERIES. MORE EXPOSURE

Local galleries had always boosted Washington artists, but the difference in the flush 1980s was in sheer numbers. Chris Addison and Sylvia Ripley, Barbara Kornblatt, Ansley Wallace and Eric Wentworth, Manfred Baumgartner, Tom and Judy Brody, Robert Brown, Rebecca Cooper, Hollis Taggart, Marsha Mateyka, Michael Olshonsky, Barbara Battin Fiedler, Wretha Hanson (Franz Bader Gallery's new owner), Jack Rasmussen, Jo Tartt , and Kate Jones and Sally Troyer (soon to be joined by gallery partner Sandy Fitzpatrick)[8] all opened galleries or got their footing in the 1980s. Three others—Diane Brown, Jack Shainman and Barbara Fendrick—opened branches in New York's SoHo district during the decade, introducing the work of several D.C. artists to that market.[9] Shainman and Brown eventually left Washington for good.

7. Art Attack, *Zones 1 ... 5*, 1985, three-month installation curated by Holly Block for the Washington Project for the Arts, northwest corner of 9th and G Streets N.W.

Seasons
Greetings
from Osuna Gallery

406 7th Street, NW
Washington DC 20004
(202) 296-1963

Ramon Osuna, President
Jean Pierre de Andino, Director
Suzanne Jover, Administrator

8. Osuna Gallery's new digs at 406 Seventh Street, proudly if fuzzily trumpeted in this *Washington Review* ad. Ramon Osuna (President), Suzanne Jover (Administrator) and Jean Pierre de Andino (Director) pose amid Latin American colonial art in the David Schwarz-designed space.

Meanwhile, a mini-migration from P to R Street brought new energy to the Phillips Collection/Dupont Circle gallery district. But that shift was in effect eclipsed by the emergence of the 7th Street corridor downtown (today's "Penn Quarter")—WPA's neighborhood — north of the Hirshhorn and National Gallery on the Mall and south of the American Art/Portrait Gallery building. There, beginning in 1980, with hyper-hip amenities nearby (the Lansburgh/Atlas studio-office complex, the 930 F Street club, and the new "dc space" music venue/coffeehouse-bar/photo gallery,[10] the 930 Club), the three-story 406-7th Street Gallery Building held season after season of exhibitions blending local and national artists.

To open 1985-86, for instance, McIntosh-Drysdale Gallery (as in Nancy, one of Martin Puryear's early champions, just returning from doing business in Houston) mounted a show by manic Los Angeles installation artist Jonathan Borofsky (soon to open a Corcoran retrospective); Jane Haslem presented agitated figure paintings by D.C. veteran

9. W. C. Richardson (b. 1953), *Red Shift*, 1985, oil, acrylic and charcoal, 78 x 122 inches. Collection of the artist. Noumenalism, spiritual abstraction or Color-School-baroque—no matter how you classify it—Richardson's works have been a mainstay of Washington painting since the California-born, heartland-raised artist first arrived in the area to teach in 1978. Here, chevrons are boomerangs, linear systems go haywire, and color is illogical—an obsessive fusion of aboriginal and Moebius-strip fantasy.

Joe Shannon, and Barbara Kornblatt rounded up serene color abstractions by the distinguished Dutch-born painter and Phillips curator Willem de Looper, and so on.[11] Earlier in the decade, in 1981, 406 had been the site of Harry Lunn's memorable Robert Mapplethorpe show of elegant still-lifes, portraits and (whoa!) sexually repellent acts. In that same space a few years later, David Adamson's presses churned out prints using the latest technology ("Iris," for one) while impressive shows featured multiples by well-known local and national artists. Also memorable were Ramon Osuna's and J.P. de Andino's compellingly incongruous, market-savvy shows of Latin American Baroque paintings and sculpture.

The 7th Street gallery scene not only galvanized Washington's collecting, curatorial and art-involved public, but also ramped up opportunities for local artists to show and sell their own work as well as see what others were up to, here and elsewhere. Still, for many artists, inclusion in an exhibition at the Corcoran was the ultimate prize.

## THE CORCORAN—A THORN AND AN ALLY

Even though the continuation of Washington-oriented exhibitions at the Corcoran was pretty much a given, a loose-knit group of artists, some nationally renowned like Sam Gilliam, wanted to be sure that happened. In 1981, they formed the Washington Artists' Coalition and got to work lobbying. First came curator Jane Livingston's "Ten plus Ten plus Ten," a fascinating, somewhat screwy exhibition of 1982 conceived a bit like a snow-ball dance. Ten artists chosen by Livingston picked ten more artists who picked ten more, resulting in 88 works by 30 artists.

Although personal politics played a part, this democratic, adventurous show was good for Washington to see, but something far more ambitious, encyclopedic and ultimately controversial was on the horizon. The large-scale, artist-curated exhibition of 1985, was titled, triumphantly for some but anti-climactically for others, "The Washington Show." Pegged as the biggest museum sampling of contemporary Washington-area art to date, the exhibition brought together some 125 works by 84 painters, sculptors, photographers and mixed-media artists chosen from almost a thousand who applied. A stylistically diverse, six-artist curatorial team made the selections.

The artist-curators came half from the Coalition—Rockne Krebs (laser art), Martha Jackson-Jarvis (earthen installations) and Simon Gouverneur (icono-abstract painting), and half by invitation of the Corcoran's Board of Trustees—Kevin MacDonald (realist-luminous painting, Rebecca Crumlish (film) and Polly Kraft (landscape and still-life). The division may have reined in the Coalition a bit and given the Corcoran an edge, but no matter — uniting six respected artists who knew, or at least knew of, one another was a sound political move for both sides.

Exhibiting artists were delighted by "The Washington Show," which married under-exposed with well-known figures on the scene. The selections were broad, encompassing, to cite only a few, John Gossage's fleeting night view of the Berlin Wall,

Ed Love's expressionist, welded steel figure in memory of Reggae star Bob Marley, and, as a kind of anchor, new works by old-school painters Tom Downing, Leon Berkowitz and Jacob Kainen. The show's opening date (April 11) was proclaimed "Washington Artists Day" by the (as yet untainted) Mayor Marion Barry, and spirits seemed to be soaring. However, there was grumbling. Two hundred non-participating artists staged a *salon des refusés* (called the "All Washington Show") in another part of town. As if that wasn't enough, the Corcoran also had to brace for some bad press.

Thomas Lawson, having visited from New York, called the exhibition a "horror show" in *The New Art Examiner* and lambasted its uneven quality and lack of focus.[12] D.C.'s Lee Fleming, writing for *Art News,* declared the selections monotonous and predictable.[13] Even Washington-friendly art critic Paul Richard of *The Washington Post* had problems. While acknowledging the show's celebratory tone and plethora of "imposing work," he bemoaned that "any show so varied is bound to leave a blur." [14]

Even if the critics' response to "The Washington Show" wasn't stellar, its catalog was—and still is—a virtual Rosetta Stone articulating the nature and dilemmas of art life in Washington. Essays by artists, curators, critics and poets (one with an artist's collaboration) explored Color School and African-pattern influences; how and where local artists interacted; the impact of museums, galleries, streetscapes and neighborhoods, and whether art does, or does not, fit in a city obsessed with politics, laws and world issues. It was a remarkable written record, but one basic question remained: Was Washington's art at all distinctive on a national scale? Or, was art in the Capital, as with so many American metropolises in the 1980s (even mega-New York), nothing more than a self-referential hodge-podge of market-driven mediocrity with only isolated instances of fresh, resonant work? The fact that two major Color School figures (Gene Davis and Tom Downing) died in 1985, the year of "The Washington Show," made for a certain cosmic irony. Where to next?

## A HOME-GROWN ISM

After the Corcoran exhibition, a number of independent curators (mostly also artists) emerged on the scene and set out to identify a "Washington art" by means of thematic exhibitions, primarily in commercial galleries. Among these were John Figura's "Significant Movement" (in two parts) at Anton, Keith Morrison's "Myth and Ritual" at

10. OPPOSITE: Sherman Fleming/ Rod Force (b. 1953), *Fault: Axis for Life*, 1986, 20-minute reprise performance of an earlier WPA premiere at an aquatic-themed fundraiser at Yale Laundry, New York Avenue, N.W. Washington's ubiquitous performance artist spun upside-down Whirling-Dervish-style — from gradual to frantic to still, and back again— lulling, entertaining and startling partygoers with African dance actions, childhood games and vanguard theater. Such "States of Suspense" performances were gentle but emphatic reminders of the insidious, invisible forces of racism and sexism.

11. Gayil Nalls (b. 1953). *Smiling Backwards/One Who Saw/Depth*, 1985, oil on canvas, 78 x 70 inches, Dave Burnett collection, Canada. Grouped with "Iconoclassicists" in one show and "Eccentrics" in another, Nalls' work of the 1980s was "about how life, as humans have known it, was under siege" (email to author). Mentored by Gene Davis, Elaine de Kooning and others, Nalls eventually left her native Washington for New York, where she also kept a studio and ultimately moved. This painting is awash with emotion, sexual possibility and wry comedy.

Touchstone, Jim Mahoney's "Transcendence" at Baumgartner and "Aspirations" at the Collector Art Gallery Restaurant, Mahoney's "Elegies" co-curated with Mokha Laget at Tartt, Laget's *Metaphoric Structures* at Strathmore Arts Center in Rockville, Maryland, Mel Watkin's *Dream On* at WPA and a dual show curated by its exhibitors, most of them sculptors, *Gathering Forces*, at Brody's and Gallery K.

These exhibitions covered artists as stylistically varied (serene, expressive, geometric, abstract, figurative, diagrammatic) as Simon Gouverneur, Hilary Daley-Hynes, Yvonne Pickering Carter, Robin Rose, Caroline Orner, Tom Downing, Genna Watson, Denise Ward Brown and W.C. "Chip" Richardson. What held their productions together was a kind of home-grown spiritualism—something New York art critic Dan Cameron called "a sincere effort to transcend irony and to reintroduce a spiritual dimension to painting." Cameron also wrote, in a D.C.-focused article for the *The New Art Examiner* in March 1988, that Washington was "one of the premier groundswells for art activity that addresses these concerns." [15] *Washington Post* art critic Paul Richard put it another way a year later, noting a "sense of myths retrieved, of retrospective dreaming" and "private passions, deeply felt." [16]

Clearly the idea of a movement was in the air, and, in a piece for *The New Art Examiner* published in February 1990, painter-curator Mokha Laget gave it a name: Noumenalism. Created in reaction to "the threat of a universally meaningless art" (her sly reference to Postmodernism), Noumenalism represented "a reconciliation of reason and imagination, of logic and intuition...an authentic aspiration toward a well-formed *inner* life capable of generating *outer* transformation" [Laget's italics] and "a return to metaphysical consciousness."

In attempting to bring "the simultaneous diversity and unity" of Washington art under one banner, Laget charted the emergence of three sub-trends of Noumenalism—"transcendent abstraction," "painterly mythic figuration" and "sculptural eco-mythic figuration." [17] Laget's stamp was perhaps too theoretical to take hold, and it may have overlooked such salient developments as Art Attack's guerilla installations, Sherman Fleming/Rod Force's race-tinged performances and an intensely emotive figurative art then being developed by such genre-straddling individuals as Jody Mussoff with her colored pencil drawings, assemblagist "Big Al" Carter and painter Gayil Nalls. Nevertheless, the newly-named Washington "ism" indicated the seriousness of the possibility that there might be a credible replacement for the Color School. The sense of Washington as a center for a significant, singular art—an art of painting, primarily—was again being articulated.

## SELF-WORTH

New York's cavalcade of galleries, museums and hip neighborhoods was tempting to artists, but Washington offered freedom from the tyranny of the New York art world's culture of conformism —the alignment of galleries, critics, curators and collectors with the trends of the moment, which in the 1980s alternated between cool Postmodernism and hot Neo-Expressionism. What is more, the low-lying, vaguely European Capital City, with its serene, tree-lined streets and self-contained grandeur (with echoes of Paris or Vienna), lacked New York's frantic pace, visual aggression, physical claustrophobia and intense competition (no tens of thousands of artists, no SoHos, Madison Avenues or 57th Streets, no mega-influential publications). Washington allowed artists to take their time, to follow their own voices. The aura of the art community was comforting, condensed, open-hearted, almost small-town; studios spread from downtown into the suburbs and, on occasion, the Virginia and Maryland countryside.

Many influential personalities—"believers"—sometimes quietly, sometimes exuberantly, made things happen in the decade. Here are some of them, with apologies for omissions:

### Collector/Patrons

Sandy and Jim Fitzpatrick, Mary and Jim Patton, Anita and Burton Reiner, Ira Lowe Esq. and Ella Tulin, Vivian and Elliot Pollock, Robert Lehrman, Anne and Ron Abramson, Elizabeth French, Norton Dodge, Heidi and Max Berry, Joshua Smith, Sherley and Bernard Koteen

### Impresarios/Energizers

David Furchgott, Marc Zuver, Conrad and Peggy Cooper Cafritz, Don Russell and Helen Brunner, Bobby Lennon, Giorgio Furioso, Franz Bader, Chris Murray, Steve Weil, Michael Clark, Jack Rasmussen, Bill Dunlap, Janet Solinger

12. Joe Shannon's Maryland studio with his portrait (center) of Jane Livingston

### Salonistas

Herb White, V.V. Rankine, Sal Fiorito, Alice Denney, Mary Swift, Olga Hirshhorn, JoAnn Crisp-Ellert and Bob Ellert, Livingston and Catherina Biddle

### Artist-gurus

Anne Truitt, Lou Stovall, William Christenberry, Lois Mailou Jones, Gene Davis, Leon Berkowitz, Jeff Donaldson, Jacob Kainen, Sam Gilliam, Bill Woodward

### Government-funding Whizzes

Lee Kimche, Renato Danese, Mary Ann Tighe, Donald Thalacker, Richard Boardman, Brian O'Doherty aka Patrick Ireland, Susan Lubowsky

### Exhibition Visionaries and Brokers

Holly Block, Jim Demetrion, Frances Fralin, Charles Parkhurst, Angela Adams, Lenore Miller, Jane Livingston, Francoise Yohalem, Joe Shannon, Philip Brookman, Mary Anne Goley, Anne-Marie Pope, Ann Vandevanter, Kimberly Camp, Anne-Imelda Radice

### Academics, Advocates, Artbookers

David Driskell, Cliff Chieffo, Duncan Tebow, Josephine Withers, Norma Broude, Mary Garrard, Marcella Brenner, Flo Davis, Skuta Helgison, Sabine Yanul

### Critics, Stringers, Reporters, TV people

Paul Richard, Jo Ann Lewis, Benjamin Forgey, Lee Fleming, Frank Getlein, Martha McWilliams, Robert Aubrey Davis, Alice Thorson, Mike Giuliano, Iris Krasnow, Michael Welzenbach, Jacqueline Trescott, John Dorsey, JoAnna Shaw-Eagle, Joe Kelly, Mary Lynn Kotz, Hank Burchard, Kara Swisher, Gary Tischler, Sarah Grusin

13. A Washington vista from Robin Rose's studio on Columbia Road

14. Frank Di Perna (b. 1947) *Stone Slab—Art France*, 1980, Ektacolor print, 11 ¾ x 17 ½ inches on 16 x 20 inch paper, collection of the artist. Di Perna's close-in, Cézannesque view of a French hillside, included in Frances Fralin's influential "Images of the 1980s" Corcoran show of 1982, uses texture, tonality and man-on-the-moon anthropomorphism (can you spot it?) to suggest teeming nature. Mentored by Gary Winograd among others, the Pittsburgh-born photographer moved to Washington in 1974 to teach fine-arts photography, which had yet to embrace color.

Could it be that Washington's focused, committed, almost folksy art community fostered a sense of serenity, self-worth and purpose for artists in the studio—a spiritual rather than a material or competitive motivation—that translated into art objects? Whether rife with outside allusions (travel, childhood, literature, politics, mythology, nature), focused on homegrown culture (street life, families, the look of architecture) or tinged with psychological torment, the creation of these objects was buoyed by the best intentions of a community striving to make its way in a political town.

Consider also what D.C. artists were exposed to here, art-wise. The breadth of photography, for instance, included 19th- and 20th-century landscapes, figures, urban scenes and abstractions. Exposure to photography excelled in Washington

thanks to the Corcoran's commitment to the medium[18] via Jane Livingston's and Frances Fralin's carefully modulated programs of exhibitions, gallery talks and collection building. Innovative photographers on the faculty and elsewhere in the Washington area were plentiful (John Gossage, Steve Szabo, Mark Power, William Christenberry, William Eggleston and Frank di Perna), as were insightful dealers (Harry Lunn, Gerd Sander, Kathleen Ewing, Jo Tartt, the Kate Jones/Sally Troyer team, Sandra Berler, all nationally known, as well as newcomer Diane Brown who showed several young photographers on the national scene).[19]

Washington's museums were another factor. The spectrum of shows accelerated in the 1980s, among them Vermeer and American Luminism at the National Gallery, "Different Drummers" and Lucian Freud at the Hirshhorn and Black Folk Art and war photography at the Corcoran.

In 1987, non-Western holdings expanded via the Arthur M. Sackler Gallery, with Asian art to supplement the Freer, and the National Museum of African Art, Warren Robbins's inventive, private Capitol Hill institution nationalized and relocated to prominence on the Mall, where its collection would influence such artists as Renee Stout.

Further revelations could be gleaned from the National Museum of Women in the Arts (which opened in 1987) and smaller institutions like the Textile Museum, Dumbarton Oaks with its ancient and pre-Colombian holdings and the Smithsonian's off-the-mall, black-oriented Anacostia Neighborhood Museum, whose new facility opened in 1987 with a show of D.C. artists Sam Gilliam, Martha Jackson-Jarvis, Keith Morrison and William T. Williams. Few self-respecting Washington artists, even those who made it their business to follow national art trends via progressive D.C. museum

15. Renee Stout (b. 1953), *Fetish #2*, 1988, mixed-media, 64 inches high, Dallas Museum of Art, Metropolitan Life Foundation Purchase Grant. Stout made this work three years after moving to Washington from her native Pittsburgh. African collections in both cities—the Carnegie Institute, where she studied, and the Mall museum originally on Capitol Hill—influenced the figure's tribal adornments, Bakongo-style stomach-box and ritualistic creation as a body cast of the artist herself. This powerful figure reflects Stout's lifelong interest in how Africa lives on in African-descended people. Domestic tableaux were next.

shows, New York's moveable feast, or coverage in the major periodicals, could ignore the deep wells of art right here at home, most of it steeped in handicraft and spiritual uplift.

## BAD BOY ON THE BLOCK

Still, in the 1980s, the proposition that Washington could be the seedbed for a nationally significant art was a daring one, and it is no surprise that *The New Art Examiner* (which published Cameron's and Laget's articles, as noted previously) put forth the idea. This bad boy" of American art periodicals, with its main offices in Washington, repeatedly challenged conventional art-world wisdom, ignoring New York-centric issues and shows and running offbeat, gutsy, left-leaning articles (often using local authors) with impeccable timing.

The monthly publication ran assaults on Hilton Kramer's neo-conservatism and the mediocrity of Reagan-era collecting, an ahead-of-the-curve look into the surge of governmental art support in post-Franco Spain and, at decade's end, several deconstructions of conservative politics and the National Endowment for the Arts vis-à-vis the Andres Serrano and Robert Mapplethorpe firestorms. Readers who rolled their eyes at the very mention of Jacques Derrida were delighted.

Behind this kaleidoscopic-critical approach were the publication's feisty publisher Derek Guthrie and art-literate editor Jane Addams Allen (Guthrie's life partner named for the 19th-century social-reformer, an ancestral aunt). The couple, who had started the publication in Chicago in 1974, moved to D.C. in 1980 to expand its focus and "drill down into the essence of Washington art culture," in the words of frequent contributor J.W. Mahoney. The buzz of arts funding, aura of officialdom, breadth of museums and small but active art underground were irresistible to these two.

In the course of the decade, Guthrie and Allen (1935-2004) expanded the publication from tabloid to magazine format and opened offices in Philadelphia, Boston, Los Angeles, London and, yes, New York. Seldom missing a D.C. art event, the two journalists were watchful, politically astute, argument-hungry (in the British Guthrie's case) and amazingly perceptive and articulate (in Allen's; she also wrote art criticism, ironically, for the politically conservative *Washington Times*.) The couple's presence

16. LEFT: Jane Addams Allen in 1988
17. RIGHT: Derek Guthrie in 1984

and the prestige and roller-coaster notoriety of their publication gave Washington art life a major jolt.[20] And so, increasingly, did the Washington Project for the Arts.

## WPA STORMS THE BASTILLE

By mid-decade, WPA was booming with its street front "Bookworks" store of international artists' publications (launched in 1981) and partnerships with District Curators to bring Philip Glass, Laurie Anderson and others to town. The art space's location gave art-world regulars accessibility to the 406 galleries and an ambiance much more urban, if such was your taste, than Dupont Circle. Wig shops, soul music stores, dilapidated storefronts and down-at-the-heels street life were a bit rare near the Phillips Collection. .

18. A classic cover of
*New Art Examiner*

After Al Nodal left WPA in 1983, Jock Reynolds, a photo-artist from California, arrived as director with his artist-wife (and frequent collaborator) Suzanne Hellmuth. First, Reynolds hired John Ireland and Robert Wilhite, San Francisco conceptualists, to re-carve sections of the WPA structure into "artists' apartments"—a calming and thoughtful installation very different from the visual and thematic aggression of WPA's past projects. Nodal was a fireball, but the mild-mannered Reynolds was radical and politically astute in his own way, overseeing some of the most groundbreaking Washington shows

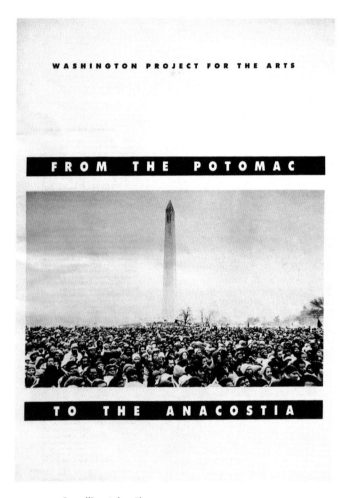

19. Powell's catalog. The illustration titled *We're with it, Washington* by Sharon Farmer

of the decade. "War and Memory," a photo and installation show of 1987, rekindled long-buried memories of tragedy and graphic violence of the Vietnam War which had ended a dozen years before and had been largely experienced through TV.

Reynolds then opened WPA's exhibition schedule to shows themed to what we'd now call "diversity." The revelatory "Art in Washington and its Afro-American presence, 1940-1970," a 1985 project of painter-writer-curator Keith Morrison. This extensive exhibition probed the interconnections among Color School tenets, African art, Barnett-Aden Gallery's multiracial stable of artists and the work of black painters like Alma Thomas and David Driskell (like Morrison, a multi-talented individual who taught African-American art history at the University of Maryland, where a scholarship and research center is named in his honor).

In 1989, newly appointed WPA curator-scholar Rick Powell presented "From the Potomac to the Anacostia: Art and Ideology in the Washington Area", a racially-mixed exhibition for a racially-divided city, marrying such works as Cheryl Casteen and Charles Flickinger's "Bird Woman" with African-American hair-braid designs by Fana. Powell's nationally focused "Blues Esthetic: Black Culture and Modernism," later in 1989, presented a whole new take on "black" American painting, which in the case of David Hammons's mural-size portrait of Jesse Jackson as a blue-eyed white man[21] could be pretty hard-hitting. Few other art spaces in town, with the possible exception of Mark Zuver's Fondo Del Sol on R Street, with a mostly Caribbean/Latino agenda and an openness to African-American expressions, confronted race so directly.[22]

## AIDS AND WASHINGTON ART LIFE

In the early years of the AIDS epidemic, national artists such as Keith Haring, Robert Mapplethorpe and Paul Thek of New York, and Roger Brown of Chicago, would be infected with the virus and eventually die. What about Washington? Tom Pattison was a studio model for British-born D.C. painter/critic Andrew Hudson. Pattison, whom Hudson remembers as "like a brother to me," nursed friends through AIDS in the 1980s and then himself died of the disease.

This author recalls the loss of several art acquaintances. The dynamic Jack Bolton, who had just left Washington to establish himself as a curator for a New York bank, committed suicide after receiving the diagnosis. Richard Boardman, an effusive, witty individual whose job was to send exhibitions abroad for the State Department, made ironic jokes about his health, sold his eccentric cache of worldly goods, and withdrew to Sydney, which he loved, to die among Australians. Michael Watson, an elegant, smart *Americain-de-couleur* who worked down the hall in the Hirshhorn's Registrar's Office, reported on his various ailments to coworkers, with disbelief but matter-of-factly, made up a will (at barely 30) and eventually stayed home to die.

20. Jody Mussoff, *Woman Dyes Her Hair*, 1981, colored pencil drawing, 22 x 30 inches, Art Gallery of the University of Maryland. Mussoff's work — part Egon Schiele nude, part Punk wailer, part manic caricature— projects uncertainty and anxiety despite the mundane subject. The Pittsburgh-born artist came to Washington as an art student in 1974, and remained. The surge of figurative expressionism and women's subjects during the 1980s—plus the ease with which her work could be transported—allowed Mussoff also to show in New York and Europe. An AIDS Zeitgeist inflects her vision.

21. Artists and allies march from
the Corcoran to the Capitol steps,
June 1989

AIDS left many more holes in Washington art life, but since the disease was seldom named in obituaries, the full extent may never be known. The pall of AIDS may also have turned up in local artworks, but that, too, is elusive (ACT-UP, which recruited artists, was a New York cause). But worth noting is that early in the epidemic, in 1985, Gallery K held an art sale to benefit the health-care response to AIDS. Jody Mussoff, one of Washington's most angst-y figurative artists, co-organized it with gallery director Komei Wachi. One hundred and thirty Washington artists donated works, each priced at $100, and the exhibition sold out. Thus Mussoff and Wachi were able to present the Whitman-Walker Clinic, a gay men's health center facing new AIDS cases almost daily, with a check for $13,000.[23]

Artists and buyers had been generous and compassionate, but the epidemic raged on, and before long, Christian Coalition conservatives, like Senator Jesse Helms, would rail against expressions of sexuality, gender and religious beliefs in contemporary art. The Culture Wars raged on too.

## ROBERT MAPPLETHORPE—THE DEFINING MOMENT

In the first months of 1989, Senator Helms and others on the Hill were condemning the NEA for its support of a North Carolina exhibition that included "Piss Christ," Andres Serrano's surreal, large-scale, yellowish photograph of a crucifix in urine, which they felt to be blasphemous. The Corcoran's new Director, Christina Orr-Cahall, was watchful.[24] Robert Mapplethorpe's "X Portfolio" photographs depicting sadomasochistic gay sex—shadowy images not for the faint of heart[25] — were to be included in "Robert Mapplethorpe: the Perfect Moment," a retrospective opening that June at the Corcoran. Would they fan right-wing extremism on the Hill and thereby jeopardize the Corcoran's partial reliance on federal funds? Orr-Cahall must have feared as much, so in what she no doubt felt was an astute political move, and with the backup of a narrow Board quorum, she canceled the exhibition.

The decision created a firestorm. The art world, joined by the Left, cried censorship and organized protests while the Right, driven by homophobia and an anti-pornography agenda,[26] added Mapplethorpe (who had died of AIDS a few months before) to its blacklist of artists. Orr-Cahall was vilified by the art

community for her bad judgment, and Jane Livingston, the Corcoran's valued curator, resigned in protest.

Courageous acts abounded. Jock Reynolds cleared WPA's galleries to open the entire exhibition in July, including, behind panels, the "X Portfolio," and record crowds came. And on June 30, the very night the exhibition was to have opened at the Corcoran, a small coterie of art undergrounders saw to it that thirteen of Mapplethorpe's photographs—portraits, still lifes and figure studies, some homoerotic but none from the X-portfolio—were projected onto the museum's façade.

The Mapplethorpe projection, now legendary, was the brainchild of Rockne Krebs, Ruth Bolduan and Mokha Laget from the Washington Artists' Coalition, independent curator Andrea Pollan (a new arrival in town who came up with the projection idea "in casual conversation," she recalls), curator-artist J. W. Mahoney and art patron/ restaurateur Bill Wooby. In the back room of Wooby's Collector Gallery Restaurant on U Street, the group worked into the wee hours on the complex logistics of permits, equipment, fundraising and publicity, expecting, on projection night, perhaps 250 people.

All the same, an estimated 2,000 people showed up—artists, curators, collectors, dealers, critics, TV crews, museum staffers, officials from the National Endowment for the Arts (which had helped fund the exhibition), gay activists, AIDS activists, civil libertarians and many, many more. An art-world event had turned into a broadly galvanizing, freedom-of-expression demonstration — the perfect us-versus-them situation — generating page one news around the nation and beyond. Art became a *cause célèbre*, not in New York, London, L.A., Tokyo or other "excitement cities" of the 1980s but in staid, colonnaded Washington, D.C.

## WHAT NEXT?

The explosive spirit of the Mapplethorpe moment was never again quite equaled. Chill and retrenchment soon extinguished the excitement. The Hirshhorn, Corcoran and NEA began to pay more careful attention to contemporary art with a potential to offend; they adjusted accordingly. Galleries, tripped up by a recession in 1989, lost business and slowed their expansion. [27] The "earlier organic, interconnected, fond, and feuding scene," as Lee Fleming has put it,[28] faded away as the art world

scattered and regrouped in smaller, mostly but not always, respectful fiefdoms. And although artists kept active in their studios—as they always do—the celebratory polemic of a nationally distinctive Washington art and the certainty that "we are trustees of our culture," as the Washington Artists' Coalition proclaimed in 1988,[29] eventually dissipated.

The painter-curator Mokha Laget, who had championed a cohesive Washington art for the 1980s, offers this closing assessment[30]:

*In the wake of the Color School, D.C. needed to emerge and find its own way. But no true critical discourse followed in the decades after Clement Greenberg had put his stamp on the chosen few. The fear and loathing of regionalism loomed large back then, and it was seen as a curse, not an attribute. Still, there was plenty of electricity in the air, especially at the height of the Culture Wars. But ultimately, Washington's conservative veneer, big money, slow power and absence of any real urban art hub were what prevailed. Awakening Washington to its own artistic identity was, as we say in French, like stabbing water with a sword.*

**NOTES**

1  This paragraph opens a draft essay submitted for this project, then withdrawn by Mr. Mahoney because of a long-standing commitment as curator/catalog essayist for the WPA "Catalyst" exhibition at the Katzen's American University Museum (see Further Reading). The current essay follows Mr. Mahoney's path and borrows a few choice phrases, with gratitude. Uncited quotations are from this draft.

2  Joseph McLellan, "Enigmatic Empire," *Washington Post*, April 16, 1981, D9. Carolyn Campbell, the Corcoran's PR person at the time, recalls that Longo's girlfriend Cindy Sherman, the photographer, participated as a dancer, along with Arnie Zane and Bill. T. Jones (pictured). It was a School project that the *Washington Review*'s Mary Swift helped make happen.

3  Also part of the series: Corcoran professor-alumnus Tom Green's sharp, imagist-y paintings and works by Corcoran alumni Kendall Buster and Peter Fleps

4  *Options '83*, Washington, D.C.: Washington Project for the Arts, January 21 – March 5, 1983, p. 4.

5  Irving Gordon, quoted in Michael Welzenbach, "Putting on the Ritz," *Washington Post* , April 12, 1983, D7

6  Sarah Booth Conroy, "Art in the Raw," *Washington Post*, April 4, 1983, G1

7  American Alpine Club, *Accidents in North American Mountaineering 1985*, volume 5, issue 2, number 38. (See "In Print" section in Album).

8  Jean Lawlor Cohen adds that Troyer was an accomplished potter, Jones a serious collector and member of the deMenil-Schlumberger family and Fitzpatrick the co-author of a cultural history of black D.C.

9  In 1983, 1986 and 1988, respectively. See Jo Ann Lewis, "Hello SoHo: The DC Art Dealer Exodus," *Washington Post*, Sept 18, 1988, C14. Also setting up shop in New York, eventually permanently, was Franklin Parrasch, a dealer in fine woodwork and craft art.

10  The 930 Club, d.c. space and other venues fostered Washington's hyper-active Punk/New Wave music scene during the period. See Cynthia Connolly, Leslie Clague and Sharon Chaslow, *Banned in D.C.: Photographs and Anecdotes from the D.C. Punk Underground, 1979-1985* and the Corcoran's ephemera and film clip exhibition of Winter 2013, *Pump Me Up*, which focused on both Punk and D.C.'s Go Go music scene in the 1980s.

11 Paul Richard, "Grand Opening," *Washington Post*, September 28, 1985, G2. Jean Cohen notes that at times McIntosh-Drysdale took important pieces on consignment from dealers like Leo Castelli.

12 Thomas Lawson, "Horrorshow," *New Art Examiner* (July 1985): 24

13 Lee Fleming, "Washington Show, *Art News* (Oct. 1985), p. 13

14 Paul Richard, "Contrasts at the Corcoran: Rifts and Revelations at the Washington Show," *Washington Post,* May 11, 1985, G1.

15 Dan Cameron, "Is There Hope for Art in Washington?", *New Art Examiner* (March 1988): 34.

16 Paul Richard, "Gathering Forces: DC's Lightning Bolt." *Washington Post,* Sept. 12, 1989, E2

17 Mokha Laget, ""Vision and Revision in DC Art," *New Art Examiner* (February 1989): 31, 33-34.

18 Started in the 1970s by Jane Livingston after a pow-wow with Lee Friedlander and others to build on Washington's past as a locus for news and documentary photography and make the Corcoran a center for "modern and contemporary photography." Conversation with the author, Nov. 4, 2011

19 Ewing, who represented many local photographers, co-founded the Association of Photography Art Dealers (APAD) in 1981—as AIPAD (adding "International") it still presents yearly shows in New York — and went on to become President. Sander, who relocated to New York in 1983, was a pioneer international dealer along with Harry Lunn (see Margaret Loke, "Photography Review: A Collector Who Knew How to Beat the Drum and Sound the Trumpet," *New York Times*, Jan. 26, 2011.., D.14). Tartt helped to champion 19th -century photography, Jones and Troyer also came to be much admired for their keen photographic eyes, and Berler, working from a Bethesda gallery space, kept DC photography collectors well stocked with works by major figures. Brown, remembered perhaps best today as a sculpture dealer, also sold work by such up-and-coming national photographers as Leland Rice and James Casabere.

20 Guthrie and Allen, who stopped writing for the *Washington Times* in 1989, left DC in 1995 to settle in Cornwall, England. They married in 1996. *The New Art Examiner* ceased publication in 2002, two years before Allen died of cancer.

21 "How Ya Like Me Now?" now part of the Glenstone Foundation collection, Potomac, Maryland.

22 Ned Rifkin, the Hirshhorn's Chief Curator from 1986-91, pushed for solo exhibitions by African-American artists. "Houston Conwill WORKS" (1988), a site-specific installation curated by the present writer, started the process. A number of solo shows and acquisitions followed, but the first black show to be curated by an African-American staffer did not happen until 2000, when Senior Educator Teresia Bush (now Adjunct Professor at Howard University) curated "Directions: Leonardo Drew."

23 Telephone conversation with Mussoff, November 2011. (see also *Washington Post* coverage via ProQuest as cited in Further Reading). Some years later, the New York-based American Foundation for AIDS Research (AmFAR) staged a fundraising auction (see Further Reading), with mixed success.

24 Before coming to Washington from California, Orr-Cahall was director of the Art Division of the Oakland Museum, a city-funded institution in this largely black metropolis across the bay from San Francisco. There she cancelled a scheduled exhibition of Robert Colescott's racially charged paintings, as reported to this author by Harvey L. Jones, Senior Curator at the time.

25 Even Mapplethorpe's closest friend, singer-poet Patti Smith, was mystified and repelled by the elegantly printed X-Portfolio, which represented Mapplethorpe's deepening fascination with secret desire. See Patti Smith, *Just Kids*, New York: Harper Collins, 2011, pp. 235-36.

26 Thomas Birch, "Introduction: The Raw Nerve of Politics," in Jennifer A. Peter and Louis M. Crosier, eds., *The Cultural Battlefield: Arts Censorship and Public Funding*, Gilsum, N.H.: 1995, p. 16.

27 Telephone conversation with Bill Wooby, November 2011. A Wikipedia article, "The Early 1990s Recession," reports more generally on this downturn, which started with a "Black Monday" in 1987 and extended globally to the mid-1990s.

28 Lee Fleming, "Then and Now: Afterword," in *The Constant Artist* , exhibition catalog, 2011, American University Museum at the Katzen, p. 43.

29 Rockne Krebs, "Opening Remarks," in Mokha Laget, ed. *The 1988 Artists Congress at the Corcoran Gallery of Art, Washington DC, September 24 and 25 sponsored by the Coalition of Washington Artists* [publication described in *Further Reading and Looking*].

30 Email to the author, Nov. 5, 2011

# Voices, Observations, Chat

## 1980S PART 2

### EDITED BY SIDNEY LAWRENCE

## VIGNETTES

**J. W. Mahoney:** A few fond, random impressions. A WPA opening with Gene Davis downstairs and Yuriko Yamaguchi, Jeff Spaulding and Betsy Packard upstairs. The Examiners' lead singer Michael Reidy enters WPA's Botswana Club. The No-Name Discussion Group meeting in Carol Goldberg's Connecticut Avenue studio. Tuesday night openings at the Olshonsky Gallery. Hilary Daley-Hynes discusses Uranus Transits in his Atlas Building conservation studio. The Mapplethorpe Demonstration. The "Other Rooms" show at the Morgan Annex. Tom Downing and Simon Gouverneur together at the Phillips in 1985—the passing of a torch.

**Elizabeth (Betsy) Tebow:** The indefatigable Sal Fiorito—glass artist, performance artist, restaurant designer, party organizer and longtime friend of my husband and me—had "Camp Fioritos" over several summers at his property near Gettysburg, Pennsylvania. Fifty to 100 "campers" came each time and pitched tents near his cottage. Sal roasted a pig, and we brought side dishes. Guests could float on rafts in the nearby river, but getting involved in a group art project was the main reason to go. One year we made a balloon bridge to cross the river, and once, to celebrate Bastille Day, we wore berets and penciled-on mustaches and assembled in a cornfield enthusiastically waving French flags much to the bewilderment of the pilot of an ultra light who happened to by flying by. Sal's Halloween costume parties were equally wild. At one, he dressed up as Jesus on the cross, at another he sewed live worms onto a body suit and at a third he was a turtle in a terrarium.

**Sidney Lawrence:** Then there were the sweaty, rock-out dance parties—Motown redux!—at Alan Stone and Sherry Jones's Edwardian digs near Dupont Circle with artists, film/TV people and who knows who else, plus Mary Swift's undergrounder blasts in her modernist house in (otherwise Ye Olde) Georgetown with art, art and more art, and music, too. Hirshhorn openings were great—drawing celebs like Liv Ullman and Diane Keaton, as well as the usual "groupies." I liked the loud, decked-out, party-loving artists the best (hello, Judy Jashinsky!). And the characters like that older, hungry, always alone bearded older guy who never uttered a word, or the eccentric, classy JoAnn Crisp-Ellert in her ethnic outfits with her husband Bob, dashingly Princetonian in every detail, or the beret-clad, ever-interested Barry Alpert, or the

1. PREVIOUS: Hirshhorn fun, circa 1980—staffers Carol Parsons, John Beardsley and Sidney Lawrence pose with some cool-looking art-world dudes. Darkroom dental "adjustments" to Parsons and Lawrence, the Hirshhorn's de-facto Fun Couple, add further hilarity to the picture. The fright wig is real.

intense-to-the-*max New Art Examiner* editors Jane Allen and Derek Guthrie, stalking Washington's art world with the acuity of old-line European intellectuals.

## BOONS

**Mokha Laget:** Jane and Derek came to shows, wrote reviews and articles, brought in some heavy hitters to write from the outside, pushed the discourse with artists, poked and prodded to stimulate the scene. They took on the Culture Wars.; D.C. was ground zero. They were not in it for the money or the glory. Their presence in Washington was considered more of a thorn in the *beau monde*'s side than the catalyst for wider cultural understanding.

**Derek Guthrie:** Jane and I launched *The New Art Examiner* in Chicago, where our independence, tolerance, politics and openness of spirit were sometimes embraced, sometimes demonized. The publication could find little financial backing in Chicago but our national stature was growing, so expansion was necessary. Al Nodal at WPA suggested D.C. would be a positive move. The charm of the city and its museums were an enticement, as well as the proximity to New York. The other consideration, particularly for me, was the National Endowment for the Arts, where the thorny

2. Sal Fiorito in the 1990s

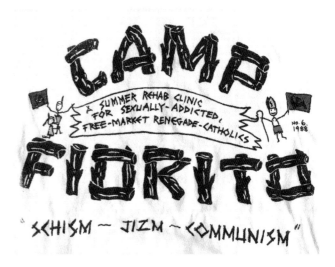

3. Souvenir T-shirt, 1989

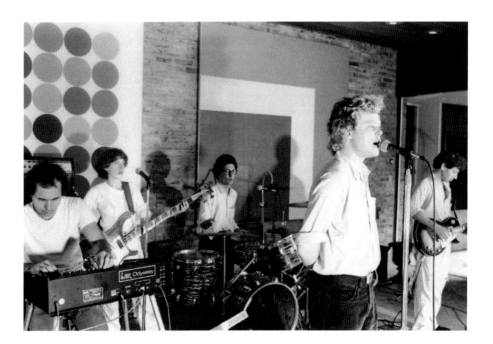

4. Mary Swift soirée, ca. 1980—Robin Rose on synthesizer, vocalist Roddy Frantz, drummer Danny Frankel and guitarists Linda France and Robert Goldstein AKA The Urban Verbs celebrate their first record contract with Warner Brothers. Backup by Tom Downing and Ellsworth Kelly.

arena of art politics—the U.S. government rewarding and, therefore, shaping artistic expression—could be a cogent and consistent editorial focus.

**Clarissa Wittenberg:** The Washington Review had artists reviewing artists, writers reviewing fiction, poets thrilled to have a place to publish, great interviews with artists and regular profiles of Poet Laureates of the Library of Congress. Mary Swift brought her energy and deep knowledge of the arts, as well as her camera and pen. E. Ethelbert Miller, the great poet, was senior editor. We learned as we went, using a large format for strong images, and talked to everyone, joined in on activities, wrote about people who were not yet widely known—Bill Warrell, Al Carter, Rockne Krebs, Peter Sellars (the director), Martin Puryear and others. We made sure that people learned there was a lot of creativity burning under the stolid surface of this one-company political town.

**Jean Lawlor Cohen:** The 80s, in retrospect, were a good time for us freelance writers. I covered Francophile topics (from Duncan Phillips to visiting performers) for *France*, published here still by the embassy. I also wrote for *Sculpture*, the

ongoing national publication produced by the International Sculpture Center, its headquarters then on a cobblestone alley in Georgetown. Key people were ISC director David Furchgott, editor Penny Kiser and resident critics like Eric Gibson, who became art critic for *The Washington Times* and later editor of *Art News*. Whenever we could, we pushed to cover D.C. artists like Bill Christenberry, Larry Kirkland, Eric Rudd and Jim Sanborn.

No doubt *Museum&Arts Washington* made the biggest impact, because it reviewed so many gallery shows and profiled artists and dealers. Thanks to high-end advertisers, publisher Anne Abramson had fine art direction, good paper stock and insightful editors like Jamie Loftin, Jeff Stein, Lee Fleming and Sarah Grusin. She paid for photo shoots by people like Tom Wolff, Max MacKenzie and Mary Noble Ours.

I edited reviews for awhile and, on the writer mast with me, were, among others, Florence Gilbard, Florence Rubenfeld (biographer of Clement Greenberg), John Beardsley, Susan Tamulevich, Mary Gabriel and Mary Lynn Kotz. Many still bemoan the loss of our glam *M&AW*, but an economic downturn caused it to cease publication after six years in 1991.

**Sidney Lawrence:** Bloggish, grassroots publications like *Ken Oda's Art Newsletter* aka *KOAN* (2013 Newsflash: Koan is a Zen Buddhist term for paradox-based enlightenment. Who knew?), which painter Robyn Johnson-Ross wrote for, perceptively, *The Washington Artists News* (good interviews) and *Eyewash* (reviews) rounded out the terrain, with newspaper coverage, of course. There was a lot to write about during this decade, but the boom year, in terms of sculpture at least, has to have been 1980.

**David Furchgott:** The Eleventh International Sculpture Conference opened in June 1980. With less than a year to plan and implement, it was a cliff-hanger, but through the hard work of many, lots of good fortune and a prudent trimming of the budget, we pulled it off, taking over the U.S. capital with sculpture talks, area-wide exhibitions and celebrity figures like Richard Serra, Beverly Pepper, Christo and Isamu Noguchi who came to town to join 162 speakers, panelists and workshop leaders, plus Nancy Holt, Lita Albuquerque, our own Rockne Krebs and others, who created site-specific works. SC11, as we called it, attracted 2700-plus visitors, occasioned an 88-sculpture exhibition throughout Washington's core (including Seward Johnson's ever-popular *The Awakening*) and

galvanized some 60 community art spaces to organize their own shows. The National Endowment for the Arts helped fund us; Joan Mondale, the Vice President's wife, was honorary chair and the installations and conference were covered by hundreds of newspapers nationally. The city was high on sculpture.

**Duncan Tebow:** Spurred by David and emboldened by the Conference, we started the Washington Sculptors Group in 1983. Leonard Cave was the first president, then I was, then Joan Danziger. In a few years, our original 100 members rose to 225. In co-sponsorship with museums, embassies and other organizations, we presented technical talks, art history lectures, "what-I-did-on-my-summer-vacation" type evenings and programs in tune with the times like "site-specific-sculptor-disillusionment" night with a GSA official who revealed that Richard Serra signed a contract that allowed the government to move, even destroy, *Tilted Arc*. And, of course, we sponsored regular sculpture exhibitions chosen by reputable, independent jurors. The goals were, and still are, to keep Washington's thriving sculpture scene in the public eye and foster its professionalism and growth.

## STYLES

**Sidney Lawrence:** My style, as part of scores of "emerging" and/or active artists in the 1980s, was *Preppy Primitive*. Or so a sound-bite-crazy friend of mine called it; I understood since I worked at the time as the Hirshhorn's PR guy. Now it's my turn. So with apologies for flippancy, inaccuracy and probable irritation to you, fellow artists, here are some '80s styles I've invented for fun and nostalgia: *Redneck realism* (Fred Folsom). *Solid-Figure-ism* (Rebecca Davenport, Judy Jashinsky, Joe Shannon, Robyn Johnson-Ross, Betsy

5. Gay Glading and Kevin MacDonald read their favorite rag.

Packard). *Hallucinato-Figure-ism* (Carol Goldberg, Margo Humphrey, Lisa Brotman, Hilary Daley Hynes, Eric Rudd, Keith Morrison, Ruth Bolduan). *Spiky-Figure-ism* (John Antone, Rebecca Kamen). *Jesuito-Intellectuo-Hermeticism* (Brian Kavanagh, Jim Mahoney). *Dwellingism* (Tom Nakashima, Alan Stone, Billy Dunlop) *Icono-Culturo-Patternism* (Simon Gouverneur, Mokha Laget). *Hallucinato-Abstractionism* (Anne Marchand, Benita Berman, Joanne Kent). *Identity-as-Symbiosis-ism* (Ed Love, Mindy Weisel, Renee Stout, Yuriko Yamaguchi, Maxine Cable). *Globalisto-Yearningism* (Richard Dana). *Homeland Yearningism* (William Christenberry). *Yearningism* (Gayil Nalls). *Dollism* (Suzanne Codi, Noche Christ). *Duckism* (Bill Suworoff). *Sign-o-the-Times-ism* (Susan Firestone). *Chaste-ism* (Dale Haven Loy). *Trompe-ism* (Mark Clark). *Paint-as-Trompe-ism* (Sam Gilliam). *Serenism* (Nan Montgomery). *Anxietyism* (Jody Mussoff). *Silhouette-ism* (Catherine Batza). *Culture-as-Earth-ism* (Martha Jackson-Jarvis). *Compare-and-contrast-ism* (Susan Eder). *Neat-yet-Offkilterism* (Lee Haner, Rex Weil, Gay Glading). *Over-the-top Vernacularism* (Ed Bisese, Elaine Langerman, Wayne Paige, Joan Danziger).

**And more:** *Muscle-ism* (John Van Alstine, Lenny Cave, Foon Sham). *Squiggle-ism* (Janis Goodman). *Dare-to-Wear-Me-ism* (Maria da Conceicao/Sao). Crispo-Organico-Imagism (Tom Green, Steve Kruvant, Ann Stoddard, Steve Cushner, William Willis). *Introverto-Obsessionism* (Andrea Way, Wayne Edson Bryan). *Extraverto-Obsessionism* (W.C. Richardson). *Inner-Glow-ism* (Robin Rose). *Take-on-the-Modernists-ism* (Duncan Tebow). *Emulate-the-modernists-ism* (Hildy Van Roijen). *Messy-yet-Logical-ism* (E. H. Sorrells-Adawale, Jeff Spaulding, John Dixon). *Brute-Delicatism* (John McCarty). *Steel-as-Bloom-ism* (Wendy Ross). *Retro-Revivo-Statue-ism* (Tom Mullany, John Dreyfuss, Raymond Kaskey, Frederick Hart, David Mordini). *Photo-Lumiere-ism* (Manon Cleary, Kevin MacDonald, Joe White, Alan Sonneman, Michael Clark, A. Brockie Stevenson, Barbara Frank). *Hit-Them-in-the-Face-ism—Politico branch* (Leslie Kuter, Judy Byron, Akili Ron Anderson, Lawley Paisley-Jones, Jeff Donaldson) *& Expressionisto branch* (Sal Fiorito, Sherman Fleming/Rod Force, Jenna Watson). *Non-Neo-Neo* (Al Carter, Edward Knippers, Sylvia Snowden). *Internalized Flirtationism* (Carroll Sockwell, Ruth Balduan, Walter Kravitz). *Spacio-Mysticalo-Involvementism* (Renee Butler, Kendall

6. Jody Mussoff and Brian Kavanagh make happy at a Hirshhorn opening

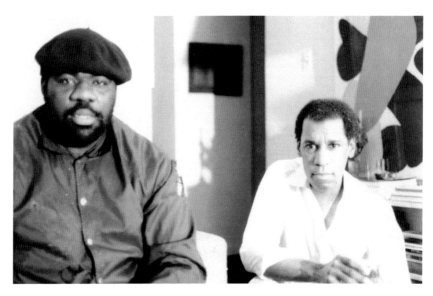

7. "Big Al" Carter and Carroll Sockwell at ease

8. Renee Butler installing *VARIATIONS 1* for the John Cage Fest at Strathmore Hall Mansion

9. Robin Rose and Kevin MacDonald face to face

10. Maria da Conceicao ("Sao") in her
wearable-art workshop

11. John Gossage and Alex Castro making photo prints

ARTISTS... HANGING OUT...ON THE SCENE... IN THE STUDIO

Buster). *Wisp-of-memory-ism* (Michael Platt, Frank di Perna, Denise Ward Brown, Joyce Tennyson, John Figura, Mark Power).

**And finally:** *Love-of-Land-ism* (Peter Fleps, Bill Dunlap, Steve Szabo, Athena Tacha, Patricia Tobacco Forrester, Jim Sanborn). *Love-of-City-ism* (Val Lewton, Michael Francis, Lily Spandorf, Zinnia, Shirley True, Bill d'Italia, Lily Spandorf). *Fascination-with-People-ism* (Annette Polan, Mary Swift, Paul Feinberg, Lloyd Wolf). *Watch-us-have-a-blast-ism* (Art Attack). And now for something completely different:

**Richard Powell** (curatorial categories, 1989): A. Systems and Grid. Art that emanates from what might be described as the city's origins in diagrammatic abstraction...B. Washington Organica. The antithesis of order... C. Faces-Places...related to realism, but with an edge... D. Inside/Outside. Art that is really life, made by black folk.... E. History-turned-into-Fodder-for-Art, Work that doesn't let memorials, marble pillars, gilded frames and other Washington albatrosses overwhelm it.

## BLACK

**Keith Morrison** (1981): Can art make Reagan a humanitarian? I don't think black artists think that way. James Baldwin said that social change in art has to do with a black kid looking at a black kid and thinking him beautiful. We're interested in a cultural cohesiveness, a sense of who we are as a people, what your image is, what is beautiful to you.... I don't know of a black artist who does not believe fervently that politics is a central aspect of art.

**Teresia Bush:** In the 1970s, such fair-minded communicators as the Corcoran's Roy Slade and Walter Hopps fostered an open, friendly, liberal atmosphere, but in the 1980s, the whole political aroma of this city changed. People went back into their little corners. Except for the WPA and Fondo del Sol, which made concerted efforts, you didn't see many mixed shows in D.C., or curatorial interest in black artists, or even mixed openings. And we're just now getting over it. Even so, some outstanding African-Americans artists either emerged or held their ground during the decade. Sylvia Snowden, Ed Love, Starmanda Bullock, Franklin White, Percy Martin, Margo Humphrey, Frank Smith, Joyce Wellman, Akili

Ron Anderson, Joseph Holston, Stephanie Pogue, Jeff Donaldson, Uzeki Allan Nelson, Al Carter, Michael Platt and Martha Jackson-Jarvis are some of them.

**Richard Powell** (1989): Two artistic forbearers, visionary sculptor James Hampton [see 1965 Retrospective entry] and sign-art surrealist Ric Roberts, suggest that the formulation for a local/black/grassroots arts movement runs long and deep. We in the cultural arena should recognize the fact that the citizens who suffer most from the city's social ills—crime, poverty, unemployment—are also the source of a rich and expressive culture, one which should rightfully share a place among our artistic offerings.

## NEW YORK

**Ben Forgey** (1985): New York's weighty presence so close by contributes to a certain inertia, if not fatalism, in the D.C. art scene. . . It contributes to a defensive local identity crisis and to the pejorative edge many perceive in the words "local art" or "Washington art" . . .

**Max Protetch** (1988): If you want to challenge yourself, there's no test in Washington, D.C. Art is peripheral activity there; it is central in New York.

**Chris Middendorf** (1988): The quality of life is better here, though New York clearly has its advantages. . . .. And we don't have fashion here. In New York, the tide sweeps people away...

**Barbara Fendrick** (1988): [In New York] everybody's interested in who's new.

12. Inside Fondo Del Sol on R Street, a singular showcase for art of the Americas and the African diaspora

13. Martha Jackson-Jarvis's 1983 installation for WPA, *East of the Sun, West of the Moon, Walking on Sunshine*, borrowed its title from jazz and soul lyrics and encouraged viewers to move through a pleasurable environment of raku sculpture, neon and sand.

**Jane Addams Allen** (1985): The dense, gritty claustrophobic urbanism that drives artists in New York . . . to cluster together in self-created ghettoes is largely absent here.

## IDENTITY CRISIS

**Richard Powell** (1988): Anacostia artist John Robinson is of more importance to D.C. than Paul Gauguin because of his proximity to us.

**Sue Green** (1988): Enough of this cliché that this is a cultural wasteland; it's not. . . . What happens is burnout. Somehow, the enthusiasm dissipates.

**Robin Rose** (1988): Washington will never have an economic base to support art the way all of us would like to think.

**Jane Addams Allen** (1985): Groups of artists rise and fall here, for the most part without geographical center and without notice.

**Rex Weil** (1985): Making art in Washington is not easy. . . We make art side by side with those who fashion an increasingly unpleasant political and social context. . . Art here should be toughened and purified by daily confrontation with the hardest questions about what we are doing and why.

**Dan Cameron** (1989): People in Washington should stop hibernating so much; they might find that artists (and their functionaries) tend to come up with remarkable ideas when they gather in groups larger than two.

**Gene Davis** (1981): . . . make no mistake, each [artist] . . . is a solitary voyager.

14. Michael Platt arranges works on paper in the 1990s. His 1986 WPA installation focused on the Atlanta child murders of 1979-81, which claimed 28 young black lives.

## SOURCES*

*see *Further Reading & Looking* for full citations not given here.
VIGNETTES: Mahoney—unpublished essay draft. Tebow—correspondence to editor. BOONS: Laget, Guthrie, Wittenberg, Tebow—correspondence to editor. STYLES: Powell—*From the Potomac to the Anacostia: Art & Ideology in the Washington Area* [p. 2], BLACK: Bush—correspondence to editor. Powell—op. cit. [ p. 10]. Morrison—Paul Richard, interviewer, "Black Artists: Their Pride and Problems: Keith Morrison," *Washington Post*, March 15, 1981, G1. NEW YORK: Forgey—"Making Art in Washington," in *The Washington Show*, p. 22. Protetch, Middendorf, Fendrick—quoted in Jo Ann Lewis, "Hello SoHo! The D.C. Art Dealer Exodus," *Washington Post*, September 18, 1988, C1, C4. Allen—"A Starting Point: Refracted Light and Received Values in Washington Art," in *The Washington Show*, p 24. IDENTITY CRISIS: Powell, Green and Rose—*The 1988 Artist's Congress at the Corcoran Gallery of Art*, pp.23, 7-8 and 10, respectively. Allen—"A Starting Point" The Washington Show, p. 25. Weil—"The Washington Show—An Artist's View" in *The Washington Show*, p. 39. Cameron—"Is there Hope for Art in Washington?", *New Art Examiner* (March 1988): p. 37. Davis—Options '81, Washington Project for the Arts, April 17 - May 18, 1981 [p.4], in reference to the 20 artists he and Mary Swift chose as co-curators.

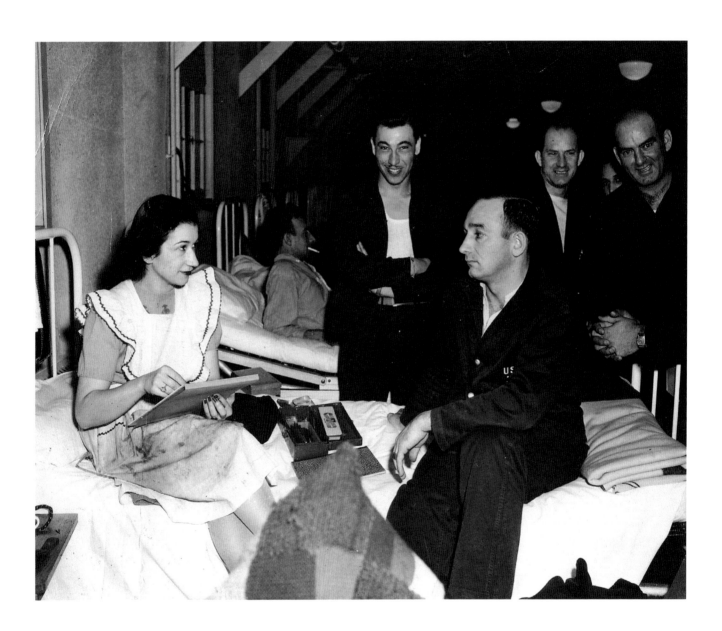

# Retrospective

OTHER MOMENTS IN 50 YEARS OF WASHINGTON ART

## 1940

Jack Perlmutter moves to D.C. for a job in the U.S. Navy Hydrographic Office as draftsman and lithographer. His nautical charts become useful in wartime.

## 1941

Duncan Phillips buys Paul Klee's *Arab Song*, a whimsical work on burlap (harbinger of paint on unprimed canvas!), later admired by gallery habitués Davis and Noland.

## 1942

Prentiss Taylor (1907-1991), art therapist and American U. painting teacher, is elected President of the Society of Washington Printmakers, a position he holds for 34 years. Earlier with poet Langston Hughes, he founded Golden Stair Press that published writers of the Harlem Renaissance.

## 1943

Lila Oliver Asher, later a Howard U. art professor, begins her three-year tour with the U.S.O. volunteer Hospital Sketching Program, later recounted in her book *Men I Have Met In Bed*.

Marilee H. Shapiro moves to Washington from Chicago, having studied with Alexander Archipenko. At 89, she studies computer graphics. At 101 (in 2013), she continues to show her figurative painting and abstract sculpture.

## 1944

At the National Gallery of Art, *Paintings of Naval Medicine* sets a record single-day attendance (25,000). Of 14 exhibitions this year, six depict the armed forces in action.

Bernice Cross receives her first of several Phillips solo shows, justice for the painter whose WPA mural (scenes from Mother Goose) at a Maryland children's TB treatment center disappeared under whitewash ("unsuitable to the dignity of a public institution").

1. PREVIOUS: Lila Oliver Asher sketching soldiers for the U.S.O., 1944

## 1945

American U. establishes the Watkins Collection, a memorial to art professor C. Law Watkins, with works by 25 artists including Karl Knaths and Marjorie (Mrs. Duncan) Phillips.

Alice Acheson (1895-1996) teaches drawing and painting to wounded soldiers. The wife of Dean Acheson (later Truman's Secretary of State), she had shown at The Phillips and the Corcoran.

## 1946

Ad Reinhardt presents his *Tree of American Art* and puts Kainen, whom he knew in the 1930s, on the same branch with Rothko and Gottlieb.

## 1947

Gene Davis, a reporter for Transradio Press and member of the White House press corps, accompanies President Truman to Key West. One Davis dispatch describes Truman's wardrobe as "up and down the color scales." (Jacob Kainen recalled that Truman later got Davis fired for "leaking news" to Drew Pearson.)

## 1948

Marcella Comès Winslow, encouraged by her friend Alice Roosevelt Longworth, visits poet Ezra Pound incarcerated at St. Elizabeth's Hospital. The National Portrait Gallery now owns her portraits of Pound, a Conté crayon drawing and an oil.

2. Ezra Pound poses at St. Elizabeth's for Marcella Comès Winslow, Conté crayon, 14 7/16 x 12 13/16 inches.

3. Felix de Weldon

4. *The Magician, 1951,* by Jacob Kainen
20 x 28 inches

## 1949

Gene Davis enters lifelong psychotherapy in the fall. He later tells writer Steven Naifeh, "one month, almost to the day, afterwards, I had this very strange, difficult-to-explain urge to paint."

## 1950

Felix de Weldon (1907-2003) allows reporters to visit his chilly 60-by-40-foot studio and see the plaster model of the *Iwo Jima U.S. Marine Corps War Memorial.*

## 1951

*The Washington Post* publishes an article by Gene Davis entitled "Art Becomes New Lure for Tourists." Davis notes that almost 5,000 people a day visited the National Gallery to see captured German art and that New York's MOMA now shows "the latest atomic era creations of advance guard painter Jackson Pollock."

Wang Ming arrives from Taiwan. A master framer (his National Art and Frame Company closed in 1980), he quietly produces thousands of paintings, prints and drawings, earning solo shows at the Corcoran Gallery (1974), Brooklyn Museum (1979) and, as the first Asian-American artist featured there, the National Air and Space Museum (2009).

The daughters of painter Alice Pike Barney (1857-1931) donate part of her collection to the National Collection of Fine Arts and, in 1960, her Sheridan Circle studio-salon residence.

## 1952

Franz Bader shows the watercolors of Richard Dempsey. This may be the first exhibition of a local black artist's work in a white-owned gallery.

In the Dupont Theater Lounge, Gene Davis has his first show (drawings), and curator Jacob Kainen installs his own paintings, perhaps the first purely abstract show in Washington. *The Post*'s Leslie Judd Ahlander says the canvases "look as though they had been shot out of a cannon."

## 1953

This is the "Anno Mirabile" of Washington art, according to Leon Berkowitz. The Workshop mounts both Louis's first one-man show and a Willem de Kooning retrospective. Among 33 paintings hauled from New York by de Kooning in a Studebaker is *The Women*, to some proof the artist is a woman-hater.

Robert Gates shares a discovery with the progressive Artists Guild—an amazing water-based, Bocur acrylic resin paint that dries instantly.

## 1954

Leon Berkowitz sets sail on a freighter for Spain. For the next 10 years, he and his wife Ida Fox paint and write abroad with sporadic returns.

## 1955

The Dupont Theater Lounge features self-portraits by 14 artists, ranging from a Marcella Comès Winslow near-likeness to a Jack Perlmutter wildly-colored surrealistic image.

As juror of the Corcoran Gallery Area Show, Andrew Wyeth picks only three abstract works—one each by Mehring, Noland and Downing.

## 1956

Barnett-Aden Gallery organizes two important shows: one, perhaps for the first time together, works by Louis, Davis and Noland, the other "soft, atmospheric" still lifes by a D.C. junior high school teacher named Alma Thomas.

## 1957

Duncan Phillips buys two works by Mark Rothko from New York art dealer Sidney Janis, then gives Rothko his first Washington exhibition and later his first dedicated gallery.

5. Alma Thomas with her work, circa 1958

**1958**

Helen Stern of the *Northern Virginia Sun* writes: "The Jefferson Place is the one gallery where everyone has chosen a high wire for himself. The fact that some of the artists have fallen off into the Slough of Feeling and almost none into the Maze of Technique is disturbing, because it seems to be such a fashionable thing to do."

**1959**

*The Post*'s Leslie Judd Ahlander reports that Gene Davis's abstract expressionist works are "certain to arouse a storm of controversy. They make no concession to public taste."

**1960**

*The Star* reports that a man named W.S. Noisette finds time to paint despite his full-time employment as receptionist and special messenger of J. Edgar Hoover, director of the FBI.

Local group shows feature Davis's first stripes and Noland's first targets. In the spring and summer Morris Louis produces 117 paintings, all with empty centers.

Jacqueline Kennedy, who had interviewed Franz Bader for *The Times Herald*, buys a painting by William Roy. She requests Bader deliver the work to her Georgetown house a few weeks before her move to the White House. Bader recalled, "John Kennedy was sitting in the back living room like a tired human being."

**1961**

Morris Louis refuses to see Gordon Washburn who has come to select work for the Carnegie International. (Earlier Louis turned away a MOMA curator.) It may be he is wary of rejection, studio interruption or observation of his methods.

Jacqueline Kennedy, now first lady, visits the Corcoran Gallery for an exhibition of Fabergé and is greeted by the head of the Women's Committee.-

6. Mrs.Kennedy at Corcoran Gallery

Frank Getlein, art critic for *New Republic*, becomes chief art critic for *The Washington Evening Star*, a position he holds until 1972.

## 1962

Morris Louis, a longtime smoker, dies at 50 of lung cancer. Some contend he has been poisoned by breathing thinning solvents in tight, unventilated rooms.

Kenneth Noland departs for New York, living there and later in Vermont, on property that once belonged to Robert Frost.

During the tensest days of the Cuban missile crisis, an advisor to President Kennedy enters Bader's gallery/bookstore near the State Department. He requests a book [*How to Build a Boat*] that Kennedy needs next summer on the Cape. Bader recalls, "We said, if he buys a book...then there must be some hope."

The McLean Art Club, a non-profit founded by six "dogged and optimistic" women and later named the McLean Project for the Arts, mounts its first exhibition.

## 1963

Ben Shahn chairs the Corcoran's 28th Biennial jury. Out of 108 works (winnowed from 4,000 entries), the jury picks 44 lesser-knowns to hang with de Kooning, O'Keeffe, Louis and Noland.

Washingtonian Martin Puryear graduates from Catholic University with a B.A. in art.

Andre Emmerich gives Anne Truitt her first New York show.

## 1964

The Pan American Union mounts *Nine Contemporary Painters: USA* which travels to Buenos Aires and Rio with works by Downing, Davis, McGowin and Gilliam, plus the "tondo" paintings of Mary Pinchot Meyer who is murdered, that same year, on the C. & O.. Canal towpath. Later revelations identify Meyer as a lover of President Kennedy and Kenneth Noland.

7. Emerson Gallery of the McLean Project for the Arts (Founder Gerry Brock far right with unidentified volunteers)

8. *Half-Light* by Mary Pinchot Meyer, 1964, synthetic polymer on canvas, 60 1/8 inches diameter

9. James Hampton at his throne, late 1950s

Alice Denney serves as Vice-Commissioner to Alan Solomon who is charged with selecting American art for the Venice Biennale. She attends the ceremony at which Robert Rauschenberg becomes the first American to win the top prize.

Collectors John Mathews, Mary Hewes and Tim Bornstein found The Washington Print Club with advisory support from Alan Fern, Jacob Kainen, Gerald Nordland and Adelyn Breeskin.

## 1965

Artists Equity establishes a Washington chapter with abstract sculptor Alfredo Halegua as first president. Marcella Comès Winslow, painting teacher at Catholic University (1965-1969), explains that artists want "to recover some of the initiative they have lost to the self-styled tastemakers." Halegua, a native of Uruguay, receives the sculpture commission for that country's gift to the Kennedy Center.

Esther Stuttman, a prominent New York dealer, opens a gallery near the Wardman-Park Hotel. Until 1973, she shows the atmospheric canvases of Don McCarten and Leon Berkowitz as well as paintings by her close friends Milton and Sally Avery.

Andrew Hudson, a Clement Greenberg protégé, arrives from Canada to be art critic for *The Washington Post*.

Vincent Melzac donates four color paintings to the Washington Gallery of Modern Art.

Artist Ed Kelley, looking for a studio to rent, discovers *The Throne of the Third Heaven of the Nations' Millennium General Assembly*, in a D.C. back-alley garage. Created by retired custodial worker James Hampton (1909-1964), the shrine of salvaged foil and detritus, now considered an "outsider art" masterpiece, is acquired by the National Collection of Fine Arts in 1970 (now SAAM).

## 1966

The Whitney Museum (N.Y.) selects works by McGowin and Krebs for its biennial exhibition of contemporary American art.

George Washington University opens the Dimock Gallery for display of the university's collection, thesis shows and works by established artists.

David Moy wins American University's Kreeger award and a solo show at the Watkins Gallery. (In 1986, after 31 years at *The Washington Post*, 18 of them as art director of the Sunday magazine, he quits to paint full-time and shows "semi-action color field" work at Gallery K.)

Joseph H. Hirshhorn, courted by many cities in the world, donates his collection to the Smithsonian, which promises to house it in a museum bearing his name and on the National Mall. Dillon Ripley, Secretary of the Smithsonian, plays major persuader, but some say a presidential hug by Lyndon Baines Johnson clinched the deal.

Colortone printing company underwrites what is perhaps the city's first open-call exhibition of Pop Art. Jurors Jacob Kainen, Cornelia Noland, Lois Jones Pierre-Noel and Joseph Taney select 25 works (including a plastic, *trompe l'oeil* rib-eye steak by Gary O. Cohen), and *Post* critic Wolf Von Eckardt calls it "really popping...let's have more art shows in office building lobbies."

## 1967

The Jefferson Place shows *Sonata for Three Rooms*, one-inch by one 1/2" canvases painted with help of a magnifying glass by Gene Davis and dubbed "micros." Soon after Davis produces single-color "micros" in plastic.

Davis places a classified ad in *The Washington Post* announcing classes ("easels will be provided and models...on occasion") in his studio near the White House. Models, recruited by ads in *Washington Free Press*, pose nude for the few doing figurative work, while most pursue geometric abstraction.

The Corcoran Area Show receives more than 3,000 entries. Curators hang finalists salon-like up walls and over doorways.

Colin Greenly's *Wishbone* climber wins a Corcoran-sponsored competition for playground equipment.

Paul Richard replaces Hudson as principal art critic for *The Washington Post*, a position he holds until 2001. Among his colleagues over the year are Jo Ann Lewis, Benjamin Forgey and Michael Welzenbach.

10. Gene Davis "micros"

11. Student sit-in under Tony Smith's
*Smoke* at the Corcoran Gallery, 1969

12. Vincent Melzac at the Corcoran

### 1968

Twenty-one professional artists and 175 high school students paint a mural of Washington history on a construction fence surrounding President's Park.

Calvin Cafritz, with consultant Linda Lichtenberg Kaplan, initiates Washington's first corporate art collection. Kaplan, until 1967 director of public relations and communications at the Washington Gallery of Modern Art, becomes a noted appraiser and collector of American art.

### 1969

At the opening of Leon Berkowitz's one-man show at the Corcoran, art students arrive, minus invitations and black tie, and stage a sit-in to honor their teacher.

### 1970

May—*Washington Art: Twenty Years* opens at The Baltimore Museum of Art. In the catalog foreword, director Charles Parkhurst compliments the "variety and quality of artistic production in Washington over this period and the singular character of its art."

December - The Corcoran Gallery of Art shows works from the Vincent Melzac collection, paintings by Gene Davis, Kenneth Noland, Morris Louis and Howard Mehring.

### 1971

The National Park Service takes over the old Maryland amusement park Glen Echo and opens it as an art center with exhibitions, workshops, art studios and performances. Photographer John Gossage and sculptor Jim Sanborn have studios there.

February—Construction resumes on the Hirshhorn sculpture garden, which Congress halted over concern it would interrupt the unity of the Mall. Architect Gordon Bunshaft's redesign responds to suggestions made by critic Benjamin Forgey in *The Star*.

May —The Art Barn, a National Capital Park Service and Artists Equity joint project to showcase Washington art, opens in an old carriage house beside Pierce Mill in Rock Creek Park.

June—*Newsweek* art critic Douglas Davis organizes *Electronic Hokkadim*. Supported by a National Endowment for the Arts grant, the "participation television" event, as it is billed, takes phone calls from the public (singing, talking, humming, etc.) and feeds them to electronic synthesizers which transform the audio into fluctuating color designs shown on CBS TV affiliate WTOP.

## 1972

The Smithsonian's Renwick Gallery opens in the old Corcoran building to feature crafts and decorative arts with Lloyd Herman as director and Michael Monroe curator-in-charge.

Forgey succeeds Getlein as full-time art critic for *The Washington Star*.

April — An article in the *Post* dubs Sarah Baker "High Priestess of Area Artists." The septuagenarian Baker, a founder of the A.U. art department, says, "I can't think of anything duller than stripes" and laments the Washington color school artists who were "such beautiful draftsmen like Ken Noland. . . [who] sacrificed all that for the sake of being à la mode, no better than a pie."

## 1973

March—Carmen Almon, Lisa Brotman, Isabella LeClair, Bill Lombardo and William Newman exhibit together as *The Washington Color Pencil School* at the Corcoran in a tongue-in-cheek nod to teacher-friend Gene Davis.

September—Two group exhibitions of Washington art (all by women) open at nonprofit cooperatives in New York's SoHo—55 Mercer Gallery and Artists-in Residence (A.I.R.)

October —*A Tribute to Franz Bader* exhibition opens at the Corcoran.

13. Artists from early Art Barn show *Water Variations*: Michal Hunter, Michael Clark, Susan Powell, Mark D. Clark, Kevin MacDonald, Catherine Consuegra, Jim Sundquist, Joe White, Gay Glading, Jay Burch

14. Frederick Hart working from a live model on his Washington National Cathedral tympanum

## 1974

July—The Torpedo Factory opens on the Alexandria waterfront. The former munitions plant and General Services Administration warehouse holds artists' studios, craft workshops, galleries and the Art League headquarters.

## 1975

Komei Wachi, a Japanese-born mathematician, and dealer Marc Moyens open Gallery K. They remain business and life partners until their deaths a few weeks apart in 2003.

February —*The Post* reports that a Chinese delegation canceled a visit to the Corcoran after learning that a facetious inter-office memo suggested the group be escorted in via a back door so they would not see the 15-foot-high Warhol portrait of Chairman Mao.

March —Thirty-one year old Frederick Hart (1943-1999), after being awarded the commission in late 1974, begins work on the Creation Sculptures of the west façade of Washington National Cathedral. They include three tympana carved in Indiana limestone: *Ex Nihilo (Out of Nothing), Creation of Day* and *Creation of Night,* and three trumeau figures, *St. Peter, St. Paul* and *Adam.*

October—*Womansphere*, a visual and perfoming arts festival, opens at Glen Echo Park. Co-sponsored by the Washington Women's Arts Center and the National Park Service and organized by Barbara Frank and 20 other volunteers, it features over 50 events, including performances by singers, dancers and actors, crafts persons and a 100-woman art exhibit attracting over 4000 visitors over three days.

## 1976

July—In celebration of the Bicentennial, the Corcoran displays a 165-by-12-foot, red white and blue plastic banner by Mimi Herbert across the museum façade.

November—An exhibition the *Treasures of King Tutankhamun* opens at the National Gallery of Art. Record crowds visit throughout the six-month run.

## 1977

April— Memorial shows open at the Bader Gallery, The Phillips and American U. for longtime Washington printmaker, painter and teacher Leonard Maurer (1912-1976). The *Post's* Jo Ann Lewis laments that such a "hard-working, traditional craftsman" was often overlooked in "the trend-tossed 60s."

## 1978

June— Leni Stern sells her share of the art collection that she and former husband Philip Stern acquired over several decades. Handled by Pyramid Gallery, the sale includes works by Noland, Krebs and Truitt, the proceeds to benefit an orphanage in Mexico where Stern plans to live and work.

September —*The First Annual Edible Art Event* opens at the Local 1734 Collective on Connecticut Avenue. *Post* food critic Phyllis Richman, in deep disguise, juries the show and awards first prize to Vitello Tonnato's (artist Mariah Josephy's "nom de cuisine") *Nude Descending a Staircase* (after Marcel Duchamp*)* made of chopped liver, parsley, rutabaga, pickle fronds and sweet potato leaves.

15. Corcoran with Mimi Herbert's bicentennial banner

16. Leonard Maurer

17. *Nude Descending a Staircase* by Vitello Tonnato (aka Mariah Josephy)

185

18. Ed Love, *Screaming Figure on Gallows*, 1979

19. President Carter presents award to
Howard professor Lois Mailou Jones.

## 1979

Summer—*Wash Art '79* fair at D.C. Armory attracts 1,500 visitors and more than 100 dealers from 14 countries, among them Ramon Osuna and Jack Rasmussen. A Larry Rivers *Dutch Masters* sells for $150,000.

Fall—*City Art '79*, organized by the Studio Gallery and juried by Ken Young, Miranda McClintic and Lynda Roscoe Hartigan, installs shows at the Studio Gallery, Martin Luther King Library, windows of the Lansburgh building, sidewalks along 8th Street and an empty lot on Pennsylvania Avenue.

Walter Hopps leaves the Smithsonian National Collection of Fine Arts, where he had been curator of 20th-century art since 1972, eventually relocating to Houston in the 80s, to serve as consultant for the Menil Foundation museum and its first director.

December— *Washington Review* gives 18 awards for "Outstanding Contributions to the Artistic and Cultural Life of Washington" to, among others, D.C. Space and Fondo Del Sol.

## 1980

President Jimmy Carter presents an Outstanding Achievement in the Visual Arts award to Lois Mailou Jones and nine other artists. She and James L. Wells, a Harlem Renaissance pioneer, are senior faculty members of Howard University's art department, where Jeff Donaldson is also a prominent figure.

Winter—Spring *A Different Light* at WPA summarizes '70s Washington photography with 300 works. Critic Paul Richard notes a sense of consolidation among photographers in contrast to the many directions pursued by Washington

painters and sculptors during the decade.

June—The National Endowment of the Arts awards its top Artist's Fellowship Awards of $10,000 each to Jerry Clapsaddle, Tom Green, Ed Mayo and William Willis. Glassmakers Margie Jervis and Suzie Krasnican of Fall Church, Virginia, share a $10,000 award.

Summer—The Eleventh International Sculpture Conference floods Washington with exhibitions, events, sculptors and site pieces, from Rockne Krebs's spectacular laser work for the Lincoln Memorial, which runs several hours each night, to J. Seward Johnson's entertaining, traditional, ultimately beloved bearded bronze "giant" at Hains Point.

Fall—The 406-7th Street building opens, brainchild of developer Bobby Lennon, whose other projects include d.c. space and ARTransport. Framer T. Moore Hynes sets up shop in the basement. Next door are Eric Rudd's *Making Waves*, a hot-tub salon, and an art space where Gene Davis exhibits his large-scale silhouette *Heads*.

## 1981

The art world mourns the deaths of Dr. Joshua C. Taylor, 63, director of the National Museum of American Art (now the Smithsonian American Art Museum), and Joseph H. Hirshhorn, 81, the one-of-a-kind, Latvian-born art collector responsible for the Smithsonian museum bearing his name.

Lansburgh's, a former department store at 8th and E streets N.W., and the nearby Le Droit and Atlas buildings, under the direction of Philip Ogilvie and the D.C. Foundation for Creative Space, thrive as centers for community arts groups, publishers, studios, art- making workshops and installation projects. *The New Art Examiner* and lobbyists for state arts agencies and artists associations set up shop on F between 11th and 12th.

*The Washington Review* publishes its August-September issue as a "23-foot mass-produced art object"—a scroll— with conjoined compositions by H. Terry Braunstein, Lee Haner, Lisa Gladstone, Alec Dann, Sue Hoth, Julie Lea, Kevin Osborn and Michael Reidy. In later issues, museum curators Harry Rand and Phyllis Rosenzweig, also poets, contribute written works. The publication continues to embrace D.C.'s

20. Rockne Krebs's lasers at Lincoln Memorial

21. Patron-sculptor J. Seward Johnson's *The Awakening*, a conference site piece that stayed put and became a beloved local landmark, relocated in 2009 to National Harbor, downriver in Maryland.

22. Gene Davis with large and small silhouette heads at his underground home studio on Harrison Street N.W.

23. Kaprow's joyful havoc on 7<sup>th</sup> Street

black poetry movement.

Pyramid Atlantic Art Center is founded in Baltimore by Helen C. Frederick. Soon moved to Silver Spring, Maryland, it advances innovation in printmaking, papermaking and the book arts and becomes nationally known.

November 22—Allan Kaprow, the New York inventor of "happenings," comes to D.C. to stage a parade down 7th Street with drums, whistles, ceremonial staves, garbage bag decorations, rolling tires and performing children.

## 1982

Walter Hopps's *Poetic Objects* show at WPA intermingles art from D.C. (Noche Crist, William Christenberry, Sam Gilliam, Rockne Krebs, Janet Schmuckel, Yuri Schwebler, Carroll Sockwell) with Chicago, California and New York art (Don Baum, Alexis Smith, Robert Morris and others.)

February—The Corcoran opens *Washington Photography: Images of the 1980s*, curated by Frances Fralin with works in color and black-and-white by Melinda Blauvelt, William Christenberry, Frank di Perna, John Gossage, Arnold Kramer, John Balfour McIntosh, John Radcliffe, Claudia Smigrod, Steve Szabo and Shirley True.

Summer—*From D.C.: Ten Washington Sculptors*, curated by the Hirshhorn's Howard Fox, opens in San Francisco in conjunction with the 12th International Sculpture Conference in Oakland.

November 11—Maya Lin's Vietnam Memorial is dedicated near the Lincoln Memorial, thanks to the efforts of Washington-born- and-educated veteran Jan Scruggs, who conceived the idea. Two years later, after veterans groups protest the abstract conception and below-ground siting, Frederick Hart's figurative counter-memorial is dedicated.

Open Studios are initiated with the support of C&P Telephone and continue throughout the city and suburbs. Dozens of artists participate and audiences grow.

## 1983

International Neo-Expressionism comes to D.C. as Middendorf-Lane Gallery's *New Painting: Americans* introduces four New Yorkers. The "Expressionisms" section of the Hirshhorn's *Directions 1983* adds Los Angeles to the mix, and its *New Romanticism* show covers, in part, Italy's take on expressionism. The figurative resurgence in contemporary art interests such New York-savvy D.C. collectors as Robert Lehrman, Anita and Burton Reiner, and Aaron and Barbara Levine.

## 1984

The art crowd and other spectators watch Sankai Juku, Japan's vanguard dance troupe in the Butoh tradition (a District Curators booking), launch its fall run in D.C. with an outdoor performance at Freedom Plaza. Three male dancers wearing only loincloths, their bodies painted white, grip ropes and slowly lower themselves, head-first, from the National Theater rooftop to the street below.

Jeff Donaldson, a co-founder of the late 1960s AfriCobra group (African Commune of Bad Relevant Artists), becomes Associate Dean of Howard University. A prominent figure there (painting professor, department head, museum director) since moving from Chicago in 1970, Donaldson promotes "Trans-African" symbols and images uniting U.S. Black Power with African and Caribbean independence movements.

October—Officials in Portland, Oregon, dedicate *Portlandia*, a 35-foot-high allegorical figure by D.C. area sculptor Raymond Kaskey. The piece marks the entrance to a 1982 postmodernist municipal building by Michael Graves.

## 1986

Painter and printmaker Jack Boul, a longtime American University faculty member, joins colleagues at the progressive Washington Studio School.

Washington Women's Art Center on Q Street emerges as a key forum and exhibition space for women.

24. A Sankai Juku dancer descends into Freedom Plaza.

25. From Herb's P Street days, a picture spread by *The Georgetowner* (June 11-24, 1982)

26. The Art Attack team, artfully photographed in Kassel—left to right: Jared Louche (nee Hendrickson), Evan Hughes, Lynn McCary and Alberto Gaitán

The Washington Art Dealers Association, generating symposia, exhibitions and awards since 1981, makes official its support of the Artist Rights Amendment in Congress.

## 1987

Summer—*Washington Square Sculpture '87* presents the work of 30 artists in a spacious office-building atrium on the southwest corner of Connecticut Avenue and L Street N.W. The Abramson family, owners of the property, encourages the exhibition and helps ensure the series continues in subsequent years.

Fall—Herb's Restaurant, an art life staple operated by raconteur-collector Herb White since the l970s, reopens at 17th and Rhode Island. Previous locations are Columbia Road and P Street.

Evans-Tibbs Gallery, devoted primarily to African-American art but often including European and European-American modernism, closes after several decades of operation at 1910 Vermont Avenue N.W. Co-owner Thurlow Tibbs, Jr.'s bequest of 1997 transfers the holdings to the Corcoran Gallery of Art.

Art Attack creates a warehouse installation for K-18, a *Documenta 8*-related survey of international group art in Kassel, West Germany.

## 1988

January—Independent curator J.W. Mahoney's flagship exhibition making a case for D.C. spiritualism, *Transcendence*, opens at Baumgartner Gallery, with works by Leon Berkowitz, Tom Downing, Simon Gouverneur, Howard Mehring, Caroline Orner, W.C. "Chip" Richardson, Robin Rose, Andrea Way and William Willis.

The 57 O Street studio/exhibition building celebrates its tenth anniversary. A nearby industrial space, 52 N Street, has been adapted for artists and pop-up shows since 1983.

September 25-26. The Coalition of Washington Artists Congress is presented at the Corcoran with the participation of over 30 artists, curators, administrators, critics, publishers and educators. Among the subjects debated: the what and whys of artists' organizations, curatorial responsibilities to artists and the need for an institute of contemporary art.

Fall—At the end of Reagan's second term, and within days of George H. W. Bush's election, Polish artist Kryzsztof Wodiczko's presents a three-night photographic projection on the Hirshhorn exterior. A microphone and presidential hands holding a candle and a pistol comingle themes of coercion, propaganda and hope.

December—*Recollections: Washington Artists at WPA, 1975-88* offers a comprehensive view of area vanguard activity with more than 100 works by 62 artists.

27. Congress panelists Rockne Krebs, Alice Denney, Jack Rasmussen, Sue Green, Jack Perlmutter and Sam Gilliam. The subject: Washington's past as an art center.

## 1989

Intermedia Arts in Minneapolis and Franklin Furnace in New York present, for the first time, all three segments of Sherman Fleming's *Western History as a Three-Story Building* performed by Fleming with D.C.-based art historian/performance artist Kristine Stiles. Included is the dual-race, nude prologue that had created a sensation at d.c. space two years before.

Several local galleries participate in *Focus D.C.,* celebrating 150 years of photography. Also marking this sesquicentennial is *The Photography of Invention*, a national survey of 1980s work at the National Museum of American Art (now Smithsonian American Art Museum). Co-curators Merry Foresta and Joshua Smith, an independent scholar-collector, focus on the staged photography genre that has largely bypassed Washington.

March —Senator Alfonse D'Amato, on the Senate floor, tears up a copy of Andres Serrano's photograph *Piss Christ*. A later *New Art Examiner* cover reproduces the work and asks, "Will

28. Wodiczko's projection, a Reagan nod, on the Hirshhorn

this Photograph bring down the NEA?" Meanwhile in New York, Richard Serra's *Tilted Arc*, another target of anti-arts funding, has been consigned to a scrap heap.

June 30—The Mapplethorpe projection.

At year's end, Jock Reynolds leaves WPA to become Director of the Addison Gallery in Andover, Massachusetts, assuming the directorship of the Yale University Art Gallery in 1999.

## 1990

*Black Art—Ancestral Legacy: The African Impulse in African-American Art* travels the country after its premiere at the Dallas Museum of Art. Washington artists Lois Mailou Jones, Ed Love and Renee Stout are prominently represented in the exhibition, and University of Maryland artist-scholar David C. Driskell contributes to the catalog. The tour bypasses Washington but includes the Virginia Museum of Fine Arts in Richmond.

Chris Gardner, who has been commissioned (in 1988) to produce Arlington, Virginia's, first city-funded sculpture on public land, creates a 25-foot-high, to-scale prototype which he exhibits in 1991 at the National Building Museum. The final piece, *Cupid's Garden*, features twisting, turning arrow forms in stainless steel stretching some 75 feet from end to end. It is completed in 1993 and dedicated, after landscaping details are finalized, on Valentine's Day 1994.

29 Chris Gardner with the scale model of his *Cupid's Garden* at the National Building Museum

# Afterword

## ART LIFE ON THE EDGES

BY BENJAMIN FORGEY

On a brisk morning in 1974 a couple of plows operated by National Park Service drivers swung into action on the grounds of the Washington Monument. This was no ordinary snow removal. The plows were following straight line routes conceived two years earlier by D.C. sculptor Yuri Schwebler.

His intent? To transform the great obelisk literally (if temporarily) into the gnomon for the world's largest sundial; to raise our awareness of the form's ancient ties to the sun; to remind us, on a suitably monumental scale, of the tick-tock of time's passing hour by hour, eon by eon.

Schwebler's friend, *Washington Star* photographer (and licensed pilot) John Bowden, took the artist into the air to get the decisive view, but the site-specific piece was transformative on the ground as well. Those hour lines in the snow focused attention on the monument as if they were imaginary boulevards in L'Enfant's plan.

Six years later, at maybe 10 o'clock on a clear June night in 1980, while pausing in my car at a stoplight facing south on 16th Street N.W., I was hailed by the driver of a car full of college-age folks who had pulled up in the adjacent lane. "Whoa, man," said the driver, "can you tell us what that is?"

The young man was referring to a mysterious beam of green light overhead, originating at the Jefferson Memorial and soaring northward over the central point of the White House pediment. It could be seen all the way up perpendicular 16th Street to Silver Spring and beyond. The beam, of course, was part of *The Source*, Rockne Krebs's stupendous laser installation that updated and expanded upon the symbolic geometries of the city's 18th-century plan.

Like Schwebler's piece, Krebs's made one feel extremely happy and proud to be alive at a particular time and place in Washington, D.C.

As a follow-on to the revelatory work of my colleagues, in their decade-by-decade accounts, I can think of no better way to start what I would like to be a love letter to Washington as an art city than to cite these two rare, ephemeral, thoroughly magical moments in the city's proud art history.

This uniquely beautiful city is of course the incredibly impressive capital of the United States . . . and it is an important art city, too. It's just that, sometimes, people don't quite recognize that second fact.

1. PREVIOUS: For the duration of a single snowfall in 1974 the Washington Monument became the world's grandest sundial. This photograph shows one of the plowed hour-lines conceived by sculptor Yuri Schwebler on a scale reminiscent of the boulevard's in L'Enfant's original plan for the city.

2.–3. This altered photograph is one of Schwebler's original 1972 drawings showing his vision for the sundial piece, with its radiating lines. Execution of the definitively site-specific art work had to wait two years for the weather to cooperate. Snow plow operators of the National Park Service were able to follow Schwebler's directions on a snowy day in 1974, as shown in aerial photograph on the left.

Hmmm. Did I say love letter?

Yes, and I meant what I said. But I do have to issue a little warning. As a declaration of love, this essay is destined to seem a bit, well, complicated. Certitude is certain to be tempered here by ambivalence, passion to be shadowed by poignancy, pride to be nagged by righteous dismay.

Could it be otherwise? I don't see how. All vital cities are complex, confounding, contradictory creatures, but Washington is so in its own highly particular way. For example, everybody knows about "The List." That is, anyone who has been anybody in the Washington art world for more than 15 minutes can recite a tired list of negatives forward and backward and forward again. Then again, anybody who has spent 15 minutes or more discussing the art scene on street corners, at parties and in studios, galleries,

office cubicles, kitchens, dining rooms, living rooms, basements, bedrooms and bars can run through an impressive roll call of positives. In many cases, the categories match up precisely.

Yeses and nos! Cons and pros! How does it all add up? Equally important questions, for an afterword, are what has changed, and what hasn't? Is Washington still growing as an art center, or has it left its better days behind?

The city's first great work of art was its street plan, composed during an inspired flurry of work in 1791 by an immigrant engineer, Peter Charles L'Enfant.[1] This audacious plan—this leap of imagination—did what a work of art must do to be judged as "great": It used the materials at hand to transform the relevant precedents, while opening vistas for the future.

The materials in this case were the plains, bogs and hills alongside the broad Potomac River, the site chosen by George Washington to become the capital of the new nation. The precedents were monuments of Baroque planning dedicated to the glory and comfort of kings, queens, earls, popes, bishops and all the fancy baggage of Europe's tired hierarchies. The vision was to boldly adapt these planning strategies to the needs and ambitions of an experimental form of government—representative democracy—and to confidently provide for its stability and growth far into the future.

A profound idealism, in other words, is embedded in Washington's wide avenues and tree-lined streets, its traffic circles and long vistas and powerful monuments, both functional and symbolic. One tends to forget about this inspirational quality in the day-by-day press of things, but it's a potent residue. Ever so often, it just hits you: the city, its beauty, its exalted goals, its boundless potential—an astonishing urban package.

Unfortunately, but inevitably, the reverse is also true: One consequence of starting with such high intentions is a sort of perennial frustration. Disillusion is an enemy that must be kept at bay, especially in the messy business of democratic politics—but not just politics. It amounts to a positive-negative rhythm that affects many aspects of life in D.C., art life most assuredly. Expectations are always high and high goals are met, but disappointments, one learns to suspect, may lurk just around the corner.

Oddly enough, Washington has a similar problem in what we might call its external relations. Lots of Americans hate Washington, or say they do. The city is a symbol of evil or, at least, of "what's wrong with America" for hundreds of right wing politicians and uncountable thousands of their followers. Running "against Washington" is a staple of the political scene. And yet, voting with their automobiles (and feet), Americans of all political stripes love their capital city. They come by the millions in the spring, summer, fall and even winter to revel in the city's

beauty and symbolism, to walk the Mall's long distances and to visit the monuments, memorials and museums.

I'm not sure how many of these visitors think of D.C. as an art city—probably not a large percentage—but they keep the turnstiles turning not only at the Air and Space and American History museums on the Mall but also at the 20 or so major art museums that dot the city, from the Mall to downtown to the neighborhoods. This popularity, indeed this inundation, paradoxically helps to explain why the museums are at the top of "The List" in practically everybody's mind.

Museums without question are the glory of the Washington art world. The formidable array of public and private art institutions devoting space, time, money and expertise to collecting, preserving, interpreting and exhibiting the world's art (a bit of it, yes, from Washington) has few rivals around the world. The number of high-quality museums *alone* makes Washington an art capital.

Ironically, this glorious assembly of art institutions also is, to a significant extent, the bane of the Washington art scene. But this is a love letter, after all, and it must be noted that the potential for change definitely does exist. Almost all of these institutions do have at least a peripheral involvement in contemporary art, and all are permanently there for artists as sources of information and inspiration. For maybe a dozen or so, the modern and the

contemporary are major foci. Many of them do from time to time add important pieces made in or around Washington to their permanent collections and some do sometimes take the time and effort necessary to mount exhibitions of art by one or more Washington artists. On occasion, they even cooperate in this mission, as in *ColorField.remix* of 2007, conceived by the Kreeger Museum with the participation of some 30 galleries and museums and focusing primarily on the Washington Color School—a useful and sometimes thrilling look back.[2]

The fact remains, however, that a majority of Washington's major art museums continue to operate as if they were located in some neutral—almost extraterrestrial—space, rather than in a living city with a vibrant art culture. The routine defense? They have a mission to serve national and international audiences. This is, of course, a worthy goal and even a legitimate legal claim for those institutions supported primarily by federal tax dollars. (The magic of so much museum-going in Washington: Free admission! One wonders only how long it can last.) Trouble is, this high goal and the aim of supporting the Washington art scene in consistent, imaginative, creative ways are quietly considered to be mutually exclusive by most of the powers that be.

Logically, this separation need not be the case. Ethically and, we might say, ecologically, it *should* not be so: Do not enlightened self-interest and proper sense of duty require one

to nourish one's home environment? To view with affection and support the people, institutions, histories and social relations that surround one every day? To feed the soil in which one is able to flourish? The answer from most of the larger museums to such important, even urgent, questions, in effect, has been "no." In the long run, for the Washington art world to thrive as it should and can, this "no" must be turned into an emphatic "yes."

Actually, sad to say, things have been getting worse of late at two of the city's key private art institutions—The Corcoran Gallery of Art and The Phillips Collection—whose past importance to the Washington art scene can hardly be overstated.

The great old Corcoran, with its distinguished building, high sky lit galleries, outstanding American collection and attached professional art school, used to hold down a central position in the Washington art world. With its biennial exhibitions of contemporary American art, its (almost) annual Washington area shows, and important, innovative solo and group exhibitions of Washington work on more or less an annual basis, the Corcoran was a vital force. But in the last two decades, with but occasional exceptions, such as Jonathan Binstock's brilliant Sam Gilliam retrospective in 2005, Washington has figured hardly at all in an erratic schedule of exhibitions. To say the Corcoran has lost touch with the regional art community is to put it mildly. Today, it is something of a basket case.

First, there was the bold vision that turned into a fiasco, followed by what could turn out to be a full-fledged disaster. The first blow was the failure of director David Levy's plan to add a radically contextual new wing designed by Frank Gehry, one of the world's best and most innovative architects. The project took up most of the institution's energy for a decade and a half, but sadly collapsed in the mid-'oos bust of the tech economy.

In my view this was a great shame. With its elegant, wavy walls (initially designed to be sheathed in marble matching the main Corcoran building), the addition would have unified the south block of New York Avenue in a startling way and have made a stunning aesthetic statement in a city known for its architectural reserve. The towering atrium inside, majestic in a dynamic new way, would have been a spiraling spinal cord leading to a sequence of impressive galleries. (It must be said that Levy only hinted at the marvelous new art collections that would have filled these spaces—a very big if.) So, we're left to imagine the galvanizing ripples this great construction might have sent out into and from the Washington art world—equivalent, say, to the opening of the Tate Modern in London back in 2000. This could have been an achievement for the city and its contemporary culture to build upon.

This grand flop was followed by a floundering half decade during which the Corcoran seemed

to drift ever farther from its historic mooring in the Washington art community. On June 4, 2012, board chairman Harry Hopper III and director Fred Bollerer confessed as much when, shockingly, they announced that the historic Corcoran building was up for sale to the highest bidder. The museum, its collections and its College of Art and Design in the meanwhile would consider alternative locations, possibly in the Washington suburbs.

Then, three months later, the board announced a possible union with the University of Maryland. Whew! Saved by the bell! Or, more accurately, in the form of a question: Saved by the bell? It would be hard to imagine a greater failure of vision and leadership on the part of the Corcoran board and director over a period of eight years, from 2005 - 2013. Whether partnership with a university six miles away is the answer remains to be seen. (Collaboration with nearby George Washington University would have made a lot more sense). Each institution clearly has something to offer the other, but the Corcoran has much, much more to lose—its independence and its vital connection to the Washington art world. At the time of this writing, both sides are talking a good game, but as yet no one in a position of authority has come up with a inspiring vision to lead the wounded old Corcoran back to the promised land.

Turning to the great old Phillips, we shift gears from contemplating disaster to dealing with mere disappointment—although mere is

perhaps not quite the word. For me, the word severe would work. The Phillips has undergone a major, necessary transformation from the decades when it was a private house museum, run as a beneficent autocracy by Duncan Phillips and his family. By many measures, the change has been successful. The museum now has an accomplished curator/art historian as its director (Dorothy Kosinski), an active, supportive board, a large professional staff, a next-door expansion for staff, educational programs and, most critically, space for much-needed storage and care of its priceless collections.

But direct support of Washington art, once a key aspect of the Phillips's annual exhibitions activity, has largely disappeared. Through many decades, but especially during the 1970s, 1980s and parts of the 1990s, shows of work by Washington artists were frequent and imaginatively conceived, and through much of the museum's history artists gathered at the Phillips as at the home of an enlightened friend. (A good many of them worked there too.) Now, at least as reflected in its exhibitions, the Phillips is more like a distant, icy relative who just happens to occupy the old family manse (and its rather unmanse-like additions). Why can't this valued institution be both intensely and creatively friendly to Washington art and also a necessary stop on the art tourist's itinerary? Good question.

# WASHINGTON MUSEUMS: UPS AND DOWNS

4. Frank Gehry's planned "radically contextual" addition to the Corcoran, at once startling and elegant, would have handsomely complemented the original building and have transformed the 1700 block of New York Avenue into one of the more enticing and surprising in the city. The innovative design would have been a stimulant in an architecturally cautious city but, alas, the project proved to have been an ambitious overreach.

5. This "spiraling spinal cord" would have been the central space leading to galleries behind Gehry's wavy façade for the proposed addition to the Corcoran. Washington has quite a few magnificent, monumental interior spaces, but this one would have been dynamic, mysterious and light-filled in an entirely new way.

6. Facing Ward Circle "in a self-conscious blaze of monumentality," the Katzen Center for the Arts on the campus of American University has been a significant haven for past and present Washington art since its opening in 2005.

7. Popping under and through the mighty Hirshhorn doughnut like an equally mighty, if playful, balloon, the proposed "Seasonal Inflatable Structure" would have been, if built, a striking venue for periodic global get-togethers examining the state and stakes of art in the 21st century.

203

There is uncertainty on the Mall, as well, with the apparent collapse of director Richard Koshalek's dazzling plans to transform the Hirshhorn Museum into a global showcase for new ideas. The transformation was to have had its architectural symbol in the "Seasonal Inflatable Structure" designed by the New York firm of Diller, Scofidio + Renfro. This extraordinary "tempo" would periodically have popped out, balloon-like, from the sides and top of the central courtyard of architect Gordon Bunshaft's mighty cylinder, to house programs for the exchange of ideas about the changing nature of art in a changing world. But boardroom ambivalence about the "bubble" concept and rising cost estimates led Koshalek to resign in the late spring of 2013 (effective at year's end), leaving the future of the concept and the structure in precarious limbo.

Koshalek's technology-friendly changes, international initiatives and "issue-driven" programs and exhibitions may yet have broad implications for the future of contemporary museums, but with his departure it is plausible to assume that they'll have to happen somewhere else. However, it is pertinent to note here that Koshalek's ambitions never seemed to pay much attention to D.C. as a city with its own vigorous art life. Was Koshalek doing Washington artists a favor by attaching this major museum to the worldwide communications revolution? Or were his the same old highfalutin' blind-to D.C.

attitudes in a dynamic new suit of ideological clothes? We'll probably never know the answers.

But all is by no means lost. American University has played an important, though gradually diminishing, role in the D.C. scene from the time its art department was founded back in the 1940s. But though delightful to visit, the tiny, post-Quonset-hut Watkins Gallery, tucked away in a nook on the A.U. campus, was modest almost to the point of invisibility.

The same definitely cannot be said of the new American University Museum, housed in the Cyrus and Myrtle Katzen Center for the Arts, which opened in the spring of 2005. (Not incidentally, Cy Katzen's money was made mostly in local real estate). Facing Ward Circle in a self-conscious blaze of modernist monumentality (designed by the Washington office of EYP architects), the building contains, in addition to the university's art, theater, dance and music departments, a whopping 24,000 square feet of soaring, curvilinear exhibition space. Curvy walls and eccentrically-shaped spaces are not generally favored by museum folks because they make installations difficult, but, nonetheless, Washington art vet Jack Rasmussen leapt at the chance to become director and to fill those spaces with adventurous art from around the world and—most emphatically—art made in the Washington region.

Rasmussen's guiding idea has been to treat the Katzen building as a *kunsthalle* in the European

mode, sponsoring and hosting contemporary exhibitions, while occasionally and appropriately trotting out examples from the museum's permanent collection of some 5,000 objects. Not incidentally, Rasmussen's beginnings in the art world trace back to his curatorial apprenticeship in the 1970s under Alice Denney at the Washington Project for the Arts, which doubtless helps to account for his flexibility and openness to experimentation and controversy. Among his earlier exhibitions, for example, were Fernando Botero's scathing works on the treatment of prisoners at Abu Ghraib and a spirited tribute to the deceased Washington art dealers Marc Moyens and Komei Wachi. With his catholic taste and intimate knowledge of the nooks and crannies of the Washington art world and its history, Rasmussen has made the Katzen into a sort of living encyclopedia of Washington art, every year *averaging* more than four solo exhibitions devoted to the works of Washington area artists, each with its own (sometimes rather skimpy) catalog. Every year, too, there have been at least a couple of focused regional group shows.

The A.U. museum under Rasmussen has been sophisticated, opportunistic and tirelessly supportive of the local scene. It is edgy, in a good way, but it's also sort of a one-man band operating without much curatorial or scholarly support out there on the northwest edge of the city. Close by, it should be noted, is the Kreeger

Museum in its Philip Johnson-designed mansion. With limited resources, the Kreeger under director Judy A. Greenberg has been supportive of D.C. art, most recently in a joyfully provocative sound-and-assorted-stuff installation by Dan Steinhilber in the fall of 2012 and in May, 2013, a commanding outdoor exhibition of large-scale abstract sculptures by John L. Dreyfuss.

As it happens, edginess in both senses— creative stimulation and lonely isolation—are characteristic features of the Washington art world. Hence, the title of this essay.

The elephant in the room of D.C. edginess is none other than the city's reason for being. That is, the omnipresent federal government itself. It's a fact: The widespread dedication to the acquisition, perpetuation and disposition of power on a national scale—and its blanket coverage by the local and national media— absorb much of the ambient oxygen. Not surprisingly, this condition leaves innovative artists and art institutions gasping for breath out on the edges. Yet, as so many artists and art aficionados have proven in the 50 years covered by this book (and as they and those who followed continue to prove) life on the edges has its rewards in generous helpings of creative freedom, discovery, excitement, productivity and, above all, artistic quality.

Yes, there are incidental advantages to the federal presence, such as the General Services Administration's art requirements for new

federal buildings or the State Department's Art in Embassies program. Definitively, there are incidental disadvantages as well, as when Congressional nitwits decide to play censor, e.g. Mapplethorpe in 1989, or David Wojnarowicz at the Smithsonian's National Portrait Gallery in 2010. Come to think of it, the censorship issue can't be dismissed as merely incidental. It's Big Brotherism on our very doorstep, and it has its silent, depressive effects on museum directors and curators throughout the system.

Year by year the biggest direct effect is this: The omnipresent federal government is like an enormous economic security blanket. Washington and its surrounding suburbs are enviably wealthy (although here as elsewhere the wealth is, to say the least, unevenly distributed), and the main reason is government, pure and simple. Its direct payrolls and its long-term contracts with private companies insulate the region from the worst effects of most economic downturns. And, in reality, the influence is much broader and deeper than that and has had very real consequences for the Washington art world.

Money is not central to the making of art. Artists would continue to do what they do were they paid purely in emotional appreciation and intellectual understanding—a sophisticated kind of support not lacking in Washington. But, leaving aside that philosophical nicety, money is, of course, high on The List, as it would be in the consideration of any complicated socioeconomic micro-system such as an "art world." The common complaints are that not enough money is made right here in the D.C. region and that too much of what is made here isn't spent on art or is frittered away elsewhere, in New York or London or wherever. These complaints are oversimplified, but there is just enough truth in them to make them hurt, especially when one compares Washington to the world's industrial and financial dynamos.

George Washington dreamed differently. He envisioned his eponymous city as an economic powerhouse because of its strategic position on a mighty river linking the vast natural resources of the west with the ports and commercial resources of the east. But the collapse of that dream can be traced back directly to the day in 1835 when the first Baltimore and Ohio train pulled into D.C. Sure, those sturdy drays for years continued to pull cargo barges up and down the Chesapeake & Ohio Canal, but trains effectively signaled a different fate for the capital city. It took ages for Washington the city to grow into L'Enfant's capacious scheme, and, by and large, politics and governing have remained the city's chief "industry."

William Wilson Corcoran was one of the first private citizens to benefit in a major way from this state of affairs. He made his money mainly by doing business with the federal government, by helping, for instance, to finance the Mexican War. Corcoran was atypical in one big respect: He

did spend a whole lot of his Washington-made money on art, as we can see most succinctly in the inscription above the door of the first of the museum buildings to bear his name (today's Renwick Gallery): "Dedicated to Art."

Otherwise, Corcoran's career signaled the direction the Washington economy was to take. Serving the federal government, rather than making great quantities of useful things or even transporting them, became the region's lifeblood, and by and large, still is. The city's two principal "other" industries—lawyering, and the building, buying and selling of real estate—remain heavily dependent on the feds. (Lobbying might qualify as a third industry, but basically it's a subset of governing *and* lawyering.)

So, although lots of money has been made here, it has up until recently been money of a certain kind. Cautious money, you might call it, especially as far as collecting and otherwise supporting art is concerned. To be sure, K Street law firms and even real estate empires have propped up many a local gallery, but, to adorn their thousands of linear feet of wall space, they've generally preferred beautiful abstract paintings, luminous landscapes, bucolic idylls— art without obvious commentary, a silent sort of governing taste.[3]

This is not to say there have not been adventurous art aficionados—otherwise, how to explain the amount of edgy art produced here or the long run of an art emporium like Gallery

K (the Moyens-Wachi operation). Artists will do what they need to do, and a lot of them, in and around Washington, clearly enjoy challenging or even taunting the prevailing calm. Curator J.W. Mahoney posited the idea of an alternative "Washington School" in his manifesto for "Signals," an exhibition with works by 40 area artists staged at the District of Columbia Arts Center (DCAC) in the fall of 2012. The "School," Mahoney wrote, "consists of renegades and outliers . . . functioning as anomalies, working under the radar." [4]

Things have changed quite a bit on the money front in the last couple of decades, with the development of sophisticated technology sectors in Northern Virginia and close-in Maryland counties. I wouldn't at all say that dependence of the feds has disappeared, but the ties that bind definitely have loosened. Nor would I exactly call this infusion of new capital *in*cautious, though it comes with sizable risks, as we witnessed in the collapse of Levy's Corcoran dream. Certainly, though the effect of the more dynamic regional economy has been hard to measure precisely, it has all in all been positive.

One can see the effect most graphically, perhaps, in the dramatic amount of construction of new or expanded legitimate theater facilities in and around the city, but it's been apparent in the art world, too. The welcome demise of quiet, segregated, backwater Washington—the city of "northern charm and southern efficiency," as in

JFK's famous quip—is well documented in this book. And the pace and extent of change have only picked up in the last 20 years—a visitor from 1990 would hardly recognize whole swaths of the growing, transforming, ever more cosmopolitan Washington of today. (Although we can't get too carried away. This visitor from two decades past surely would be all too familiar with the income and ethnic inequalities that still divide the city.)

The transformation of the "old downtown," the historic core of the city east of 15th Street where the art world for a time claimed pockets of its own, is almost shocking. By 1990, years of real estate speculation and disinvestment had produced block after block of vacant storefronts, decaying historic buildings and huge surface parking lots for daytime office workers. (At that time, the pioneering efforts of the federal government's Pennsylvania Avenue Redevelopment Corporation had yielded but a trickle of tangible results, and Mayor Marion Barry's call for a "living downtown" seemed nothing more than a sad whistle in the wind.)

Today those same blocks bustle with sleek new office buildings, a sprinkling of reconditioned public and commercial structures and, most notably, apartment buildings, cooperatives and condominium residences. A new generation of younger people with steady jobs and good incomes seems to be taking root in Penn Quarter and, further north, in the busy borderlands of NoMa (for North of Massachusetts Avenue), Shaw and central U Street.

I'm not sure what the long-term effects of this remarkable youthification-gentrification will be on the art world, but it does mean there is a large, well-heeled, enthusiastic and (reasonably) hip new audience. Yet unquestionably the transformation of the old downtown has come at significant cost. Renovations and rising rents have forced artists out of studios in the LeDroit, Atlas and similarly beautiful, decrepit and art-serviceable buildings. (Well, sort of serviceable; they were firetraps, too; no artist I know died in one of them, but at least one, Sheila Isham, lost years of her work when her studio burned.)

The same upward spiral of costs also has spelt doom or, at the very least, a change in location for most of the art galleries that had hoped to make profitable homes in the heart of the city. The geographical synchronicity was there, and still is: with just a short walk patrons can tumble into the Smithsonian's two downtown art museums in the Greek Revival masterpiece, the Old Patent Office Building, and with just a few additional paces they can access the practically inexhaustible museum riches of the Mall. The Washington Project for the Arts, Washington's premier alternative space in its splendid renovated digs on the northwest corner of 7th and E Streets, N.W., served as the pivot of what optimistically was thought of as the city's natural art center. Art lovers, art buyers, art

experts and great art—a notable D.C. art dream that didn't work out.

Unfortunately, the dream of a true center for the D.C. region's art world has proven over the years to be elusive. As documented by Jean Lawlor Cohen, Elizabeth Tebow and Sidney Lawrence in these pages, the downtown "center" was preceded—roughly from the mid-1960s to the mid-'80s—by a vital concentration of forces in the Dupont Circle area. For a brief period artists and art lovers had two anchoring institutions—The Phillips Collection and the short-lived Washington Gallery of Modern Art, and a clustering of private galleries, first on the "P Street Strip" and then on the "R Street Strip," complemented by galleries on assorted streets nearby. Thus, for a while, on a given day, near the Circle or downtown, one could expect chance encounters in the neighborhood with artists, dealers, curators, collectors, critics and knowledgeable enthusiasts, all eager to exchange gossip and information.

You could wave to Frank Wright sitting up by the open window in his second floor studio in the LeDroit and go up perhaps for a cup of coffee, and then head down to the spaces in 406 7th or the Zenith Gallery or the WPA for adventurous art and more art talk. Around Dupont Circle, you might run into Tom Downing for spontaneous conversation about the Zen of painting (plus sharp opinions delivered with that charming Virginia smile); or get together with, say,

Henrietta Ehrsam (the delightful "Henri") or Marc or Komei, who between them knew pretty much what every artist in D.C. was up to; or head over for an art argument and a beer or two with fellow critic Michael Welzenbach in his "office" at the downstairs Childe Harold bar.

Nostalgia? You bet! But the point is a serious one. The D.C. scene at present is more decentralized than ever as artists, galleries and non-profits squeeze into ever smaller spaces or, more characteristically, move toward the edges seeking suitable, affordable lodgings. The result is at worst a spread of isolated art outposts, or at best a number of little concatenations as in northern Georgetown, along 14th Street, N.W. just north of downtown, in the new arts district along H Street, N.E., remnants around Dupont Circle. One could argue that, in an age of electronic social media, the notion of a center for information exchange is out of date, but I remain a big believer in the genuine efficacy of art crowds, art people and regular art places.

Here's where I'm coming from: In 2006 at Richard Siegman's PASS Gallery near Dupont Circle, I came across a print by the conceptualist-imagist painter Wilfred Brunner that, I thought at the time, perfectly expressed my inner lament. Characteristically combining images and words, the piece was titled *for arshile* and contained, in addition to a succinct sketch of the young Gorky, a fortune-cookie-like strip floating above a vast lavender ocean with the words: "what

about painting?" A fresh, haunting version of the familiar, plaintive wail about the death of painting? Yes, definitely so, but it took me a while to realize that (1) the question could be interpreted as both lament *and* challenge, and (2) the print was a digital combination of free-hand-drawing, words and manipulated photographic images. Paradoxical. Half in the new world, half out. Like me. Or, as Robert Venturi once famously wrote, "both/and" rather than "either/or".[5]

So, along with being skeptical I'm impressed with the new energy out there and new possibilities for making, communicating and marketing art. The local art blogs are great, the information instantaneous and all over the place. I love the emphasis on experimentalism and service to artists on the part of notable non-profits, like Transformer, the DCAC, the Hamiltonian Gallery and the grand old WPA, and the imaginative ways they make do with limited exhibition space. The WPA's curated annual auction show, held for a limited amount of time in different locations around town, is a makeshift replacement for the Corcoran's old area shows. Beginning in the fall of 2011 the annual (e)merge art fair has provided a welcome bump of energy. In both 2011 and 2012 I saw a lot of good art there, met some folks new to me and ran into friends I hadn't seen up close for a while—it was a little bit like hanging out on P Street or down at 7th and E in the olden days.[6]

I'm also enthusiastic about the fact that New York no longer seems to be the high-on-The-List hang-up it used to be—maybe it's simply that global communications and identities have made geography a bit less fateful. Or possibly we've simply gotten used to living with the fact that New York remains the bigger stage and that, as a result, connections between the two cities have become more fluid. For that matter, artistic connections among the cities and cultures of the world are more fluid than ever before.

What impresses me most about art in Washington is its originality, variety and vitality. In the days that I did so on a more or less regular basis, I would tour the New York galleries and come away refreshed by the knowledge that, on a percentage basis, Washington work stood up to the competition in ambition, imagination and skill. It would do so today, I confidently venture, based in part on the amount of excellent work I see each year as a member of the selection committee for the Franz and Virginia Bader Foundation grants to regional artists. Picking the grantees is really, really hard—heartbreaking in a way, for the quality is high and the needs (for money, materials, time and, above all, space) are extraordinary.

Art space in Washington or, to be precise, the lack of it, remains high on The List for obvious historical reasons: Washington didn't develop any major industry to speak of and so, when industries began to fail in the late 20th century, the city didn't

8. The digital print (*for arshile*) by Wilfred Brunner (2006, 3 6/8 x 11 5/8), with its sketch of Arshile Gorky as a young man, its ocean and cosmic sky, and above all its poignant question, "what about painting?" remains poised between past, present and future.

benefit from the sudden availability of vacated buildings perfectly suited for studio or gallery conversions. (Jack Rasmussen may have a point when he quips that if you could put Baltimore and Washington together you would have a perfect art city—tons of empty old buildings coupled with tons of services and more money!) Still, I wouldn't call the space issue a limitation, exactly, because, after all, it's not really a genuine excuse. And, after all, look what has been achieved with the space at hand: Morris Louis! Alma Thomas! John Robinson! And one-thousand-and-one other Washington artists adept at making do!

The question, what *is* Washington art, has always been asked with what seems to me to be an unnecessary sense of urgency. The underlying assumption seems to be that there needs to be one thing, one set of preoccupations, one look, one style—one label, in effect, that will put Washington on the art world map. But such labels are primarily a journalistic convenience: The Washington Color School, What Came After. In actuality, what defines the vitality of the scene is the variety of intense preoccupations, looks, styles. Identifying and defining one thing, one movement, one mood is always an

important critical/curatorial task, but that one thing is, was and always will be part of a larger, complex whole. The next big thing lasts but a moment. What truly count are the next big, and small, *things*.

Regionalism, by this broad definition, is about the plurality and intensity of visions that occur in a given place at a given time. *New York Times* critic Roberta Smith called this phenomenon "cosmopolitan regionalism" in her perceptive review of "Pacific Standard Time: Art in L.A., 1945-1980," a huge, tumultuous collaboration among more than 100 museums and galleries in southern California in the fall of 2011. Backed by $10 million (!) from the Getty Center, the gargantuan effort proved, among other things, how intensely varied has been the art culture of Los Angeles and its vast surround.

This galvanic grouping of exhibitions, Smith wrote in her ringing conclusion, "is a great argument for museums concentrating first and foremost on local history, for a kind of cosmopolitan regionalism, if you will. It sets an example that other curators in other cities should follow, beginning in my mind with Chicago and San Francisco. If America has more than one art capital, it probably has more than two."[7] Or more than four, we here in Washington would have to insist: NYC, LA, CHI, SF and, emphatically, D.C.!

Of course, as they did in LA for Pacific Standard Time, we should now think of Washington as a powerful metropolitan region including not only the city and it immediate suburbs but also extending out to the Shenandoah Valley, to the Eastern Shore, to Richmond and Baltimore.

As briefly noted in our preface, the book was conceived as a beginning, a push forward, a pointed suggestion to scholars, curators and above all our public and private institutions that they treat the subject of Washington art and its history with the respect and passion it deserves.

I must acknowledge here the poignancy I feel in writing an afterword that will, in an official sense, be the last word directly connected to the noble undertaking that has been the Washington Arts Museum. It is an honor and a privilege to have been asked to contribute. As this essay suggests, however, poignancy is an emotion that fits my take on the act—the thousands of individual acts—of making art in the nation's capital.

One of my favorite Washington art moments never took place. Back in 1974, in celebration of Washington and of the Art Now Festival, Yuri Schwebler proposed the following flight of fancy: A pair of skywriting planes would spell out "HIGH ART" on first pass across a blue dome of sky. On the second pass, they would reverse the word order: "ART HIGH."

Alas, this delightful witticism was destined to remain on the ground. But the idea stuck with those who encountered it, and I've always been able to summon up an image of the piece in

process on a perfect windless day in a spotless
blue sky, reflecting the ideals—and the reality!—
of the beautiful art city that is Washington.

**NOTES**

1 Yes, Peter, not Pierre, because that was the name the
   Paris-born engineer chose to signify his attachment to the
   new nation that, as a Revolutionary War hero, he helped
   to establish. See "Peter Charles L'Enfant," by Kenneth R.
   Bowling, The Friends of the George Washington University
   Libraries, 2002.

2 In a March 3, 2012, lecture on the art market for Color School
   paintings, art dealer George Hemphill informatively, and
   amusingly, discussed K Street tastes and the changing
   mores ushered in by the new tech economy.

3 J.W. Mahoney, "A Washington Manifesto," exhibition essay,
   *Signals*, District of Columbian Arts Center, Fall 2012.

4 Robert Venturi, *Complexity and Contradiction in
   Architecture*, The Museum of Modern Art, New York, 1966,
   citation in chapter 1 and, basically, throughout. Though
   devoted to architecture, this influential theoretical
   tome can also be read usefully as a riposte to the linear
   doctrines of art critic Clement Greenberg, an "either/or"
   guy if there ever was one.

5 The (e)merge event was backed by Donald and Mera Rubell,
   Miami collectors who purchased the southwest hotel
   where the event was held, and who talk of converting the
   empty Randall School nearby (which they also own) for
   commercial and arts uses.

6 Roberta Smith, "A New Pin on the Art Map," *New York Times*,
   Nov. 11, 2011.

# Sources 1940s-1960s

## 1940s

Jonathan Bucci, curator, and Ben L. Summerford, professor emeritus, American University, *Living Legacy: 60 Years of the Watkins Collection.*

Melvin P. Lader, "David Porter's Personal Statement: A Painting Prophecy, 1950," *Archives of American Art Journal*, Vol. 28, No. 1 1988

## 1950s

Gene Davis, "Starting Out in the '50s," *Art in America,* July-August 1978

Sue Scott and Gerald Nordland, *Washington Color Painters: The First Generation*, Orlando Museum of Art, 1991.

Peter Schjedahl, *Simplification, Complications, Mystifications*, review of Mehring exhibition, *New York Times,* April 7, 1968.

Sonia Stein, "Workshop Turns Reluctant Novices Into Artists," *The Washington Post*, May 14, 1950.

## 1960s

Leslie Judd Ahlander, "An Artist Speaks: Gene Davis, " *Washington Post*, December 21 1961.

Legrace G. Benson, "The Washington Scene," *Art International*, Vol. 13, No. 10. (1969).

Jean Lawlor Cohen and Andrea Pollan, *Gene Davis: Interval*, catalog, The Kreeger Museum, April 14-July 31, 2007.

John Elderfield, *Morris Louis*, N.Y.: Museum of Modern Art, 1987.

Benjamin Forgey, "The Third Wave," *The Washington Post* magazine, October 12, 1969.

Benjamin Forgey, "Washington's Bad Case of Cultural Amnesia: The Case for Rediscovering the City's Artists of the 1950s," *The Washington Post*, April 24, 1988, pp. F1-F2.

Hardy S. George, *Breaking the Mold: Selections from the Washington Gallery of Modern Art, 1961-1968*, Oklahoma City Museum of Art, 2007.

Clement Greenberg, "Louis and Noland," *Art International*, May 25, 1960, pp. 26-29.

James McC. Truitt, "Art-Arid D.C. Harbors Touted New Painters," *Washington Post*, December 21, 1961.

Steven Naifeh, *Gene Davis* (New York: The Arts Publisher, 1982).

Gerald Nordland, *The Washington Color Painters*, ©1965 by the Washington Gallery of Modern Art (Clark and Way, New York).

"Outdoor Art Fair is Opened," *The Washington Post*, June 4, 1967, B1.

Paul Richard, "A Disaster at the Corcoran," *The Washington Post,* Dec. 3, 1967.

Paul Richard, "Howard Mehring, Color Artist, Dies," *The Washington Post*, March 22, 1978.

Jacquelyn Days Serwer, *Gene Davis: A Memorial Exhibition* (Washington, D.C.: Smithsonian Institution Press, 1987).

Jamie L. Smith, *Thomas Downing: Origin of the Dot, paintings from the Vincent Melzac Collection* (Conner Contemporary Art, 2002).

David Tannous, "Those Who Stay," *Art in America,* July-August 1978.

Archives of American Art, Smithsonian Institution oral history interviews: Franz Bader, Nov. 2, 1978 (conducted by Julie Haifley); William Calfee, Jan. 11, 1995 (conducted by Liza Kirwin); Gene Davis, April 23, 1981 (conducted by Buck Pennington); Sam Gilliam, Nov. 4-11, 1989 (conducted by Benjamin Forgey); Jacob Kainen, Aug. 10 – Sept. 22, 1982, (conducted by Avis Berman); V.V. Rankine, March 2-22, 1990 (conducted by Liza Kirwin).

Interviews conducted by Jean Lawlor Cohen from the mid-1980s to the present for reminiscences of the 1940s-1960s: Lila Oliver Asher, Franz Bader, Leon Berkowitz, Sam Bookatz, Polly Downing Brewer, William Calfee, Bill Christenberry, Michael Clark, Alice Denney, Florence Davis, Gene Davis, Barbara Fendrick, Ted Fields, Sam Gilliam, Eleanor Green, Jacob Kainen, Rockne Krebs, Ed McGowin, Vincent Melzac, Breton Morse, Marc Moyens, Steven Naifeh, Paul Reed, Paul Richard, Barbara Rose, Eric Rudd, Ben Summerford, James Twitty, Marcella Comès Winslow

In the quarter century since *Museum & Arts Washington* magazine commissioned a three-part series, many of those interviewed have passed away. No cites were required for material found in archives, clipping files or private sources. Some quotations may reflect the common ground traversed by critics and journalists who wrote for *The Washington Herald, The Washington Post, The Evening Star* and *Art in America*.

# Further Reading and Looking

A USEFUL, BUT NOT COMPLETE ANNOTATED LIST OF INFORMATIVE SOURCES

COMPILED BY BENJAMIN FORGEY AND SIDNEY LAWRENCE

## EXHIBITION CATALOGUES, ARTICLES AND BOOKS

"American Art in Microcosm," *Washington Post*, January 17, 1960, E7. Critic Leslie Judd Ahlander's terse but tellingly awestruck review of a Kenneth Noland show at Jefferson Place.

*Art Against AIDS: Washington DC: A Sale Exhibition of Works by Contemporary Artists*, May 3-6, 1990, 406 7 Street, NW. The American Foundation for AIDS Research (AmFar)'s illustrated catalog (40-plus artists, one image per page) shows some striking overlaps—and differences—among artists active in New York and Washington at the time. High profile New York curators Robert Atkins and Annie Philbin participated in the selection.

*The Art Crowd* by Sophy Burnham, New York, 1973. This novel-sized book offers a juicy read primarily about the art world of New York, also including a chapter detailing the Smithsonian's economics, ambitions, politics, intrigue and good (and bad) press under S. Dillon Ripley, particularly the wooing of Joseph H. Hirshhorn and growing pains of the National Collection of Fine Arts (now Smithsonian American Art Museum).

*Art in Washington and Its Afro-American Presence: 1940-1970*, by Keith Morrison, Washington Project for the Arts, 1985. Morrison's impassioned, brilliant, scholarly essay in this 110-page catalog for an important exhibition explores the social, psychological and aesthetic ins-and-outs of Washington's racial divide.

"Art in Washington DC," *Art in America,* 66 (July/August 1978). This issue, which appeared amid the buzz of I.M. Pei's new building for the National Gallery and as the Hirshhorn settled further into the local art scene, focuses almost entirely on Washington's art, artists and arts institutions. Local notables Gene Davis (writing about the 1950s) and David Tannous (current art) contributed articles; New Yorker David Bourdon also had his say, often acerbically, about museums and galleries vis-à-vis "official" Washington.

*The Barnett Aden Collection*, Washington, D.C.: Smithsonian Institution, 1974. With essays and testimonials by various contributors, this 190-page book is an important reference work on a unique Washington institution.

*Breaking the Mold: Selections from the Washington Gallery of Modern Art, 1961 – 1968*, Oklahoma City Museum of Art, 2008. This catalog of the WGMA collection that was sold to the Oklahoma Art Center (now the Oklahoma City Museum of Art) in 1968 has color reproductions of key works and essays by Gerald Nordland, Hardy S. George and Barbara Rose, whose chapter is titled, "When Washington, D.C., Was an Art Capital."

*The Capital Image: Painters in Washington, 1800-1915* by Andrew J. Cosentino and Henry H. Glassie, Smithsonian Institution Press, 1983. This invaluable, 280-page account of painters we have, alas, mostly forgotten documents the city's allure to artists throughout the

19th century. By assiduously seeking out works long hidden in private collections, the authors provide many pleasant surprises. They also manage to show and tell a lot about the sometimes dramatic changes in Washington's social life and physical layout from its beginnings to the first decade in the 20th century.

*Catalyst: 35 Years of Washington Project for the Arts: 1975-2000*, American University Museum at the Katzen Arts Center, 2010. This catalog has insightful essays by curator-organizer J.W. Mahoney and one-time WPA director Jock Reynolds as well as an easy-to-grasp timeline with mini-essays and great photos. Illustrations for the 100-plus works in the exhibition make this book a special treat—a "who's who" of recent Washington art.

*Color as Field: American Painting, 1950-75*, American Federation of Arts/Yale University Press, 2007. This hefty catalog for AFA's traveling show is also an inclusive study by scholar Karen Wilkin who folds the work of Gene Davis, Sam Gilliam, Morris Louis and Kenneth Noland into her account of the post-painterly zeitgeist. Washington per se is not discussed. However, after the traveling exhibition left the Smithsonian American Art Museum in 2008, SAAM had the good sense to present a summer show, "Local Color: Washington Painting at Mid-Century," tapping its own collection (Davis, Gilliam, Leon Berkowitz, Thomas Downing, Felrath Hines, Jacob Kainen, Howard Mehring, Paul Reed, Alma Thomas), curated by Joanna Marsh. No catalog, alas.

*The Constant Artist,* by Paul Feinberg, with interview/statements by nine artists and an afterword by critic Lee Fleming, 2012. In this catalog for an exhibition at the American University Museum, Feinberg, Washington's graceful photographer of artists, presents then-and-now photo portraits of, alongside corresponding artworks by Manon Cleary, Sam Gilliam, Lisa Montag Brotman, Tom Green, Rebecca Davenport, Fred Folsom, Margarida Kendall Hull and (in a spectacular stylistic leap) Joe White. Look for dreams, wisdom and evocations of studio life in the interviews, and a roadmap through the dizzy, hopeful art scene 30 years ago in the afterword. Whether you laugh or cry after perusing this publication—or both—is up to you.

*The Corcoran & Washington Art.* Corcoran Gallery of Art, 1976. In the introduction, then director Roy Slade explains that the book is "a summary of the gallery's involvement with Washington art, particularly during the seventies," but also suggests that the Corcoran wanted to "stop emphasizing the separateness of Washington art and integrate it in the mainstream of American art, where it belongs." It includes illustrations of many art works, mostly by Corcoran instructors and in the gallery's permanent collection.

*The Cultural Battlefield: Art Censorship and Public Funding,* Jennifer A. Peter and Louis M. Crosier, editors, Gilsum, New Hampshire, 1995. Nearly 20 eyewitness essayists (Kimberly Camp. Jock Reynolds, Joyce J. Scott, Dennis Barrie, Jock Sturges and Susan Wyatt, among them) track

the ironies, indignities and intricacies of responding to a reactionary cultural conservatism that ricocheted from Washington's power corridors in the 1980s and remains to this day part of American politics.

*Duncan Phillips and His Collection*, by Marjorie Phillips, Little, Brown and Company, 1970, 347 pages. Written in the years immediately following Phillips' death, and published on the Phillips Collection's 50th anniversary, this book is a celebration of the man and his "life in art"—a life at once rarified and intense. Written by the woman who lived it with him, the painter Marjorie Phillips, the book is a warm inside look not only at the forming of the great collection but also, somewhat unintentionally, at the long-gone patrician social era of which Duncan Phillips was so outstanding a representative.

*The Eye of Duncan Phillips, A Collection in the Making*, Erika D. Passantino and David W. Scott, editors, The Phillips Collection and Yale University Press, 1999. This volume provides a comprehensive catalog of the collection, as well as a history of The Phillips Gallery Art School and the museum's connection with Washington art, along with entries devoted to local artists.

*From the Potomac to the Anacostia: Art and Ideology in the Washington Area*, by Richard J. Powell, Washington Project for the Arts, 1989. Don't let the tabloid format fool you—this catalog, with its essay, is major. Powell, who had just started as WPA's curator and now teaches at Duke, put together a fearless, fair, fascinating exhibition and thesis about art in a dual-race city. The bibliography is terrific.

"The Gallery Game: Five Dealers Talk About the Art Race," *Museum & Arts Washington*, July/August 1989. Iris Krasnow and Lee Fleming (with help from Michael Welzenbach) provide a lively, in-depth wrap-up of the local gallery business at the end of a heyday decade. Tom and Judy Brody, Barbara Kornblatt, Chris Middendorf, Ramon Osuna and Jo Tartt are featured.

*A Garden for Art: Outdoor Sculpture at the Hirshhorn Museum*, by Valerie J. Fletcher, Smithsonian Institution, 1998. This 96-page book celebrates highlights from a world-class collection of 20th century art in three-dimensions. It also concisely traces the outdoor sculpture spaces at the Hirshhorn through four stages of design from 1966 to the early 1990s— from the first announcement of Gordon Bunshaft's museum design to the eventful re-orientation and reduction in scale of his sunken garden in 1971 (see Retrospective) to subsequent landscaping schemes to "soften" the museum's outdoor spaces and bring them integrity as backdrops for sculpture.

*Images of the '70s: 9 Washington Artists*, The Corcoran Gallery of Art, Introduction by Claire List, 1980, 95 pages. An important exhibition documenting what director Peter Marzio referred to as "another tradition of Washington Art," namely, various takes on realistic figuration. The artists selected by "local curator" Claire List (a position of fairly short duration) were Michael Clark, Manon Cleary, Joan Danziger, Rebecca Davenport, Jennie Lea Knight, Kevin MacDonald, Joe Shannon, A. Brockie Stevenson and Genna Watson.

*Living Legacy: 60 Years of the Watkins Collection*, by Jonathan Bucci, curator, and Ben L. Summerford, professor emeritus, The American University Museum at the Katzen Arts Center, 2005. This 53-page catalog goes far in delving into "modern art and its offshoots in Washington, D.C.," as Bucci puts it. There are great period photos here and an excellent mix of (sometimes surprising) Washington paintings, plus national/international examples. The works were all chosen from a 4,500-piece collection that started in 1945 with 25 donations from A.U. faculty artists to honor department founder C. Law Watkins, who had just died. Watkins, a painter and Duncan Phillips protégée, played a key role in studio art instruction in Washington during the 1930s and early '40s.

"The Museum is Their Muse: They're the National Gallery School—Local Artists Who Study Before the Masters," a *Washington Post* Sunday article by Paul Richard (November 9, 1997, G1, via Washingtonpost.com/ Archive). Jumping beyond the Phillips Collection's well-documented allure to local artists, Richard focuses instead on the influence of National Gallery shows and collections (Degas, Velasquez, Caravaggio, Titian et al.) on Jack Boul, Michael Clark, Manon Cleary, Fred Folsom, Joe Shannon, Clarke Bedford and a host of others—a 1990s thesis that easily applies to earlier decades.

*New Sculpture: Baltimore, Washington, Richmond*, by Renato Danese, Corcoran Gallery of Art, 1970, 55 pages. Each of the 23 artists chosen by contemporary curator Danese for this exhibition gets two pages with biography, portrait and a large art image.

"New York/Washington: What's the Difference?," edited by Mary Swift, *Washington Review* 13 (December/January 1988). These nineteen interviews and short written pieces by artists and art-world professionals, among them Claudia DeMonte, Keith Morrison, Ned Rifkin, Bill Warrell and Zinnia, provide an avalanche of opinions and reflections on this age-old debate.

*The 1988 Artists' Congress Sponsored by The Washington Coalition of Artists*. This 28-page illustrated booklet, a labor of love edited by painter-critic Mokha Laget, presents transcripts from panels of a symposium (September 24 and 25, 1988) by the Coalition of Washington Artists at the Corcoran Gallery. "How do we define ourselves?" was the essential debate, and discussions often ran hot. Among the voices heard: Rockne Krebs, Ruth Bolduan, Lee Sourwine, Rex Weil, Walter Kravitz, Pat Fox and Judy Jashinsky.

*One Hundred Artists of Washington, D.C.*, by F. Lennox Campello, Schiffer Publishing, 2011. Bringing past together with present, Campello— indefatigable artist, critic, promoter, blogger—performs a much-needed service in this 224-page book. The choices are, understandably, highly personal. Each artist receives two pages and multiple images in color.

*Remembering Marc and Komei*, The American University Museum at the Katzen Arts Center, 2006. Documenting an exhibition of 92 works by as many artists, it memorializes the distinct connoisseurship of Gallery K art dealers Marc Moyens and Komei Wachi, with perceptive remembrances by four of the artists.

*Sam Gilliam: The Making of a Career, 1962-1973*, by Jonathan P. Binstock, University of Michigan Ph.D. dissertation, 2000, 332 pages (available through some libraries or for sale at ProQuest.com, dissertation and thesis database). In the process of examining and analyzing Gilliam's art and early career, Binstock provides a penetrating account of the D.C. art scene in the 1960s and early 1970s.

*Ten Washington Artists: 1950-1970*, The Edmonton Art Gallery, 1970. This 62-page catalog of an exhibition organized by critic Andrew Hudson presents a chronological survey with images by ten artists who are original "color schoolers" (minus Paul Reed) plus Michael Clark (aka Clark V. Fox), Sam Gilliam, Blaine Larson, Jennie Lea Knight and Rockne Krebs.

"Three Washington Artists," Walter Hopps and Nina Felshin Osnos, *Art International*, May 20, 1970, 32-42. Almost inexplicably, no catalog was ever published for Hopps's 1969 "Gilliam, Krebs, McGowin" show, so this lengthy article must serve, in effect, as the catalog essay for one of the truly pivotal exhibitions in the city's art history.

*The Vincent Melzac Collection*, The Corcoran Gallery of Art, 1971, 102 pages. Though focusing on paintings by the color school generation, this catalog also documents the strong New York contingent in the collection amassed by this memorable Washington figure. The collection is now dispersed.

*Washington Art*, State University College at Potsdam, New York, 1971, 24 pages. Artist William Christenberry chose 33 works by 13 painters and sculptors for this exhibition that he and several of the artists adventurously lugged to far upstate New York in the dead of winter. One image per artist.

*Washington Artists Today: A Directory*, New York: Acropolis Books, 1967, 79 pages. A nice period piece listing compiled by Artists Equity with some illustrations and lots of home/studio addresses. The D.C. Chapter of Artists Equity continued with these compilations for an unknown (to this compiler—BF) number of years.

*The Washington Color Painters*, by Gerald Nordland, Washington, D.C., Washington Gallery of Modern Art, 1965, 50 pages. The holy grail of D.C. exhibition catalogs. Note that Nordland didn't say "school."

*Washington Color Painters: The First Generation*, Orlando, Florida, Orlando Museum of Art, 1990. 79 pages. This exhibition catalog provides a more recent look back, with beautiful color images and revealing essays by Sue Scott, curator, and Gerald Nordland.

*The Washington D.C. Art Review: An Art Explorer's Guide to Washington* by Frank Getlein and Jo Ann Lewis, New York: The Vanguard Press, 1980, 125 pages. A quick, informative tour of the museums and galleries by two knowledgeable art critics.

*Washington Photography: Images of the Eighties*, by Francis Fralin, The Corcoran Gallery of Art, 1982, 44 pages. Another important Corcoran show and catalog document an invigorated local photography scene and, not incidentally, testify to the Corcoran's intensifying involvement in photography under chief curator Jane Livingston and Fralin, her assistant.

*The Washington Show*, The Corcoran Gallery of Art, 1985, 126 pages. "By now, one hopes, everyone understands the incredible richness and vigor of "Washington art,'" states director Michael Botwinick at the very beginning of this invaluable catalog, notable for its words (in essays by critics, curators and artists) as well as its art. Its story is told in this book's 1980s chapter.

*Washington: Twenty Years*, The Baltimore Museum of Art, 1970. This slim, 52- page, image-less catalog of an important exhibition containing 67 works by 42 artists is invaluable for its chronological listing of exhibitions in Washington. In his foreword, BMA director Charles Parkhurst dryly notes, "The undertaking is warranted by the variety and quality of the artistic production in Washington over this period."

*Willem de Looper: A Retrospective Exhibition, 1966-1996*, by Terry Gips and Howard Risatti, The Art Gallery of the University of Maryland at College Park, 1996. This well-illustrated catalog of 79 pages is of broad interest because of its detailed chronology, paralleling events in the life of the artist with those in the art world at large.

*WPA Document: Celebrating More than a Decade*, edited by Helen M. Brunner and Donald H. Russell Jr., Washington Project for the Arts, 1986. This informative and entertaining 98-page coffee-table-size soft-cover pamphlet contains a detailed illustrated chronology of WPA's first 11 years and 45 lively artist-created pages. Summing up the non-profit's liveliness and relevance, it has a fetching design that's like a really good website except that the navigation techniques are different.

"Younger American Painters", by William Rubin, *Art International*, January 1960 Volume 4, pp 28-29. Influential discussion of color painters in New York and Washington.

## ARCHIVES

**All four authors mined local archives and research centers with the assistance of many helpful staffers. They include:**

The D.C. Public Library Washingtoniana Division at the Martin Luther King, Jr. Branch has a wealth of photographs in its Picture Collection, including images from *The Washington Star*. It also holds the clipping files from the *Star*—its old-style morgue—in which reviews, features and news stories about the local art scene are filed in envelopes by by-line, subject and individual names. This is important to note, because the *Star* archives are a great source but have not as yet been digitalized.

The Moorland-Spingarn Research Center at Howard University has the papers of Lois Mailou Jones and other African-American artists' materials.

The Smithsonian Archives of American Art (AAA) has vast quantities of documents relating to Washington Art—the Jacob Kainen papers, for instance, measure 17 linear feet, In addition to scrapbooks, newspaper clippings, correspondence, catalogs and sales documents, the AAA has conducted numerous interviews, many of which have been transcribed and digitized and are available through the Archives website.

The Washington Arts Museum Archives. The audio-taped interviews, video-taped panel discussions, books, catalogs, posters and memorabilia assembled by WAM are to be turned over to the Smithsonian's Archives of American Art at the close of this book project.

Library of the Smithsonian American Art Museum/National Portrait Gallery (a half-block north of the museums). Staffers happily bring stacks of *Washington Reviews* and *New Art Examiners* to your table, and on monitors, the ProQuest Historical Newspapers: Washington Post, 1877-1995 search engine yields (with phenomenal accuracy) *Post* art coverage from past years in PDF format. All Smithsonian and many university and municipal libraries have the ProQuest engine, but somehow using it here, in old downtown, across the hall from the Archives of American Art, is pure Nirvana.

## WEBSITES

*www.aaa.si.edu* The Archives of American Art (AAA), Smithsonian Institution. The oral history program of the AAA is a treasure chest of information, most of it available online through this website. Washington artists and art figures whose interviews are accessible through the website include Franz Bader, Leon and Ida Berkowitz, Adelyn Breeskin, William Christenberry, Gene Davis, Claudia DeMonte, Willem de Looper, Alice Denney, David Driskell, Mary Beth Edelson, John Gernand, Sam Gilliam, James Harithas, Frederick Hart, Joseph H. Hirshhorn, Olga Hirshhorn, Lois Maillou Jones, Jacob Kainen, Raymond Kaskey, Rockne Krebs, Pietro Lazzari,

Kenneth Noland, Jack Perlmutter, V.V. Rankine, Paul Reed, Jim Sanborn, Janet Solinger and Mindy Weisel. Most (but not all!) of these interviews have been transcribed and are available on line for free.

*www.ArtAttackInternational.org*. Art Attack website is worth browsing for its photo documentation and descriptions of the wide-ranging projects in Washington and beyond of D.C.'s ubiquitous guerilla group of the 1980s. Founded in 1979 in Los Angeles, the group re-established itself in New York in the 1990s.

*www.theRestaurantMuseum.com* D.C.'s Bill Wooby, from a family of restaurateurs, created this paean to restaurant lore, but that isn't all you'll find. The site also includes insightful commentaries about the Mapplethorpe projection and other NEA-related controversies of the late 1980s, plus many photos. Wooby's "Collector Gallery and Restaurant" was on U Street. He also founded the Millenium Art Center in Southeast, D.C.

*www.RoySlade.com* In this lively, personal website, former Corcoran director Roy Slade digs deep into the experiences, policies and personalities surrounding Washington's venerable museum and school during in the late 1970s and early '80s.

*www.WPAdc.org/catalyst* This Washington Project for the Arts sub-website for the 2011 Catalyst show has the amazing "WPA Timeline" with comprehensive lists and details of events and exhibitions since the art space's launch in 1975, plus opportunities to add personal comments and reminiscences. (if any trouble finding this timeline, Google "Exhibitions & Events Catalyst").

# WASHINGTON ARTS MUSEUM: THE RECORD

## Exhibitions

*WAM BAM* No. 1: Rebecca Davenport, Tom Downing, Steve Lewis, Renée Stout, Giorgio Furioso, curator, Woodward and Lothrop Windows at 11th and F Streets, N.W., Washington, D.C., June 1-September 30, 1999.

*Emotional Attachment, An Exhibition Of New, Young Collectors' Favorite Pieces*, Anne Levine, curator; District Fine Arts, 1726 Wisconsin Avenue, N.W., Washington, D.C., September 13-October 17, 2001.

*On Our Turf*, Jamie Smith, curator. An exhibition of the work of Corcoran College of Art and Design professor Rex Weil and four of his former students: Juliane Min (photographs) and Team Response members Jason Baliki, Justin Barrow and Matthew Sutton (an installation), District of Columbia Arts Center (DCAC), 2438 18th St. N.W., Washington, D.C., April 11-May 18, 2003 .

*Jean Meisel* A Painting Retrospective 1958-2003, Barbara Fendrick, curator, catalog essayist Simon Winchester; Edison Place Gallery, Pepco Art Center, 701 9th Street, N.W., Washington, D.C., September 10-October 23, 2003.

*James Hilleary* Painting Retrospective, Donald Kuspit, curator; Edison Place Gallery, Pepco Art Center, 701 9th Street, N.W., Washington, D.C., November 1, 2003-January 9, 2004.

*Prime Work: The Art of Joe White*, Jamie Smith, curator, Edison Place Gallery at Pepco Center, 701 9th Street, N.W., Washington, D.C., May 11-June 30, 2004.

*Carroll Sockwell: Am I The Best,* Sam Gilliam, curator; catalog essay by Walter Hopps, Edison Place Gallery at Pepco Center, 701 9th Street, N.W., Washington, D.C., November 3-December 17, 2004.

*Wrinkle Free: Photographs by Joe Cameron and Paul Feinberg,* Giorgio Furioso, curator, images of more than 40 members of the Washington art scene from the Seventies and Eighties, Viridian Restaurant and Gallery, 1515 14th Street, N.W., Washington, D.C., September 10-October 22, 2005. Artists' biographies by Elizabeth Tebow.

*Manon Cleary, A Retrospective,* Jean Lawlor Cohen, curator and catalog essayist, Edison Place Gallery at Pepco Center, 701 9th Street, N.W., Washington, D.C., September 14-October 27, 2006.

*Leon Berkowitz, Seeing Light Through Color,* Renee Butler, curator, catalog essayist J.W. Mahoney; Edison Place Gallery at Pepco, 701 9th Street, N.W., Washington, D.C., April 10-June 28, 2007.

*Herb White: A Taste for Art,* Sarah Tanguy, curator; catalog essayist Alton Miller, Edison Place Gallery at Pepco Center, September 4-October 17, 2008.

## Audio Interviews with Artists and Dealers

Lilian Burwell, William Christenberry, Noche Crist
Jean Efron, Alex Giampietro, Jennie Lea Knight, Mary Orwen
Lolo Sarnoff, Leni Stern, Anne Truitt

## WAM Panels

VIdeotaped panel discussions by artists, curators, and gallery owners, supported in part by a grant from the Humanities Council of Washington, D.C., and co-sponsored by the Arts Club of Washington:

"Washington Art: Historical Perspectives, The Sixties," March 8, 2001, The Arts Club of Washington. Panelists: Willem De Looper, Benjamin Forgey, Jennie Lea Knight, Lou Stovall, Andrew Hudson and moderator Paul Richard.

"Washington Art: Historical Perspectives, The Seventies," November 14, 2001, The Arts Club of Washington. Panelists: Michael Clark, Virginia Daley, Claudia DeMonte, Jack Rasmussen, Paul Richard, Ramon Osuna and moderator Elizabeth Tebow.

## Videos of Exhibition Panels

"Carroll Sockwell," Edison Place Gallery, Pepco Center, November 12, 2004. Panelists: Sam Gilliam, Michael Clark, Jim Hilleary and moderator Jean Lawlor Cohen.

"Manon Cleary," Edison Place Gallery, Pepco Center, October 5, 2006. Panelists: Paul Richard, Chris Addison, Michael O'Sullivan and moderator Jean Lawlor Cohen.

"Herb White: A Taste for Art," Edison Place Gallery, Pepco Center, September 18, 2008. Panelists: Sidney Lawrence, B Stanley, Jim Graham and moderator Sarah Tanguy.

## Washington Arts Museum 2000 Portfolio of Prints

Rebecca Davenport, Tom Downing, James Hilleary, Steve Lewis, Jean Meisel, Carroll Sockwell, Renee Stout and Joe White

Manon Cleary, *Aloysius Beside a Victorian Chair*, 1976-77, acrylic on canvas, collection of Peter and Bernis von zur Muehlen, 70 x 40 inches. Photograph by Paul Feinberg

# ILLUSTRATION CREDITS

## CHAPTER 1 | 1940S

1. Calfee, *County Fair and Trading* (detail), mural study for P.O., Harrison, Va. (c. 1942), Smithsonian American Art Museum, Transfer from the General Services Administration 1980.133.4A
2. Unidentified photographer. Courtesy National Gallery of Art.
3. Kainen, ca. 1935 / unidentified photographer. Jacob Kainen papers, Archives of American Art, Smithsonian Institution
4. Jamieson, Smithsonian American Art Museum, Transfer from the Internal Revenue Service through the General Services Administration 1962
5. Bookatz, unidentified photographer. Louise Bruner papers, Archives of American Art, Smithsonian Institution
6. Courtesy Susan Rosenbaum Abramowitz
7. Kainen, Smithsonian American Art Museum. Gift of the artist, Courtesy Dan and Paul Kainen
8. ©Lautman Photography Washington. Courtesy Franz & Virginia Bader Fund
9. Robert L. Johnson / The Barnett Aden Collection. Courtesy Robinson Family
10. Little Paris Group, 1948 / unidentified photographer. Alma Thomas papers, Archives of American Art, Smithsonian Institution
11. Smithsonian American Art Museum. Bequest of the artist 2006.24.2
12. Lois Mailou Jones papers, Archives of American Art, Smithsonian Institution
13. Courtesy American University
14. Courtesy Lenore Miller, George Washington University
15. Morris Louis, ca. 1942, unidentified photographer. Miscellaneous photographs collection, Archives of American Art, Smithsonian Institution
16. Courtesy Hemphill Fine Arts

## CHAPTER 2 | 1950S

1. Courtesy Marlborough Gallery, © 2011 Red Grooms / Artists Rights Society (ARS), New York
2. Photograph © John Hartman, 2012
3. Photograph by Ann Edelman, courtesy Edelman Family
4. Smithsonian American Art Museum, Gift of Ruth and Jacob Kainen 1990.79.1
5. Gift of the artist, The Phillips Collection, Washington, D.C.
6. Courtesy John Winslow
7. Courtesy American University
8. The Baltimore Museum of Art: Gift of Marcella Brenner Revocable Trust, BMA 2011.184; Photography by Mitro Hood, © Baltimore Museum of Art
9. Smithsonian American Art Museum, Gift of Benjamin P. Nicolette 1977
10. Smithsonian American Art Museum Gift from the Vincent Melzac Collection 1980
11. Smithsonian American Art Museum Gift from the Vincent Melzac Collection 1980
12. Courtesy Marsha Mateyka Gallery

## CHAPTER 3 | 1960S

1. Collection of Gary O. and Jean L. Cohen
2. Courtesy Connersmith, Washington, D.C.
3. - 7. Photographs by Ann Edelman. Courtesy Edelman family
8. Unidentified photographer, miscellaneous photograph collection, Archives of American Art
9.-10. Photograph by Ann Edelman. Courtesy Edelman family
11. Courtesy Ramon Osuna

12. Photograph by Ann Edelman. Courtesy Edelman family
13. Smithsonian American Art Museum , Museum purchase from the Vincent Melzac Collection through the Smithsonian Institution Collections Acquisition Program 1980
14. Courtesy Frauke DeLooper
15. Photograph by Paul Feinberg
16. Smithsonian American Art Museum. Gift of the artist 1970
17. Photograph by Paul Feinberg
18. Private collection, Washington, D.C.
19. Photograph by Ann Edelman. Courtesy Edelman family
20. Smithsonian American Art Museum. Gift of the Target Rock Foundation 1966.52
21. Smithsonian American Art Museum, Gift of Mrs. Harold Ickes 1972
22. Collection of Vincent Melzac. Courtesy Connersmith Gallery, D.C.
23. Photograph by Ann Edelman. Courtesy Edelman family
24. Courtesy Paul Reed
25. Phillips Collection, permission Paul Reed
26. Courtesy private collection, Washington D.C.
27. - 28. Photograph by Ann Edelman. Courtesy Edelman family
29. Courtesy her daughter Helene S. Schonoebelen
30. Courtesy Ed McGowin
31. Smithsonian American Art Museum, gift of James M. Younger 1978
32. Photograph by Paul Feinberg
33. Photograph by Ann Edelman. Courtesy Edelman family, all by Ann Edelman, courtesy Edelman Family

## CHAPTER 4 | 1970S

1. Courtesy Mary Beth Edelson
2. Courtesy The Phillips Collection
3. Photograph by Richard Hofmeister, courtesy Hirshhorn Museum and Sculpture Garden
4. Courtesy Lou Stovall

5. Reprinted with permission of the D.C. Public Library, Star Collection, © Washington Post
6. Courtesy Roy Slade
7. Reprinted with permission of the D.C. Public Library, Star Collection, © Washington Post
8. Courtesy Robert Stackhouse
9. Courtesy Smithsonian American Art Museum, bequest of the artist
10. Courtesy Smithsonian American Art Museum
11. Courtesy Mary Beth Edelson
12. Photograph by Anne S. Wood
13. Reprinted with permission of the D.C. Public Library, Star Collection, © Washington Post
14. Photograph by Mary Swift
15. Reprinted with permission of the D.C. Public Library Star Collection, © Washington Post
16. Photograph by Mary Swift
17. Courtesy David Furchgott
18. Courtesy Joe White
17. Courtesy Ed McGowin
18. Courtesy Joe White
19. Collection of F. Steven Kijak
20. Courtesy Ed McGowin
21. Courtesy Robin Moore
22. Courtesy Rebecca Davenport
23. Courtesy Joe Shannon
24. © Alan Feltus, courtesy of Forum Gallery, New York, NY
25. Photograph by Mary Swift
26. Courtesy Jessica Racine White
27. Courtesy Joan Danziger
28. Courtesy Renee Butler
29. Courtesy William Lombardo
30. Smithsonian American Art Museum, Museum purchase made possible through the Luisita L. and Franz H. Denghausen Endowment, Alexander Calder, Frank Wilbert Stokes, and the Ford Motor Company
31. Photograph by Mary Swift
32. Photograph by Mary Swift
33. Courtesy Manon Cleary
34. Photograph by Anne S. Wood
35. Photograph by Anne S. Wood

36. Photograph by Paul Feinberg
37. Photograph by Paul Feinberg
39. Photograph by Mary Swift
38. Courtesy Isabel Swift

**ALBUM**

AROUND TOWN: National Gallery, Versailles and d.c. space photographs by Mary Swift; Hirshhorn by John Tennant, HMSG; DeMonte courtesy of Claudia DeMonte; On the steps of the Corcoran: Reprinted with permission of the D.C. Public Library Star Collection, copyright *Washington Post*

OUTDOORS: Flag protester courtesy Bill Wooby; march photograph by Mokha Laget; P Street and awning photographs by Mary Swift; boots photograph by Mark Gulezian/Quicksilver; bridge piece courtesy the artist; Davis street stripes by Gary O. Cohen

IN PRINT: Hanover poster courtesy Nan Montgomery; facade courtesy Art Attack International

PAINTED PERSONALITIES: Crisp-Ellert (1924-2007) *Self-Portrait*, oil on canvas, 70 x 51 inches, courtesy Crisp-Ellert Art Museum, Flagler University, Saint Augustine, Florida. This work, painted during the artist's London student days, later hung at the Ellerts' eccentrically decorated, turreted Georgetown house (3099 Q) where Talleyrand, a friendly Great Dane, greeted guests. Kainen *Self-portrait*, brush and ink on paper, 12 5/8 x 9 1/2 inches, Smithsonian American Art Museum, gift of Sara L. Lipman; Kainen; *Gene Davis*, 1961, oil on canvas, 60 x 48 inches, Smithsonian American Art Museum, gift of the artist; Donaldson (1932—2004) *Eminence*, 1976, acrylic and mixed media on corrugated paper board, 32 3/4 x 34 3/4 inches, collection of the Birmingham Museum of Art, Museum Purchase in Memory of Lillie Mae Harris Fincher With Funds Provided by the Sankola Society, courtesy/copyright Jameela K. Donaldson; Hunter, *Walter Hopps,* oil on canvas, 34 x 60 inches, collection unknown, courtesy of the artist; Lawrence, *Herb 'n' Howard in an Arty Environment,* mixed media, 33 x 44 x 6 1/4 inches, collection of Jessica Racine White; Joe White, *Chris and Palmer,* oil on linen, 46 x 38 inches, collection unknown, courtesy artist.

VISITING DIGNITARIES: O'Keeffe by John Tennant/Hirshhorn Museumf; Burroughs, Waters photograph by Mary Swift; Warhol, Colacello & Murray courtesy Chris Murray; Acconci photograph by John Tennant/Hirshhorn Museum; Carters at the Corcoran courtesy Roy Slade; Dealer Legends, Nancy Reagan at Corcoran Gallery, courtesy Carolyn Campbell

CAKES: Kreegers, Corcoran Gallery, courtesy Carolyn Campbell; Hirshhorn card courtesy Sidney Lawrence

AT THE TABLE: McGowin, Hopps photographs by Mary Swift; Forgey photograph by John Aikins

SPACE: Christenberry, Puryear photographs by Mary Swift; gallery interior courtesy Ed McGowin

**CHAPTER 5 | 1980S**
**PART 1**

1. Photograph by Frank (Tico) Herrera
2. Photograph by Carolyn Campbell
3. Courtesy Hirshhorn Museum
4. Photograph by Mary Swift
5. Three photographs by Mary Swift
6. Photograph by Ross Chapple
7. Courtesy Art Attack International
8. Courtesy the author
9. Courtesy W.C.Richardson
10. Courtesy Sherman Fleming
11. Courtesy Gayil Nalls
12.- 13. Photographs by Mary Swift
14. Courtesy Frank DiPerna
15. Courtesy Dallas Museum of Art
16. - 17. Photographs by Mokha Laget
18. Courtesy the author
19. Photograph by Greg Staley
20. Photograph by Mokha Laget

**PART 2**

1. Hirshhorn Museum photograph and touchup by John Tennant
2. Photograph by Mary Swift
3. Courtesy Duncan Tebow
4. - 14. Photographs by Mary Swift except 6.Mussoff/Kavanagh (Hirshhorn Museum) and 8.Butler (courtesy artist)

**RETROSPECTIVE**

1. Courtesy Lila Oliver Asher
2. Conte crayon crayon on paper, National Portrait Gallery, Smithsonian Instituion, Gift of the Friends of Marcella Comes Winslow
3. Photograph by Master Sgt. R.E. Westmoreland, courtesy United States Marine Corps
4. Smithsonian American Art Museum, Gift of Ruth and Jacob Kainen
5. Alma Thomas Papers, Archives of American Art, photograph by Ida Jervis
6. Corcoran Gallery, courtesy Carolyn Campbell
7. Courtesy McLean Project for the Arts
8. Smithsonian American Art Museum
9. Smithsonian American Art Museum

10. Collection of Jean L. and Gary O. Cohen
11. Photograph by Ann Edelman, courtesy Edelman Family
12. Reprinted with permission of the D.C. Public Libary Star Collection, © *The Washington Post*
13. Photograph by Mary Swift
14. Photograph by Darrell Acree
15. Reprinted with permission of the D.C. Public Library Star Collection, © *The Washington Post*
16. Courtesy Patrick A. Thomas
17. Courtesy the artist
18. Photograph by Mary Swift
19. White House photograph
20. Courtesy Nizette Brennan
21. Photograph by Janet Kincaid (2008)
22. Photograph by Gary O. Cohen
23. Photograph by Mary Swift
24. Photograph by Lucian Perkins, courtesy Bill Warrell
25. Courtesy Bill Wooby
26. Photograph by Edward Owen, courtesy Art Attack International
27. Photograph by Mokha Laget
28. Hirshhorn Museum, photograph by Lee Stalsworth
29. Photograph by Kim Curry

**AFTERWORD**

1. Photograph courtesy Enid Sanford
2. Collection of Benjamin and Gabriella Forgey
3. Collection of Benjamin and Gabriella Forgey
4. and 5. Courtesy Gehry Partners LLP
6. Courtesy EYP Architecture & Engineering, photograph by Peter Aaron
7. Courtesy Diller Scofidio + Renfro
8. Collection of Benjamin and Gabriella Forgey

# INDEX

 **N**

 **S**

Made in the USA
Charleston, SC
24 July 2013